FARMHOUSE REVIVAL

FARMHOUSE
REVIVAL

STEVE GROSS AND SUSAN DALEY

ABRAMS, NEW YORK

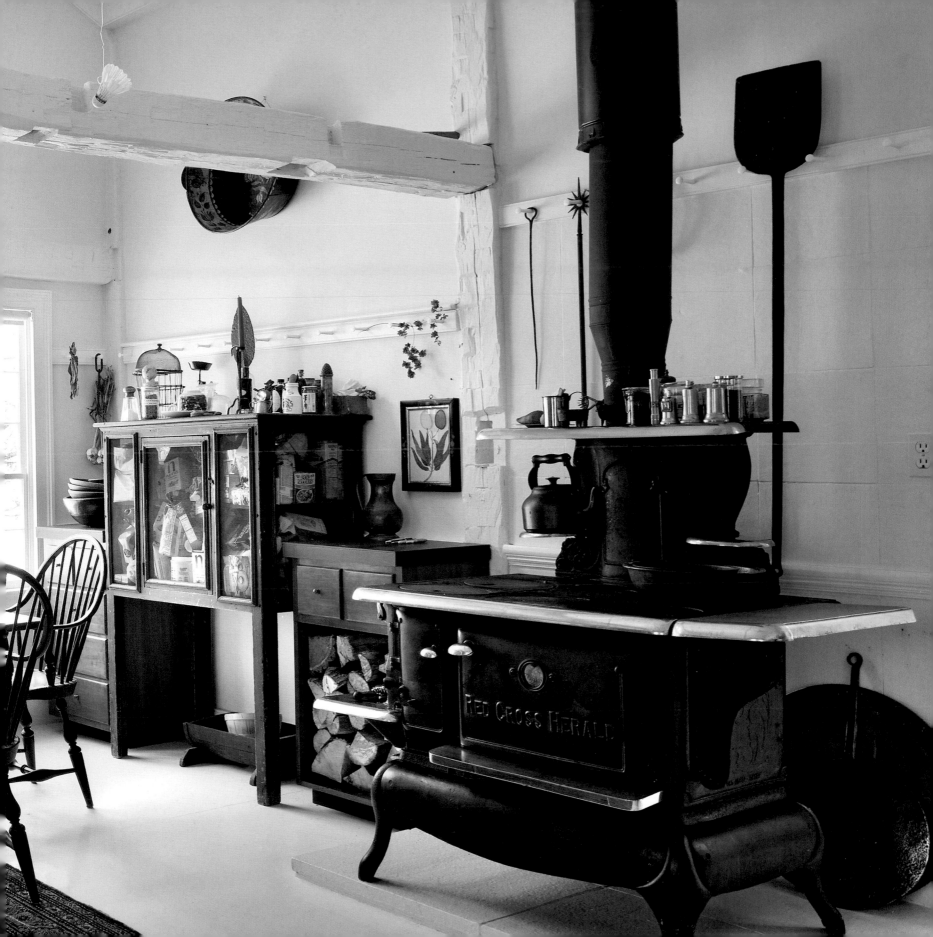

CONTENTS

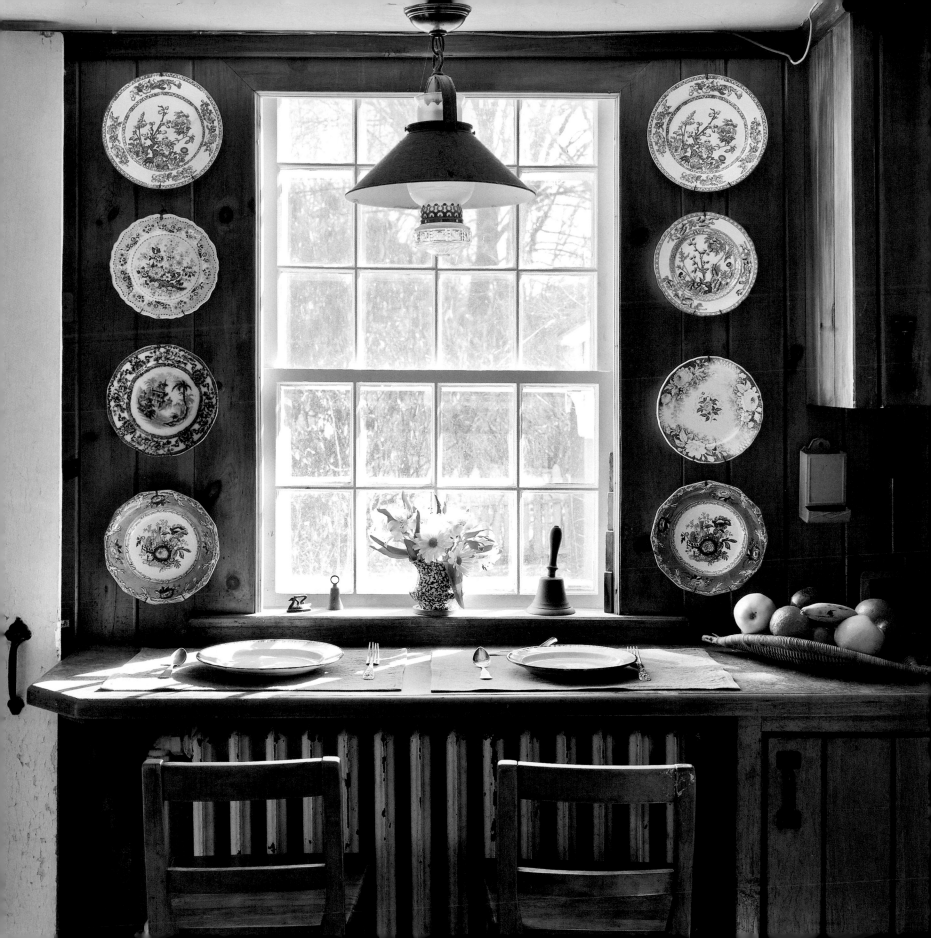

INTRODUCTION

An old farmhouse is still a sight often encountered across this country's landscape, for at one time—and it wasn't so long ago—most people in America lived on farms. We are all acquainted with vernacular farmhouses, with their red barns and various wooden outbuildings, at least from a distance. To many people living in cities and suburbs, a farmhouse might be quite idealized or remote. Perhaps they imagine it as the farmhouse seen in childhood picture books, or one created for a movie by set decorators. Or possibly it's the abandoned house glimpsed through the windshield while driving on an interstate highway: a lonely house from another time.

Old farmhouses come in many different architectural styles; there is no definitive type. They range from small, rustic one-room houses to large, elegant plantation or manor houses. Whether wood, brick, or stone, the materials often come directly from the land the houses sit upon. Plain and austere or ornamented with gingerbread, they were seldom designed by professional architects; instead they were built in true vernacular fashion by carpenters following age-old patterns and local styles, all the while adapting and evolving the designs to suit personal needs and tastes.

Farmhouses have often been taken for granted or underappreciated because of their very commonness. But today, as more people come to value the vernacular, there is revived interest and the farmhouse is seen in a new light. Farmhouses are being restored by people who recapture the original spirit and character of the house while avoiding incongruous elements.

The houses have always changed with changing times; each one speaks of an evolution according to utility and transient fashions. They were first built for posterity, and it was assumed that the houses would be altered and updated as time went on. A small Colonial-era Cape Cod might have been the original dwelling, with wings or ells added as the family grew and prospered. Later still, a front porch might have been put on, or a kitchen with an iron woodstove added to replace a central hearth where the cooking had previously, and painstakingly, been done. This flexibility and diversity holds true of their interiors as well, with furnishings taken from many different eras. Houses made in such individualistic fashion please the eye; each has its own unique sense of place and particularity.

The houses in this book are in a constant state of change and adaptation. Never complete, they have grown over time, with hybrid forms sprouting organically, similar to the nature that surrounds them. The ordinary suddenly becomes startling when viewed afresh, as so often happens when looking at the vernacular.

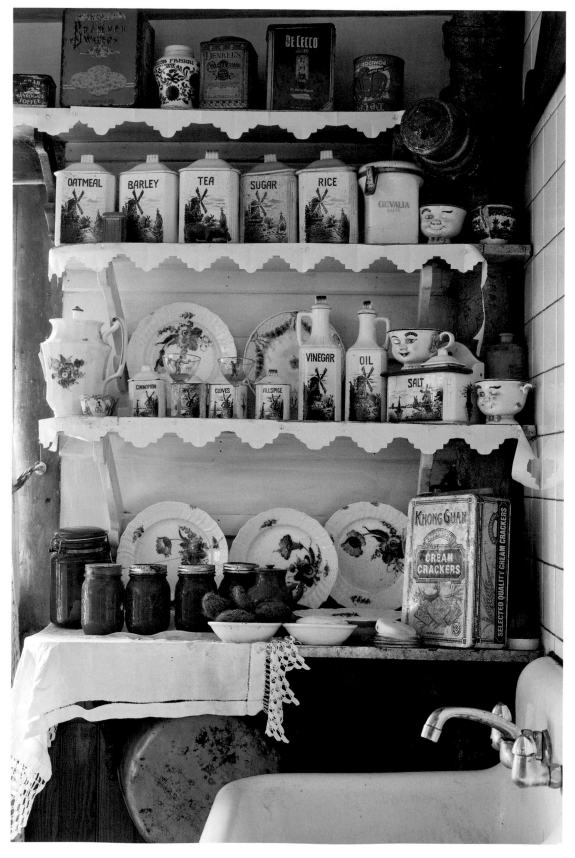

Some farmhouse owners are lucky enough to inherit a barn original to the farmstead. Though expensive to restore, barns are revered as great examples of vernacular architecture, and most people save them from ruin if they can. The informal groupings of barns, sheds, and the many other outbuildings once necessary to a farm make each farmstead look like a tiny community, but as the need for specialized buildings such as smokehouses, springhouses, wagon sheds, washhouses, and blacksmith shops declined, these humble buildings were usually torn down.

If any remain today on a farm, these simple structures are much appreciated; they can be turned into guesthouses or art studios or places to conduct one's livelihood. Working at home on one's own place with family members used to be the norm. Many farms also had attached workshops where families produced and sold useful items such as wheels, barrels, shoes, cloth, or pottery, and some practiced law or medicine from a home office with its own separate entrance. Today, some of the farmhouse owners in this book work from home at occupations other than farming: writing, architecture, or graphic design. And many of the barns are used as gathering places where potluck dinners, events, and celebrations take place, helping tight-knit communities to develop.

As photographers of old farmhouses, we see our subjects evolving and flourishing at the same time that they are also in danger of vanishing. Documentary photography can help to reclaim and preserve places by collaborating with the creation of historical narratives about what is noticed and valued. As we've traveled across the country, we've come across many abandoned homesteads and wandered through them, wondering what happened to the families that lived there, what caused the houses to become overgrown and neglected, and what it would take for them to be reestablished. We've looked through the broken windows of forlorn houses and seen

kitchen tables set for breakfasts that never took place fifty-odd years ago, the residents seemingly having gone out and never returned. The barns and houses, so obviously well-crafted and sited on beautiful, still-fertile land, were being left to dissolve quietly back into the soil. We wondered what the remaining small working farms were like on the inside, the places with old trucks and tractors in the yards, with goats and signs for fresh eggs. Were the rooms inside places from another time?

With interiors both homey and exquisite, the houses we photographed for this book are all in the Northeast, varying widely from stone houses built hundreds of years ago in New Jersey and Pennsylvania, to classic Greek Revivals on hardscrabble hill farms in New York and New England. While they range from humble to grand, the objects gathered and the environments created in these houses all reflect an earlier farm aesthetic that is comfortable, unpretentious, and convenient, as well as very visually appealing. The homes included here are but a sampling of the many old farmhouses being preserved; they were chosen not only because they show the interesting ways time marks a building and its interiors, but because they also reveal the good taste and creative personalities of the people who inhabit them. Common themes are capacious kitchens with pantries, cupboards, deep enameled sinks, scrubbed wooden tables, and pine-paneled walls, and sitting rooms with comfortable old sofas and Windsor and wing chairs gathered around fireplace hearths. There are portraits of ancestors on the wall, but also yard sale and flea market finds. All have character and an insistent beauty.

This book includes farms that have gone through many transitions over the years. Some large farms, where the land was once worked by slaves, indentured servants, or tenant farmers and which grew export crops for wealthy landlords, went on to be owned and operated by families who practiced a

much more self-sustaining form of subsistence farming; they grew most of what they needed, supplementing with barter and trade within the local community. There are farmsteads that supplied wheat to the Continental Army during the American Revolution and then became dairy farms when burgeoning city populations required milk, butter, and cheese. As the natures and purposes of the farms changed, so too did the rooms and interiors, as well as the configurations of the homesteads.

Another form of rescue and revival has been carried out by artists who were able to see the beauty behind the rotting sills and crumbling plaster, and who had the patience or skills for renovation. The restoration of old farms by artists has been happening for decades; the farms have the ample space needed for art studios as well as the inspiring beauty of a rural environment. The effort required to bring a long-neglected farmhouse back to life is not something most people would attempt, but artists often do. Those with an appreciation for the details and designs, such as the artists living at Wistaria House and Ferney, took up the challenge and created houses that retain a strong original character, where the hand of the carpenter is revealed rather than replaced.

The quirky flow of rooms that were added on over the years, the tilting, worn floorboards, and the odd angles resulting from an old farmhouse fighting gravity for a very long time all became desirable elements that enhanced the feeling of the place. Attempting to recapture a measure of dignity and mellowness after decades of rude and blatantly ill-fitting modernizations by former owners, many of these homeowners told us stories of removing "improvements" such as dropped ceilings, particle-board paneling, and prefabricated bathrooms. At the same time, they knew when to stop and leave well enough alone: preserving the original worn paint or vintage wallpaper, exposing the layers of age on an old cupboard,

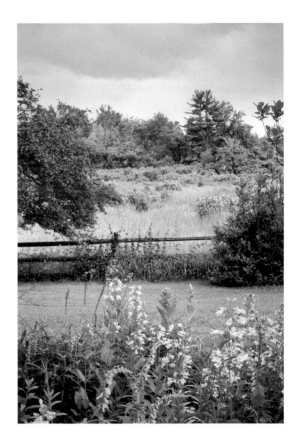

and cleaning off just enough rust from an old hand-forged hinge to keep it swinging smoothly.

As we photographed the interiors of the houses, we noticed the way the homeowners quite often seemed to visualize certain impressions of previous times and create still lifes of objects that echoed the past, whether consciously or not. It was as if some kind of collective vernacular memory was at work, with things being culled from what's called "the usable past." There is a keen sense of history evident. Although many of the things that they chose for their homes were saturated with reminiscence, there is none of the false nostalgia that comes with trying too hard to re-create perfect period settings.

Just as in the past, possessions are passed down through the owners' families, taken from attics, and reused. There is a noted preference for quotidian objects, especially the old handmade tools once used to do the work of a farm, such as the ones displayed at the Karps' farm and at Saddlebow, and also a love of handcrafted items such as rag rugs, knitted afghans, folk art, wooden bowls, and patchwork quilts. Things that had been stored away in sheds, barns, or garages turn up once again, proving to be still attractive and serviceable, despite some nicks and dents. The problem of how to furnish a farmhouse so that it looked and felt "right" was solved in many cases by finding castoffs and hand-me-downs, as well as going to the thrift shops, auctions, and yard sales in the area, where many vintage items were discovered. Patina is relished, and there is a proclivity for preserving old textures, and for favoring the old over the new. The end result is a farmhouse that looks like it has always been that way, even when it hasn't.

Above all, though, it is the perpetual presence of the land that has drawn so many to these houses. Reclaiming overgrown fields, beginning a garden, or restoring an old one found on the property often leads to wanting to do more with the land. Whether it's planting orchards for the future, growing specialty or organic crops to sell at farmers' markets, or raising horses, the lure of an old farmhouse often leads to a renewal of lifestyle.

What these places have to offer, whether the land is still worked or not, is a deeply satisfying life. Dreams of raising sheep or goats, or keeping bees for honey, may not be realistic propositions for all of these homeowners. But as Annick de Bellefeuille at Bellefield Manor told us, "Just as it is, this farm gives us a harmonious life. There is always something beautiful to look at any time of day or night, something useful to do, like working in the garden, fixing something in the barn, keeping up with the house, cooking in the big kitchen, experiencing the pleasures of dining outside, walking around the fields, or watching the sunset from the barn." The farmhouse can be a refuge from the clamor of an intrusive world, and it can redirect one's consciousness toward what is real, natural, and important. And according to the inhabitants of the houses in this book, it brings joyfulness and a deeply felt sense of beauty as well.

As the historian and literary critic Lewis Mumford once wrote about his own farmhouse in Dutchess County, New York, "In no sense was this the house of our dreams. But over our lifetime it has slowly turned into something better, the house of our realities."

BELLEFIELD MANOR FARM

The Manorkill Valley in the northern Catskill Mountains is one of New York's most remote and beautiful mountain valleys. The long, winding road that follows the Manorkill Creek was once a narrow Indian trail, before it became the busy Susquehanna Turnpike. Just past a general store and an old cemetery we find the farmhouse of writer Annick de Bellefeuille and Dr. Rhodes Adler. Originally constructed in 1790 for one George Humphrey, the house was a tavern that sheltered farmers coming from overcrowded parts of New England on their search for new lands to farm. It also provided a gathering place for local farmers to meet, discuss business, trade, and imbibe, as well as a stopover for drovers bringing their flocks or herds down the mountain to market in the town of Catskill on the Hudson River.

For more than 150 years, the fields in the valley provided crops such as buckwheat, rye, and corn. The handsome barn, which sits directly across the road from the house, was restored by a local craftsman using early barn-building techniques and materials recycled from other old farm structures. The couple now holds potluck dinners there, where neighbors gather and enjoy the views of Huntersfield Mountain through barn doors thrown wide open.

The couple purchased the farm in 1987 and sought to reveal the original character that lurked beneath multiple layers of remodeling. "We wanted rooms with the huge brick fireplaces and hand-hewn beamed ceilings exposed,"

Heated by a wood-stove, the kitchen is ornamented with a frieze of Mexican folk pottery, the colorful accents enhanced by the bright blue of the shelf and the green of the kitchen set. Wooden cutting boards are set to dry on a stone bench.

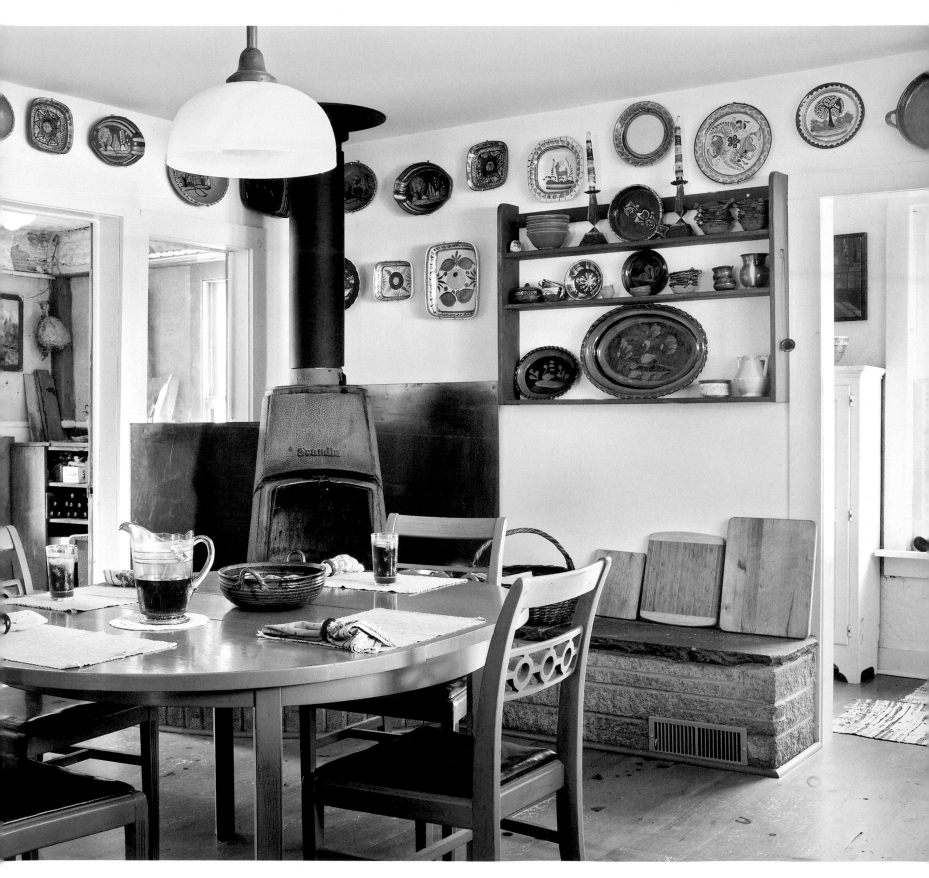

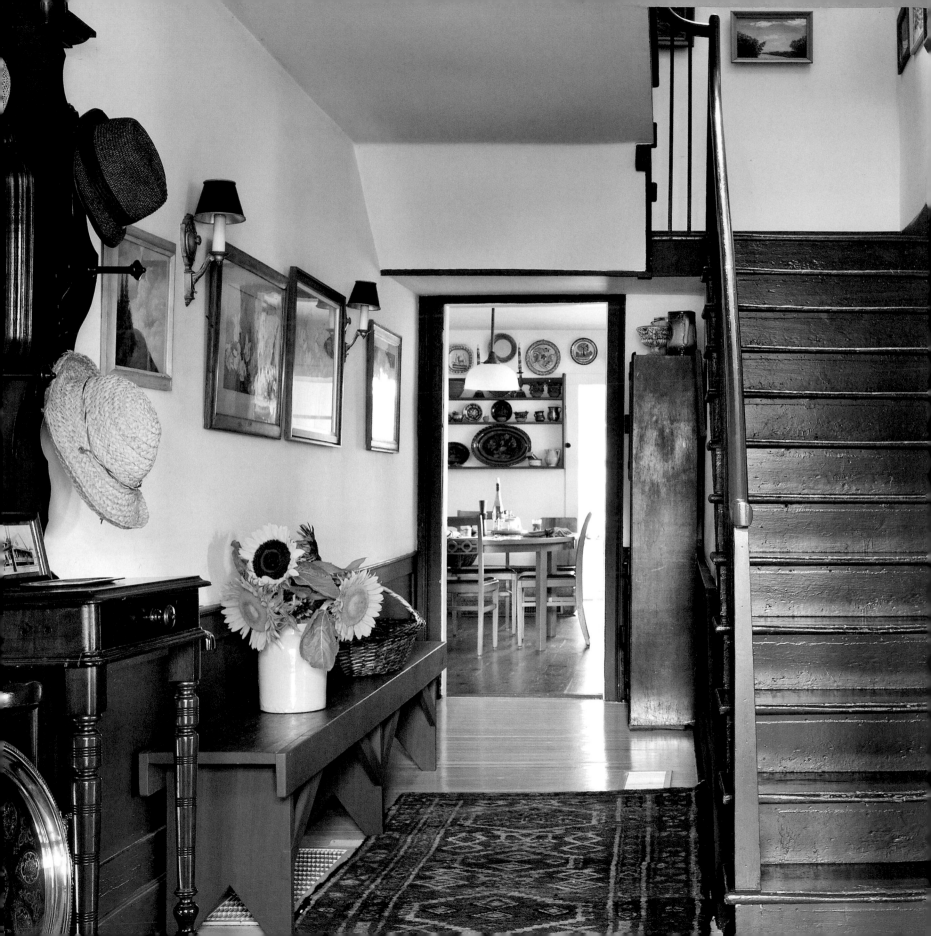

The farmhouse's entrance hall, with its Federal-style staircase, banister, and paneling, is a passageway to the kitchen. Folk and outsider art paintings that the couple have found at yard sales and thrift shops hang along the wall by the stairs. A Renaissance Revival hall tree from the 1870s and a carpenter's bench, coated in red milk paint, welcome guests.

Annick says. "At one time the ceiling beams would have been covered with plaster and lath, but once we'd stripped them bare, we liked the look."

Throughout the couple's home, a mix of vintage and antique furniture is painted in lively hues. A round table painted a bright apple green is at the center of the farmhouse kitchen, which also has a woodstove and Mexican pottery displayed on the walls and open shelves. "We have a few pieces of furniture that are classic farmhouse antiques, but the rest of it is stuff from my grandmother's house. We have a collection of yellowware pots that we've found at yard sales and flea markets. I'm especially fond of the black polka-dot milk pitcher." The feeling of family history is present in the memorabilia and groupings of photos and paintings of relatives.

Today, the horticultural focus of Bellefield Manor is the extensive flower garden that the couple has created over many years. Sloping down the hill behind the house and alongside an overgrown meadow, hollyhocks, filipendulas, and bee balm flourish in rock-bordered beds. Old poppy varieties and other heritage plants, often acquired from neighbors and friends, thrive in the rocky Catskill soil. Every fall, Annick and Rhodes collect the seeds and store them in carefully labeled brown paper bags, then hang them in the mudroom along with the many garden tools, boots, work gloves, straw hats, and assorted outdoor farmwear they use.

"One of the aspects we love about our life here is that it takes us out of the consumerist life of the city to a life of production. We may not have enough lifetimes to realize our fantasy of full-fledged farming, but in our small way, with our garden, our potluck parties, our restoring of the house and the barn, we do feel that we are making, giving, and creating more than just buying our way through life."

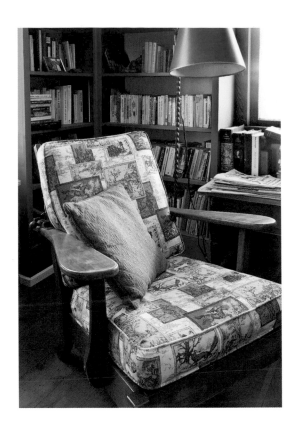

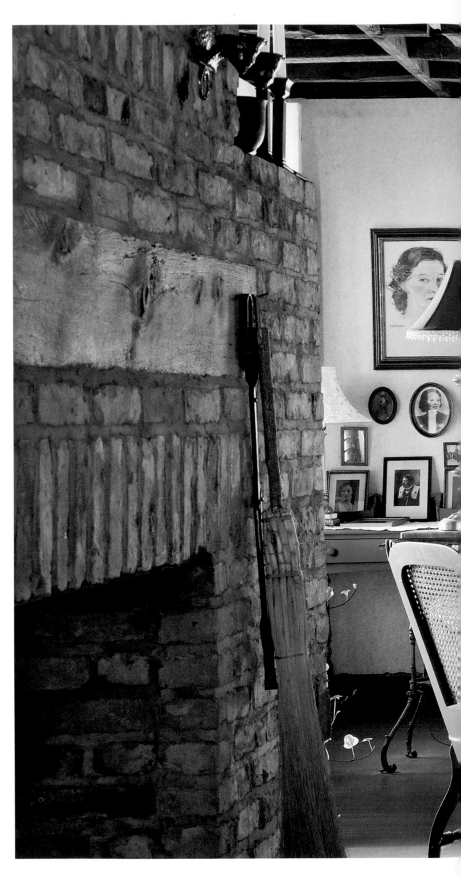

ABOVE
A vintage rock maple armchair, upholstered in fabric depicting bucolic vignettes, sits in the corner of the master bedroom. The tilt of its back can be adjusted by moving a rod, in the manner of the chair created by William Morris in the mid-nineteenth century.

RIGHT
The owners exposed ordinarily concealed architectural elements, such as the ceiling joists and the bricks and wooden lintel of the fireplace chimney. Combining these elements with brightly painted Colonial Revival furniture and woodwork, the living room possesses a relaxed ambiance. Red fringed lamp shades provide colorful accents.

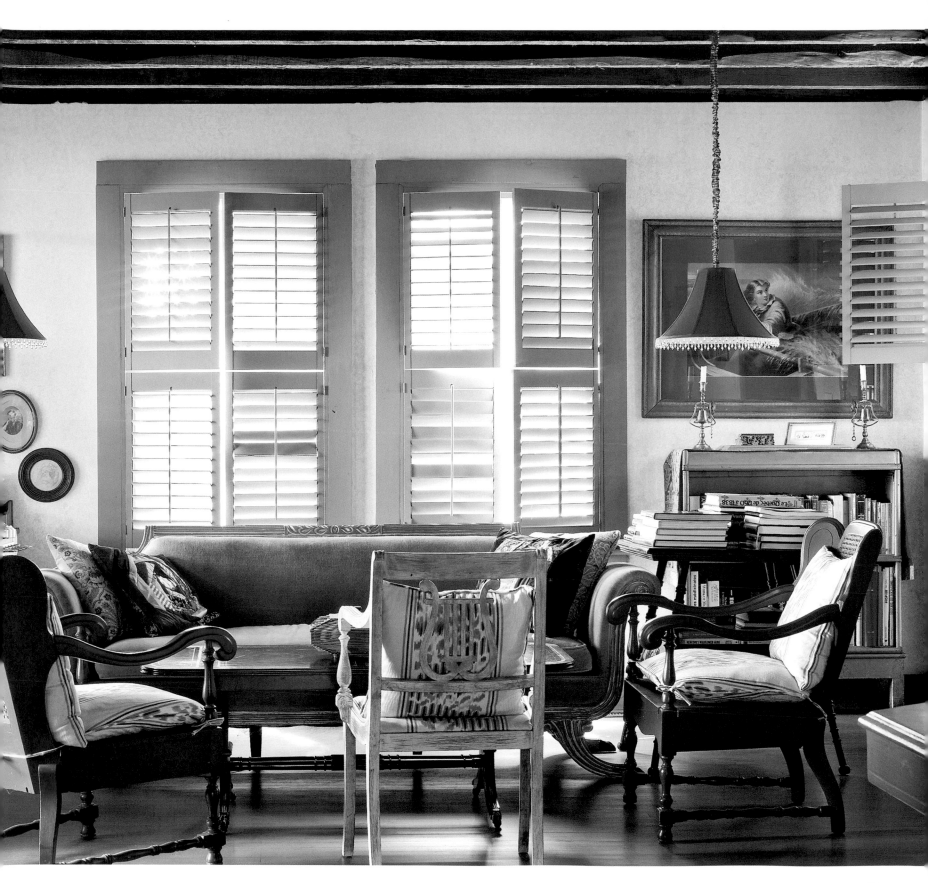

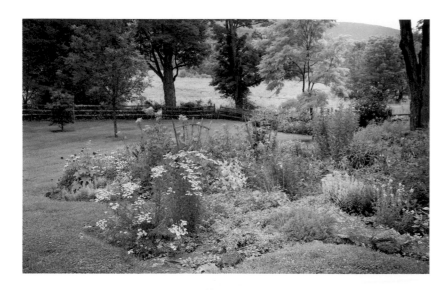

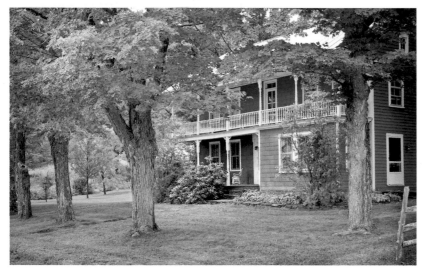

TOP

Passionate gardeners, Annick and Rhodes have cultivated the grounds over time. A lush cottage garden of perennials, including blue nigella, poppies, calendula, feverfew, and hollyhock, is bound by fieldstones. In the distance, the meadows shimmer with wildflowers.

BOTTOM

Bellefield Manor Farm's homestead began as a tavern in the 1790s and quickly evolved into a residence; the broad porch and balcony above it were a Victorian addition. Located on Manorkill Creek and surrounded by sugar maples, the thirty-acre property stands near the base of Huntersfield Mountain.

RIGHT

The couple entertains frequently, and potluck dinners are laid out on tables made of sawhorses and planks. The walls of the barn are hung with various farm and household tools, such as pulleys, hatchets, and a rug beater. Salvaged hemlock boards were incorporated into the restoration of the original barn, with its open threshing floor, hayloft, manger, and granary.

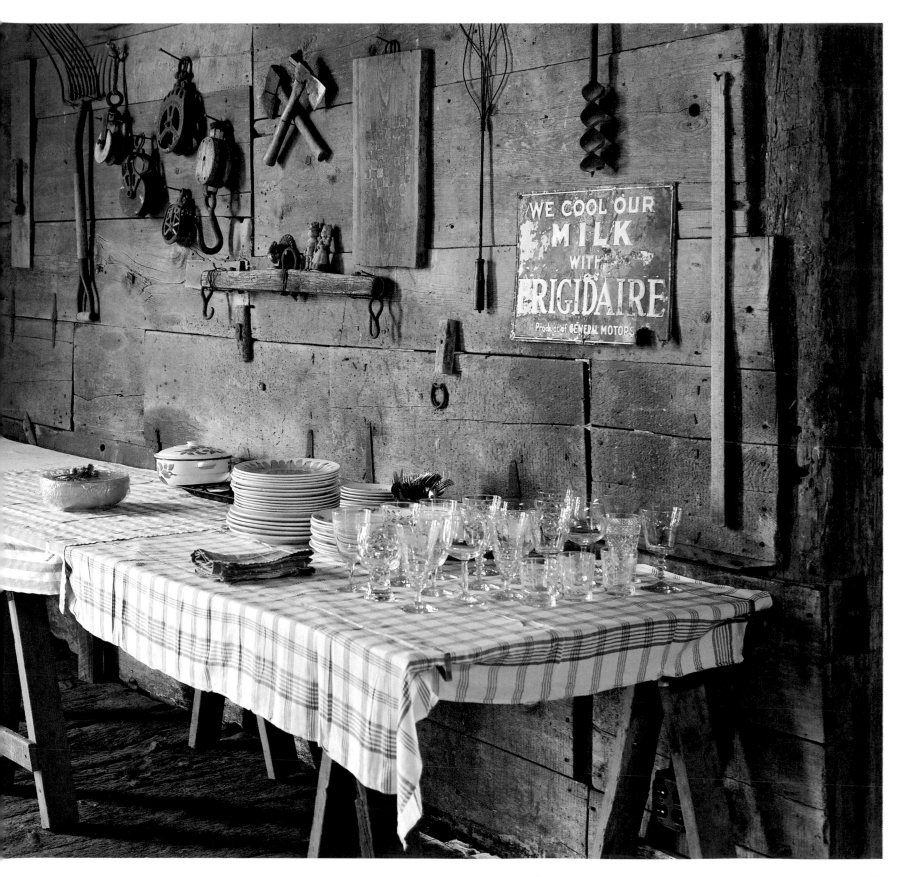

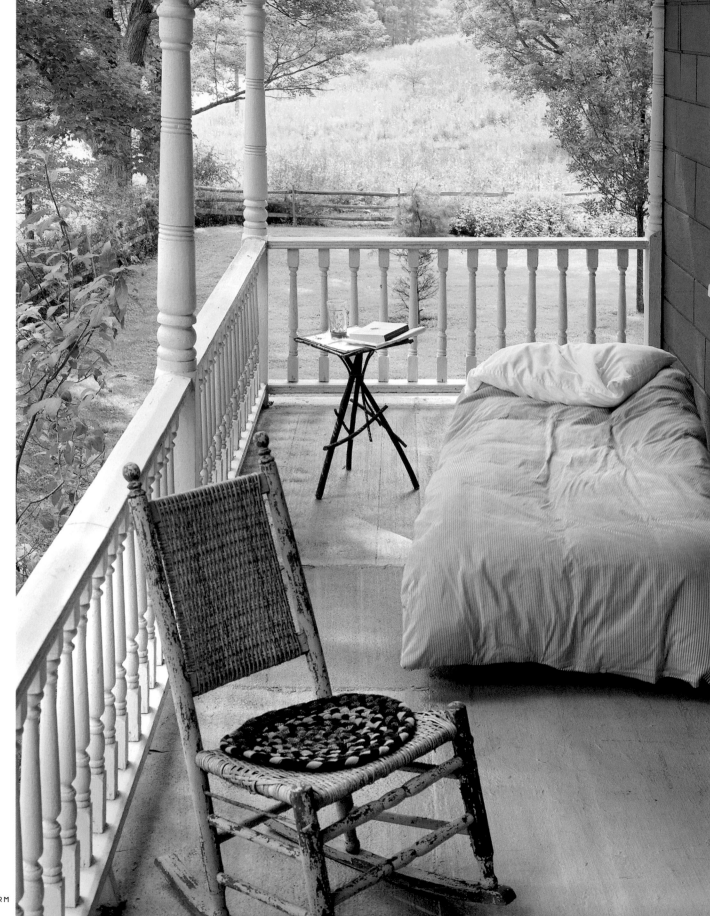

Farmhouse residents might sleep out on the balcony to escape the stifling air that gathers in the house during a hot summer day. Here, the couple has placed an inviting bed and a twig table. This upper level of the front porch looks out over the garden and distant hills.

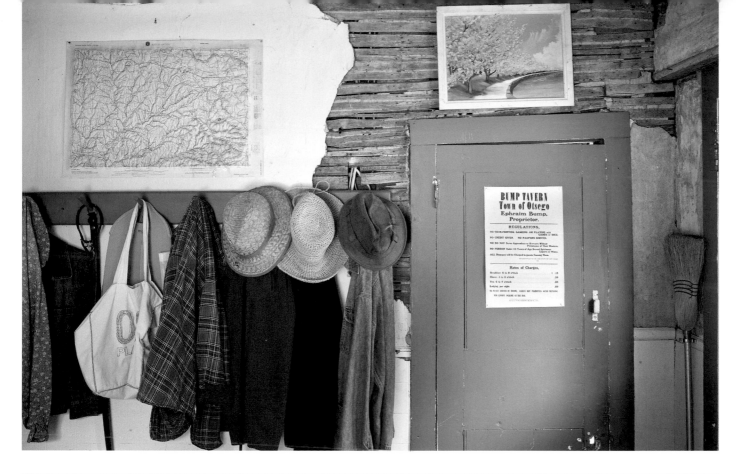

In the mudroom, wooden pegs are laden with coats and hats, and above them, an old topographical map is tacked to the remaining plaster that clings to the original hand-spilt lath.

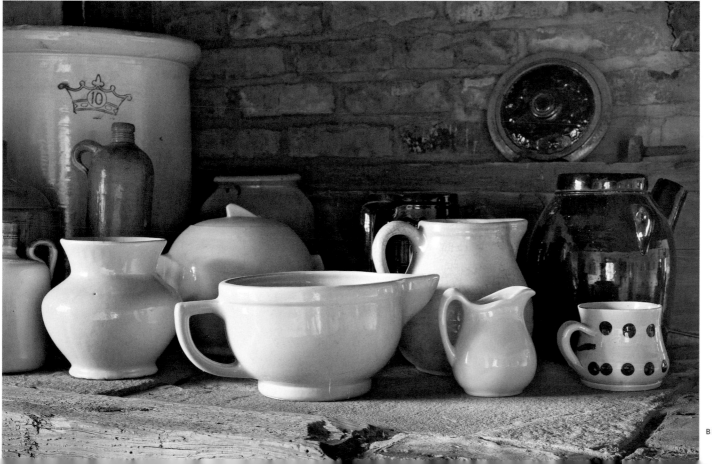

A collection of yellowware is displayed on the side of the living room fireplace. Yellowware was a popular type of ceramic kitchen vessel, formed in molds and then finished by hand. The vessel could be left in its plain namesake glaze or embellished with simple markings.

An upstairs bedroom is decorated with naively rendered floral paintings and chrome-yellow timbers that accent a Mission-style bed. Extra blankets, quilts, and bed linens are stored in the large trunk. A hooked rug, twin lanterns, and rustic twig tables complete the restful ambiance.

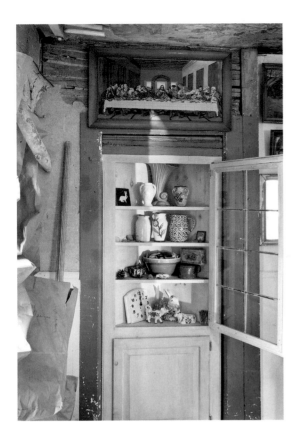

ABOVE

A built-in cupboard in the mudroom contains a collection of pottery and knickknacks, and a print of Leonardo da Vinci's *Last Supper* graces the wall above it. The owners find great appeal in the room's stripped-down condition and use it to store seeds in brown paper grocery bags for the next season of gardening.

RIGHT

The bathroom is furnished in the Eastlake style common to many late-nineteenth-century homes; the vanity and marble-top table date from the 1880s. Wooden racks and pegs display an assortment of vintage towels and linens.

FERNEY

All residents of a farmhouse leave imprints of their tenure. This can be as minor as the manner in which they have decorated the interior, or as drastic as rehabilitation after a century of neglect. Additionally, this may extend to the farm's evolution; what began as a subsistence farm and then moved on to become a grander commercial enterprise now harvests a small specialty crop.

In Upstate New York's Schoharie County, a husband and wife have contributed to the rich history of Ferney in both its appearance and purpose. "It was originally owned by the Dutton family, who purchased the land from the well-known Livingston family," the wife recounts. "Beyond that, the origins are obscure but probably consistent with early farms that had a variety of crops and poultry. It was certainly a hops farm at one point, and a dairy farm, and hops can still be found growing in the wild on the land. There are also traces of an old mill complex on the stream." Today, Ferney continues the agrarian tradition by producing organic raspberries that are sold locally and made into jam and wine. Peach and pear orchards are planned for the future, in order to supply the demand for locally grown organic fruits.

In the late eighteenth century, the fertile Schoharie Valley was one of the breadbaskets of the American Revolution, and this area was the site of two battles in that war; the English army set fire to the harvest in an attempt to starve the Continental Army. The oldest section of the farmhouse,

The open, uncluttered kitchen lends itself to frequent entertaining, with meals cooked on the large Red Cross Herald wood-burning stove. A screened wooden pie safe, which was intended to allow pies to cool free from flies, now functions as a convenient storage place for food.

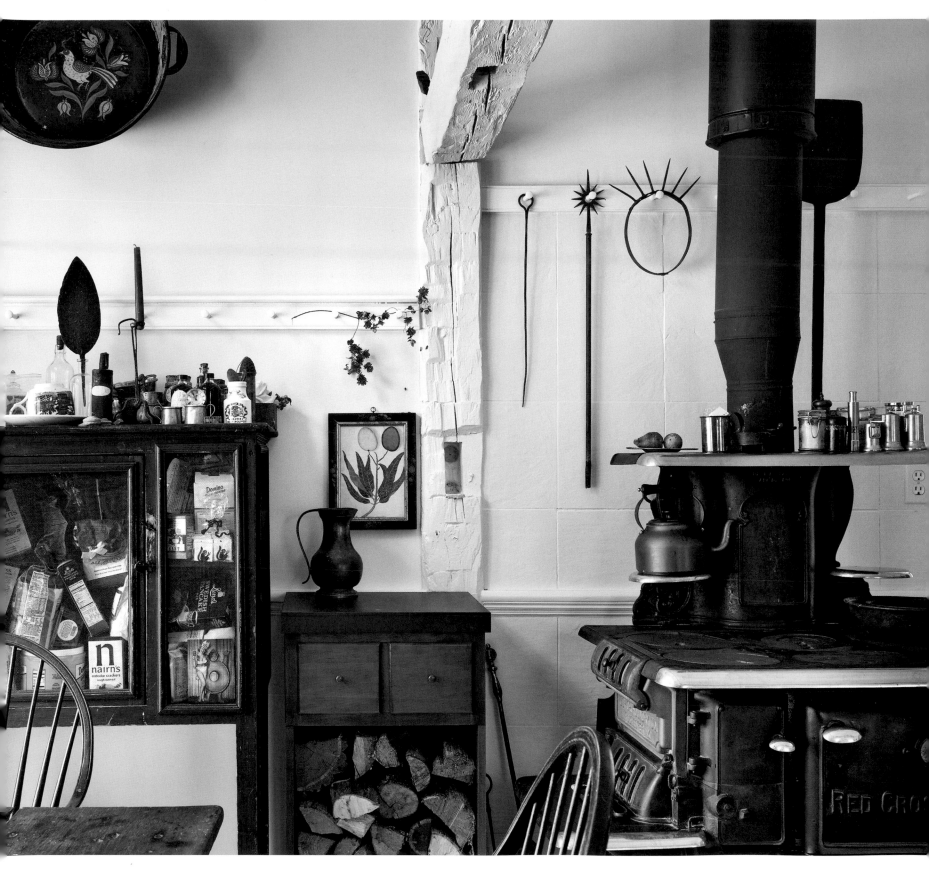

The spacious central stair is reminiscent of the austerity of the Shaker aesthetic, a favorite of the homeowners. Shakers, a religious sect of English Quakers, produced architecture and furniture of impeccable quality and slender grace. The blue-and-white ceramic crocks by the balusters are filled with wine corks representing years of celebrations.

which dates from this period, is now the large open kitchen; at the turn of the nineteenth century, a grand Federal-style house with a central entrance was attached to it. The owners, he an artist and she a farmer, purchased the house almost twenty years ago from another couple who had initiated a renovation. Before that, it had deteriorated to such a point that animals were sheltered inside.

"We were particularly attracted to the proportions and scale of the house, which are very elegant, with high ceilings, large paneled windows, and a large hall and staircase. There are details, such as ironwork and moldings, which suggest that Palatines or Quakers worked on the house."

The couple has furnished their home in a clean, minimal country style. "We very much like the simplicity and elegance of the house's interior, which reminds us of a Shaker hall. It has a timelessness which is nearly modern because of its minimalism, and we have had no problem pairing contemporary artists' work, such as my husband's squares and mobiles and our friends' pieces, along with the more traditional Windsor chairs and hooked rugs."

Throughout the house, one finds arrangements of objects, some easily recognizable, others obscure; archaic farming and cooking implements are gathered around the 1914 wood-burning kitchen stove, which is still very much in use. Natural objects, such as bird's nests, fossils, and unusual mushrooms, lie about, much admired for their sculptural beauty.

"Everything in our home has a function and is used in our everyday life. We are attracted by the spirit of these old farmhouses, whether the poignancy of their locations or the rough times many of them have been through. The enduring values that these houses embody are evidenced by the simplicity, timelessness, and practicality of the structures."

RIGHT

The bold, wide proportions of this Federal-style farmhouse are enhanced by neoclassical pilasters and projecting lintels on the door and window casings. This structure was itself an addition to a much humbler eighteenth-century house that is now the kitchen. Older farmhouses were distinguished in form and line, rather than ornately decorated.

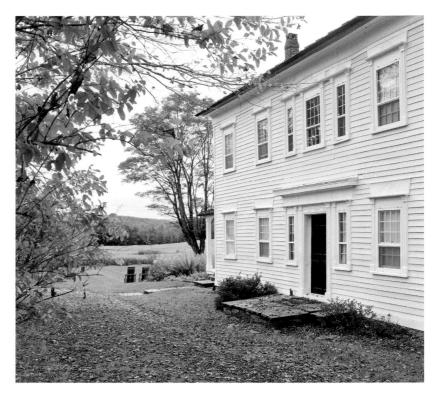

LEFT

The farm's produce helped to feed the Continental Army during the Revolutionary War, and in 1777 its harvest was burned by British loyalists. In today's more peaceful times, the estate produces a specialty crop of organic raspberries. The barn, which dates from the nineteenth century, has been home to dairy cows and poultry over its lifetime, and is now used for entertaining and as a painting studio.

RIGHT

A primitive counting desk in old paint was placed on the side porch; now, instead of tallying the day's receipts, it displays favorite stones and natural objects collected by the couple. Next to it, a garden is planted with flowers and herbs, providing the couple not only with beauty but also with savory additions for their kitchen.

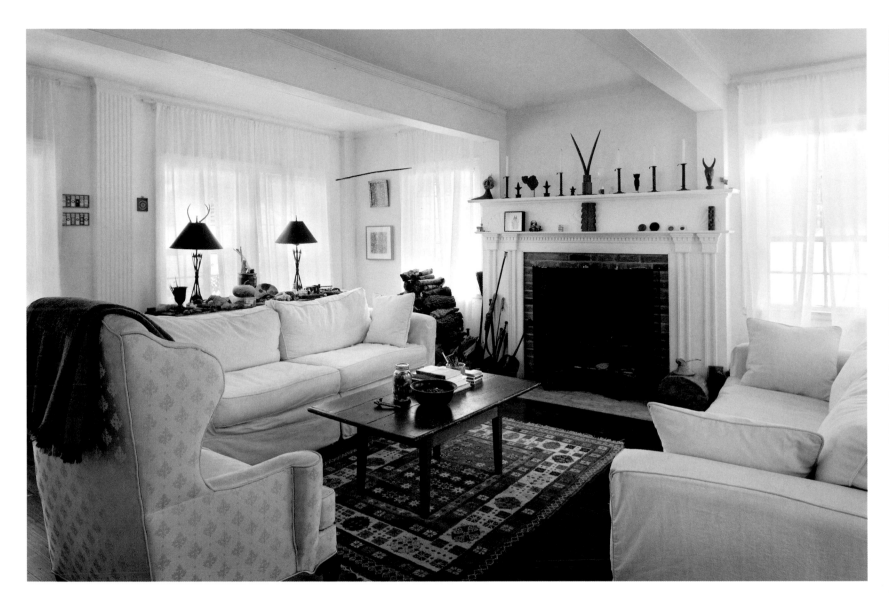

ABOVE

Wing chairs, still
a favorite in many
farmhouses, called
on the ingenuity of
furniture makers when
there was a demand for
shelter from drafts in
sparsely heated houses.
Behind a sofa, a table
under the window
holds an assortment
of rocks, fossils,
and bones.

RIGHT

Atop the pie safe in
the kitchen is a
selection of objects
unearthed from
the property by the
homeowners, including
amber dice, medicine
bottles, and various
pieces of silver. The
wrought-iron tool
placed in the bottle
is a blade from an
antique adze.

OPPOSITE

In the dining room,
comb-backed Windsor
chairs, a trio of Shaker-
style side tables,
and a simple, plank-
topped tavern table
with plain stretchers
are augmented by
pewter candlesticks
and a chandelier. The
contemporary artwork
on the right wall was
painted by the husband.

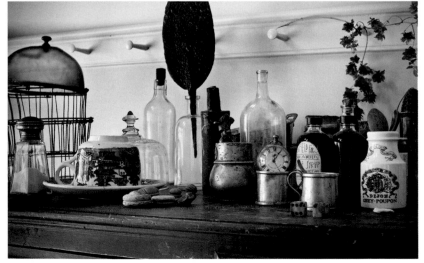

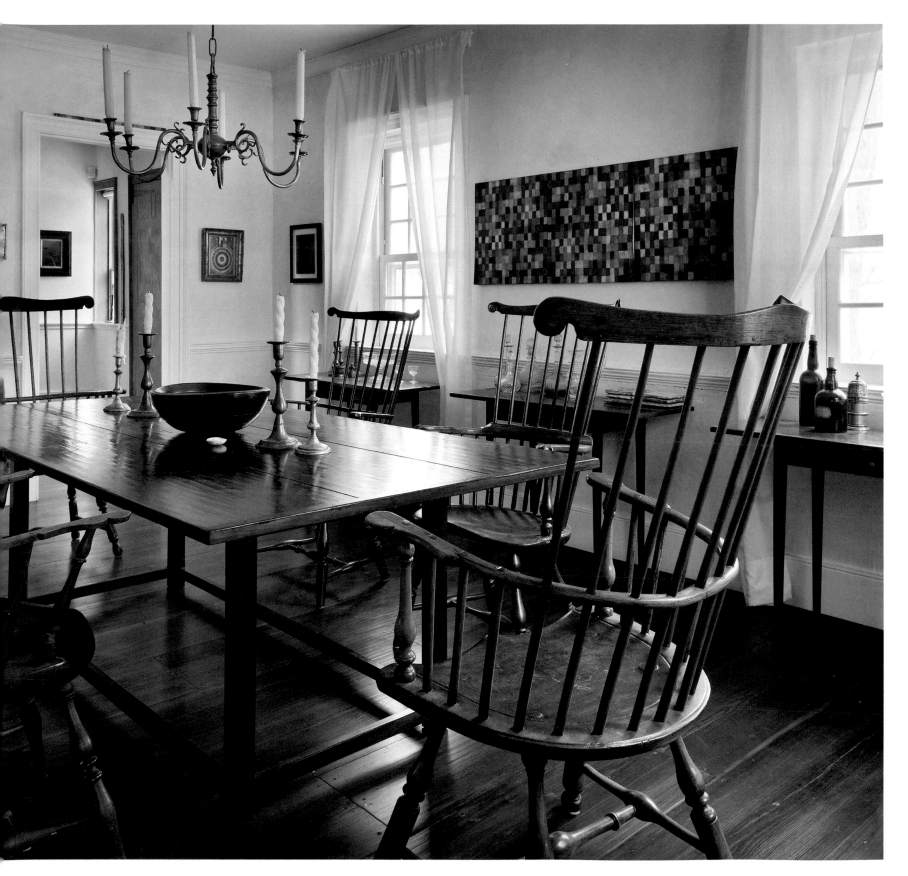

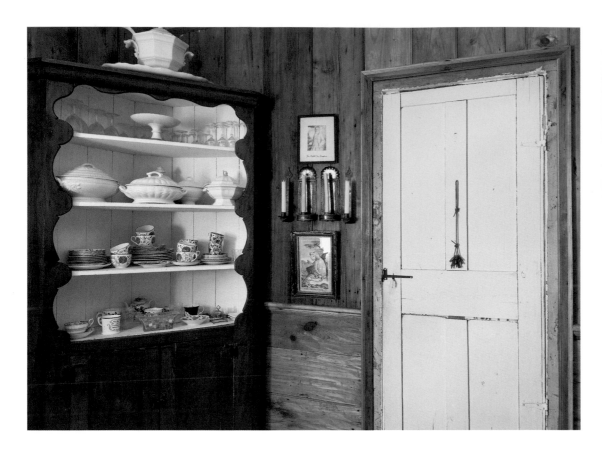

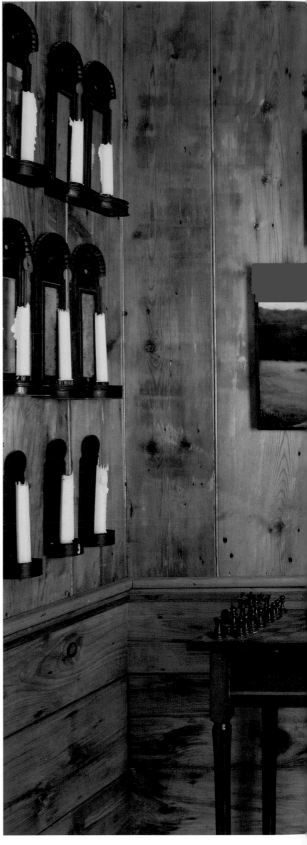

ABOVE

Corner cupboards took advantage of underutilized space and provided a place to store utensils, cups, and plates for everyday use. Later, they presented an opportunity to display favorite objects, most often china and glassware. The cabinet pictured here was constructed with a repeating scalloped motif that frames the open shelving, and it is now filled with ironstone tureens and a tea set.

RIGHT

Just off the dining room, a smaller paneled room in the main part of the house contains a cabinet of graduated drawers as well as early tin sconces, some mirrored, others not. Beeswax candles are stored in a pressed glass bowl, and the tiniest of chessboards provides a ready diversion. The paintings are local landscapes and an antique portrait.

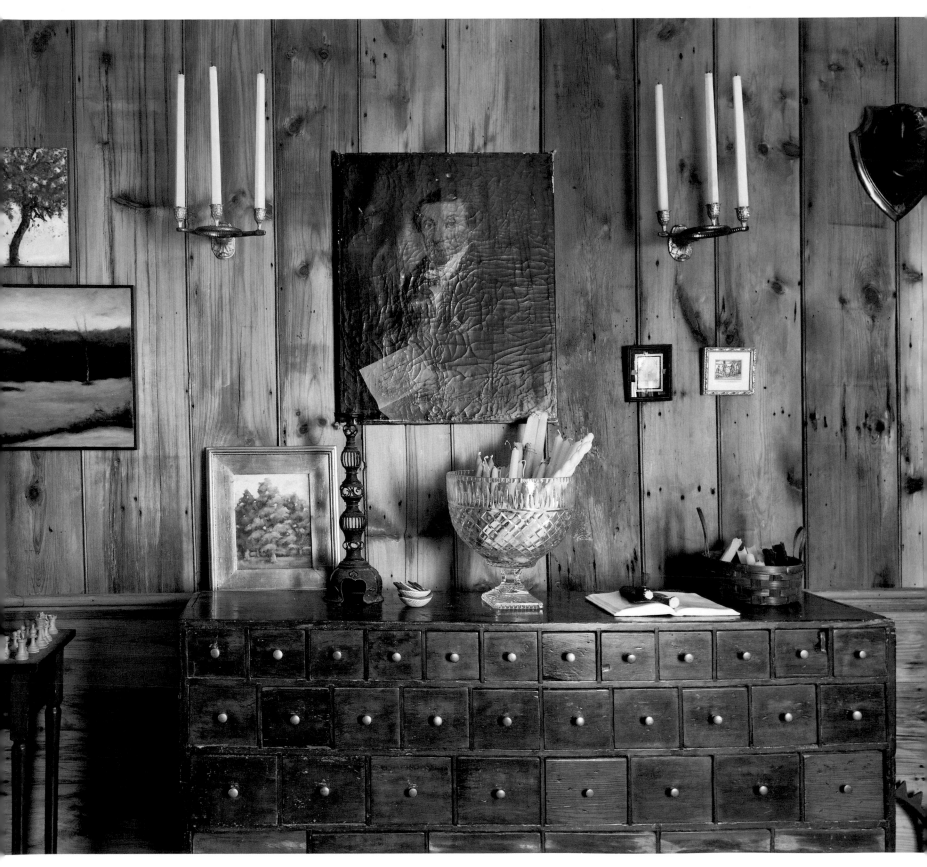

IVY HOUSE FARM

The wood-frame houses dotting the countryside of rural New Jersey yield rapidly to the gray-and-tan fieldstone of Bucks County, Pennsylvania, where stone was the preferred construction material. As houses were enlarged, tradition dictated the use of consistent exterior materials. This resulted in many thematically unified exteriors, and yet the structures' interiors reflect the passing of many generations.

This former tenant farmer's house reveals just such a succession of additions. Architect Leo Chiu, who purchased it in 1984, recounts, "The main three-story section was built circa 1723, then the dining room and upstairs dressing room were added sometime in the nineteenth century, and the kitchen and guest bedroom section added in 1930. They were all built using the same stone, although cut differently, and the transitions between periods are concealed by the masses of ivy growing over the house."

A house built of stone offered early residents certain advantages: it was warm in winter, cool in summer, and obviously resistant to fire. One man could build a house by himself, piece by piece, with the plentiful native stone, and its durability and low maintenance made stone an attractive alternative to wood. As the local farming economy changed over the years, these old stone farmhouses became available and drew many painters, writers, and creative people to Bucks County, making the area a nationally recognized arts community since the late nineteenth century. These same

Stone houses are known for being dark, due to the depth of their walls and their low, wood-beamed ceilings, yet Leo's living room is bathed in a sunny yellow. The room is designed around several areas intended for reading and relaxing. The use of slipcovers, wicker, and natural fabrics promotes a casual feel.

34

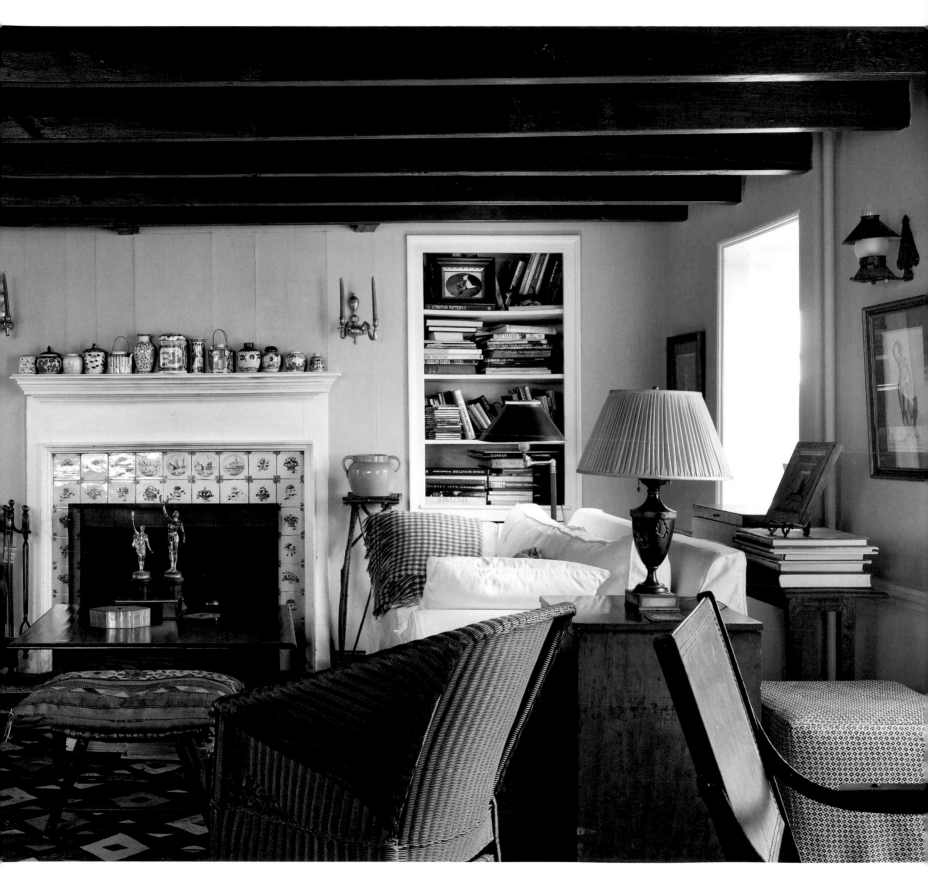

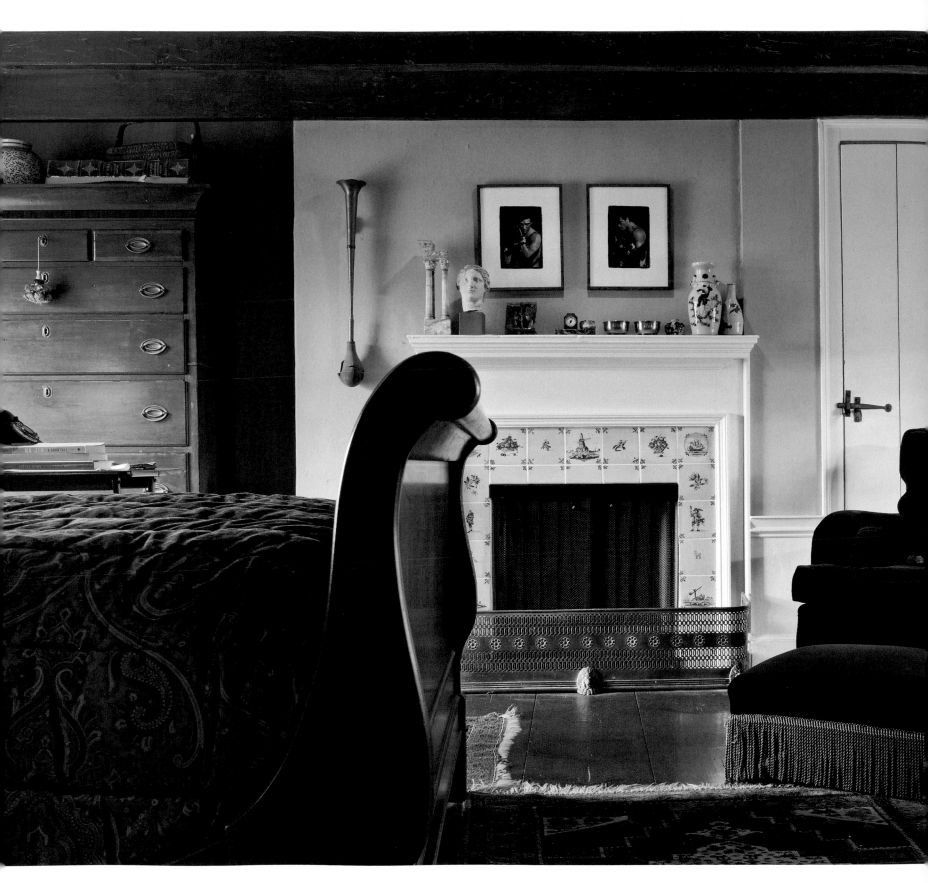

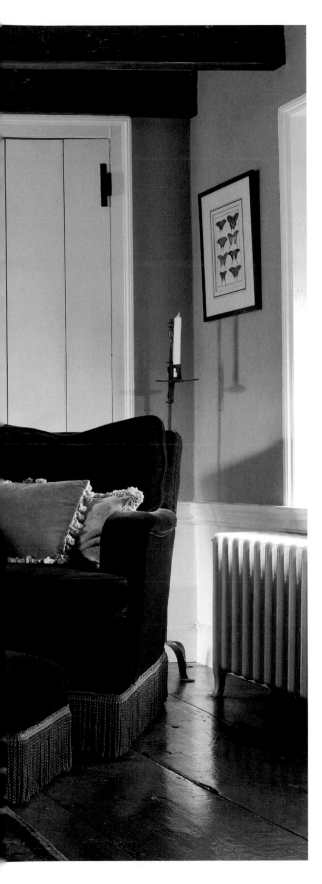

Formal furniture, informally placed, imbues the bedroom with a sense of relaxed luxury. This concept is reinforced by blending furnishings from several historic periods. A heavily fringed Turkish Revival armchair and ottoman offer an opportunity for fireside reading.

enduring qualities and the historic charm, as well as the bucolic landscape, also brought Leo to Ivy House, with its old surrounding boxwood gardens and stone walls.

In the past, livestock and humans coexisted, at least temporarily, as Leo relays: "I was told that in the winter, they used to shelter the farm animals on the first floor of my house, which would also give them extra heat, and that supposedly was why the first floor, unlike the second floor, did not have the original wood flooring."

Throughout the residence, evidence of early Colonial construction peeks out from the current occupant's design; handwrought-iron hardware made by a local blacksmith, narrow winding steps, and subtle beading on the dark wood joists serve as a constant reminder of the age of the house. Leo, who appreciates all things historic, was determined not to be constrained by them: "I wanted a lived-in house, not a museum or period interior. After all, we are no longer tenant farmers."

Leo's home is an artful combination of historic detail and contemporary comfort. Yes, there are exposed, hand-hewn ceiling timbers, paneled fireplace walls, and wide plank flooring, but the sofas and armchairs, while nodding to the late nineteenth century, are modern and comfortable. Thus, old and new coexist in comfort: candles and electricity, antiques and coffee tables abut, yet none oversteps another.

Clever arrangements abound. In the sitting room, blue-and-white Chinese pottery graces a simply molded mantel, and these coordinate with the brown-and-white European pictorial tiles in the surround. In the dining room, an arched corner cupboard sports a mix of Moroccan, Chinese, and McCoy pottery all displayed in striking prismatic order, and atop a dresser, a painting of a winter scene catches the last rays of afternoon sunlight.

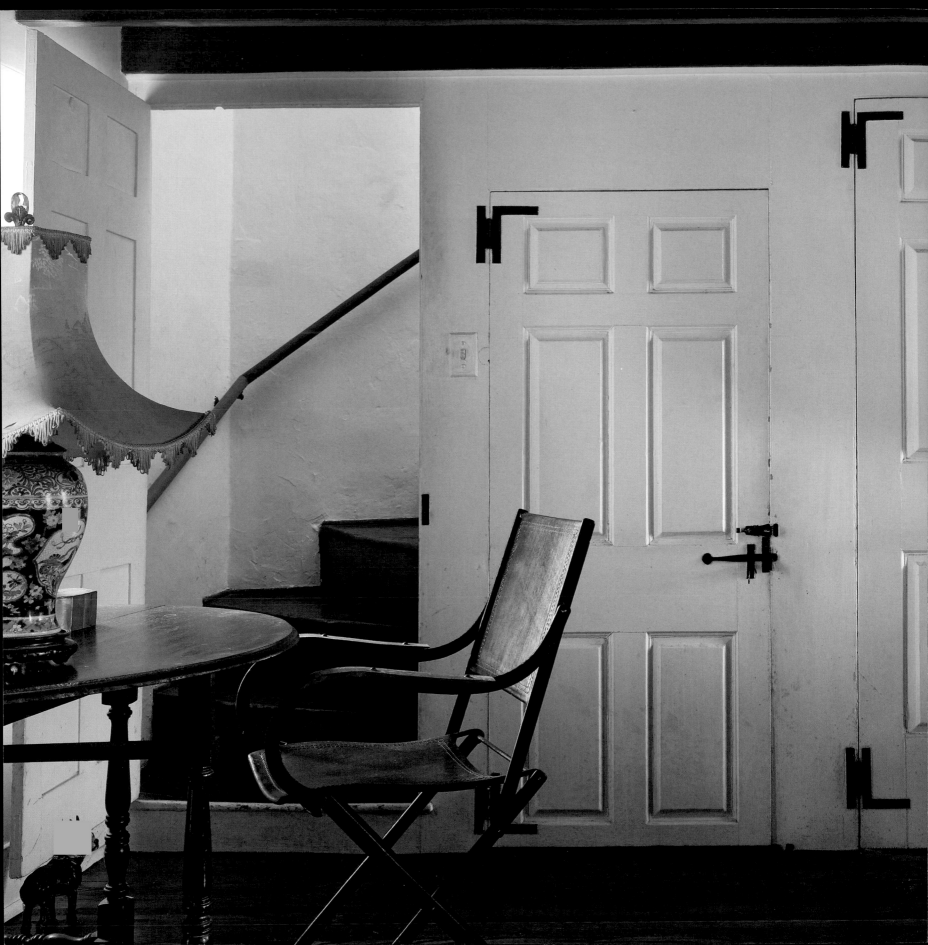

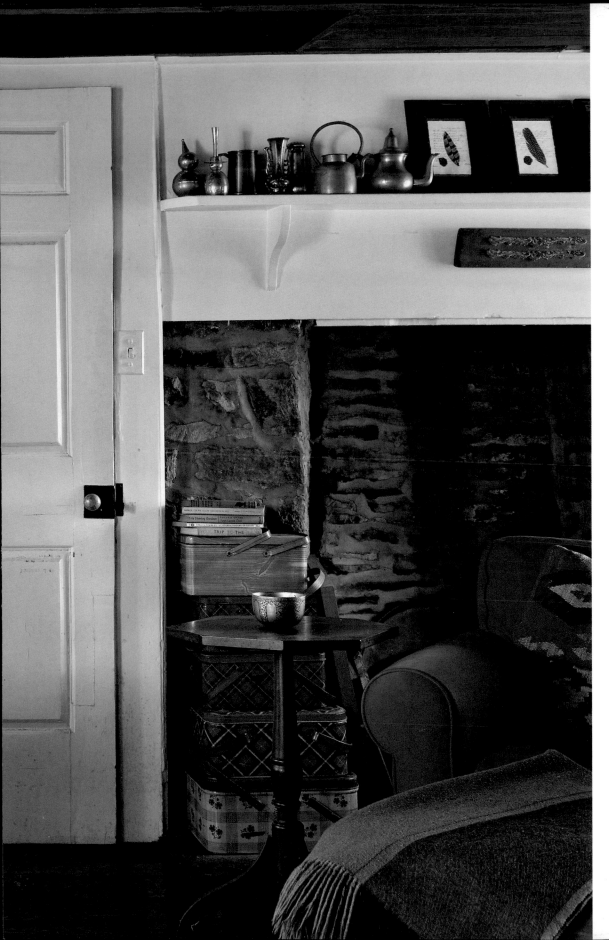

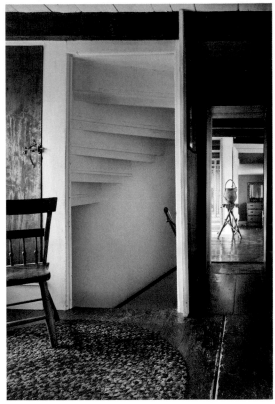

ABOVE

Ivy House contains a very narrow, winding enclosed stairwell which prevented heat from escaping the downstairs and is a unique architectural element enhancing the farmhouse. The vividly colored braided rug enhances the austerity of the white walls and dark woodwork; braided and hooked rugs were the most common floor covering of farmhouses, being practical as well as colorful.

LEFT
The living room has antique door latches and hand-forged iron HL hinges that support the raised-panel doors. This array of three doors placed in a row is a configuration typical of Bucks County farmhouses. The fireplace, one of two in the room, is fieldstone topped with a corbelled mantel; vintage metal picnic baskets of different printed designs are stacked in front of it.

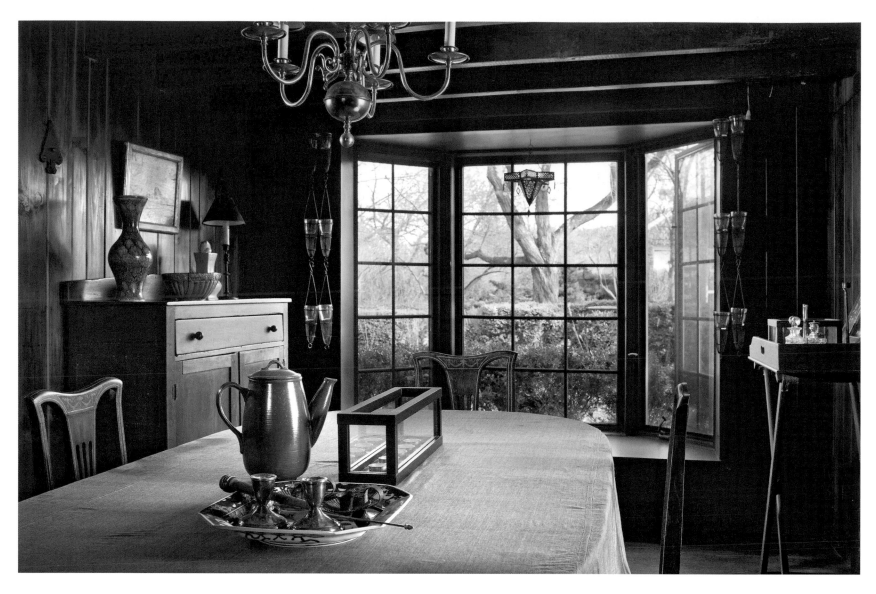

ABOVE
Paneled entirely in wood, the dining room also features a heavily beamed ceiling and a bay window that spans the entirety of the far wall and looks out upon the boxwood garden.

RIGHT
On top of an early-nineteenth-century sideboard in his dining room, Leo has arranged two select pieces of yellowware and a hand-decorated ceramic urn. Above them on the wall is a painting of a moonlit winter landscape scene.

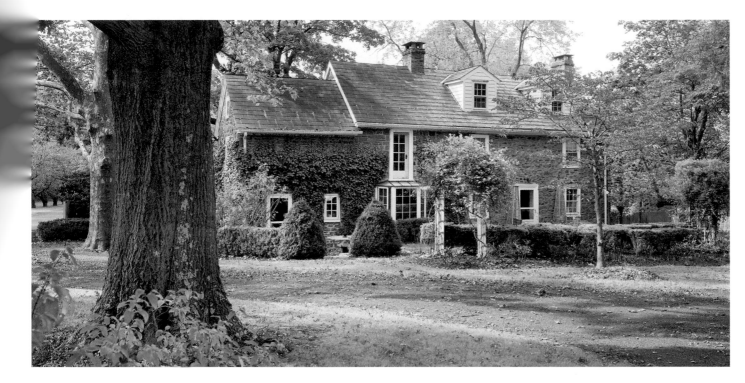

Built in the early eighteenth century, Ivy House started out as a small tenant farmer's house made of stone and was added on to over the years with two subsequent additions. The house is aptly named for the lush ivy that embraces it.

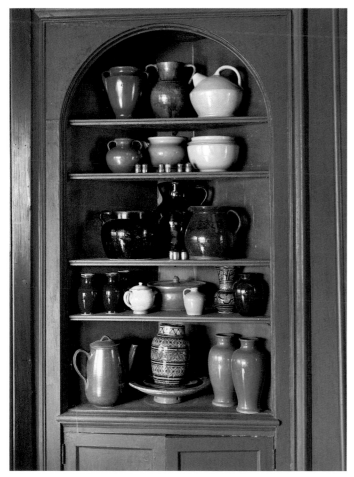

BOTTOM LEFT
Leo's prismatic assemblage of McCoy, Moroccan, and Chinese pottery is arranged artfully in a roundhead corner cupboard in the dining room.

BOTTOM RIGHT
Carefully groomed boxwood defines the border of this enclosed garden, which Leo is in the process of restoring to its former beauty. The old arbor is covered with wistaria.

AND MRS. JORRÍN'S SHEEP FARM

Sometimes, the farm finds you. In 1979, Sylvia Jorrín purchased Greenleaf, a twenty-five-room 1885 Connecticut River Valley–style house on a farm tucked into Elk Creek Valley in New York's Delaware County. Built as a summer house for a wealthy family, the parcel included a barn, a carriage house, and eighty-five acres of land. Sylvia had not planned on becoming a farmer; in fact, as she wryly says, she bought the house "with the intention of serving afternoon tea while wearing finely tailored wool crepe dresses in winter and linen ones in summer. I would sew the dresses, of course, in between planting perennial borders, complete with stone paths, along with black currant bushes on the edges and rugosa roses along the stone walls."

That vision quickly changed, and instead of merely relaxing and gardening in her country house, Sylvia became an unexpectedly devoted, hardworking shepherd who now owns 150 sheep, 14 goats, 2 border collies, two dozen chickens, and a donkey. An ordinary day might find her tending her flocks, whitewashing the root cellar, mending fences, bringing in wood for the stove, or shoveling out the barns. "Gradually, the farmer's granddaughter," she says, "who knew nothing of farming, became, in the deepest sense of the word, a farmer herself."

Sylvia's treatment of her interior is one of beautifully faded gentility. Like so many who buy old houses, she acquires all manner of things at local thrift stores, country

With bins of firewood at the ready, the parlor mantel, which Sylvia bought at an antique store, bears witness to countless fires on the hearth. In front of the fireplace is a rustic child's chair made from bent hickory sticks. An afghan that Sylvia knitted in a hexagonal pattern is draped upon a well-used wing chair.

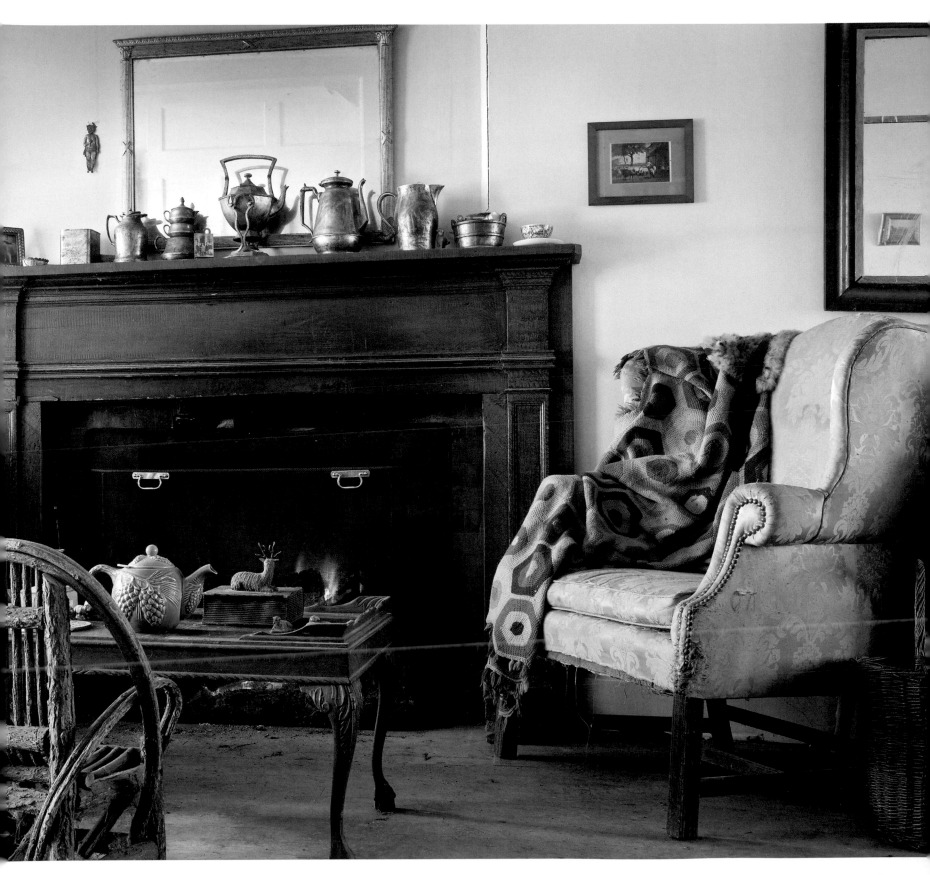

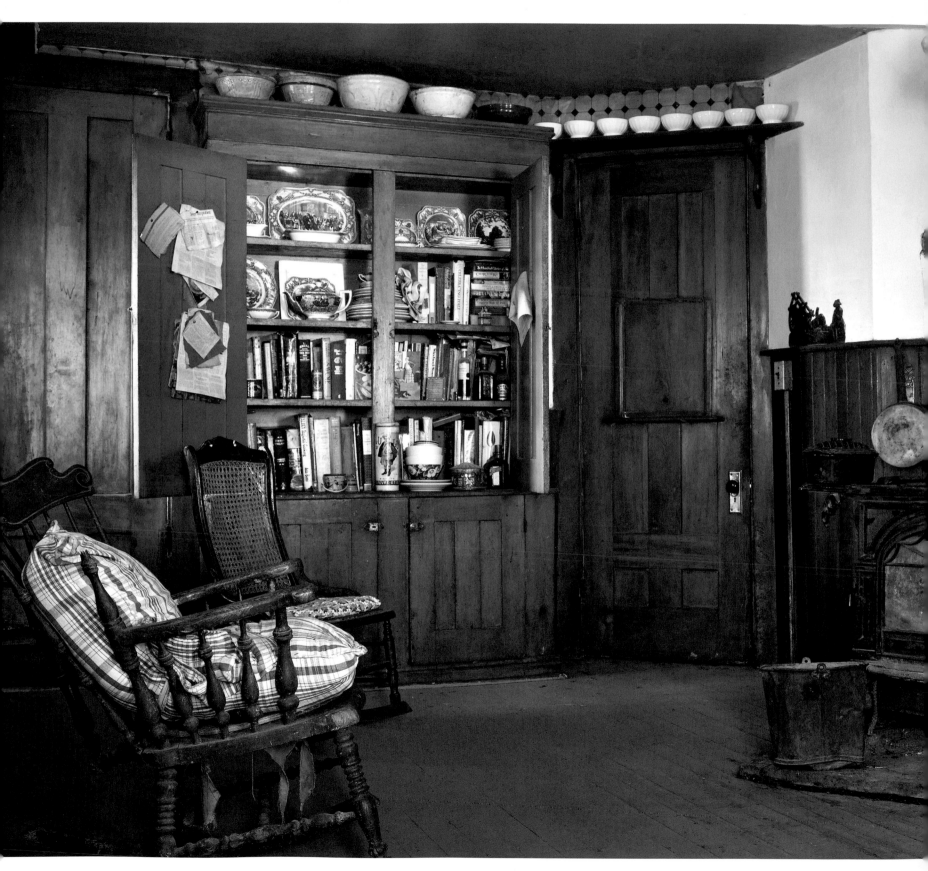

The kitchen, which is heated by a woodstove, retains the original cedar wainscoting and chestnut woodwork from the late nineteenth century. The large cupboard contains a library of cookbooks collected over fifty years. Sylvia used the old rocking chair to nurse her children, and today she often rocks newborn lambs to sleep in it.

auctions, and yard sales; it's as if by assembling exactly the right antique or vintage items, one might conjure up the presence of a grand past, or at least keep it in memory. "I love to buy stuff," she explains. "Collecting is my art form." Sylvia is obviously enamored of patina; tarnished silver tea services line the mantel in a sitting room that is filled with quirky antiques, including a bent hickory twig chair that faces two Chippendale pieces, and vintage bins hold firewood for a waiting fireplace. A favorite possession is her "lambing chair," a descriptive name for the traditional box-form armchair with wings and with a drawer space beneath the seat, made by carpenters out of wood. These large, comfortable chairs often appeared near the fireside in shepherds' homes in England and Wales.

The big, airy, old-fashioned kitchen is a wood-heated symphony of honey-toned timbers with a huge cupboard that is original to the house and holds "everything that isn't food, including cookbooks, linens, French clay baking dishes, cups, plates, and cookie cutters." Newborn lambs are brought into the kitchen to be bottle-fed and kept warm next to the wood-burning stove. Sylvia has collected blue-and-white Royal Copenhagen china and canisters, which coordinate with contact paper that emulates Delft tiles. A skilled cook, she also makes her own cheese, and in spring she gathers nettles to make a delicious soup, and chokecherries for jam in the summer.

Sylvia is philosophical about forsaking her dream of leading a life of inspired order for that of the shepherd. As she says, she's traded the luxury of keeping an immaculate house for the greater luxury of living with a sense of peace, joy, and correctness she's never known elsewhere.

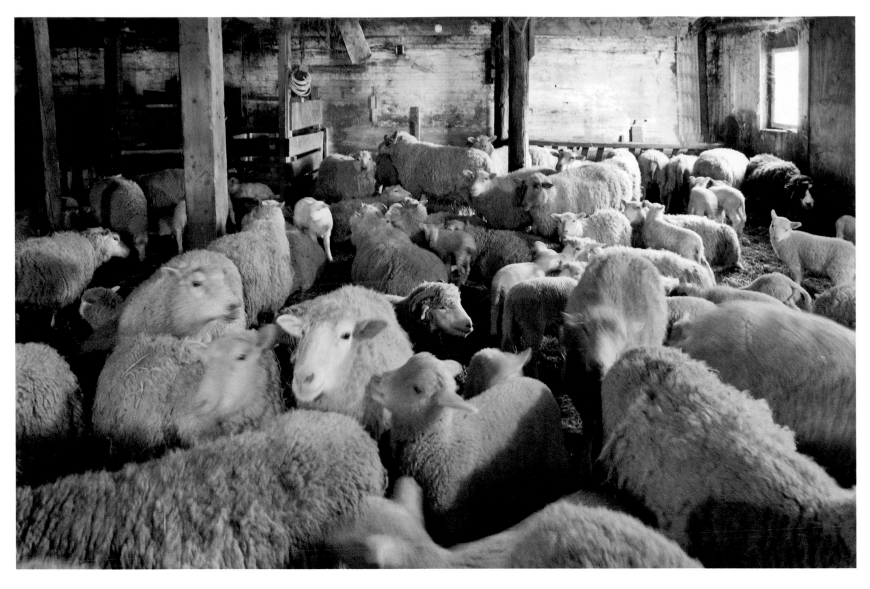

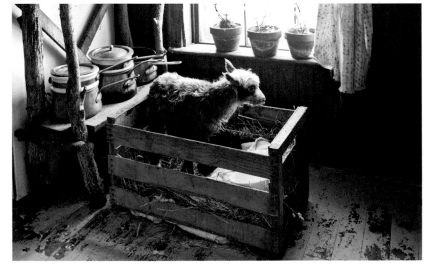

ABOVE
The lower part of the barn houses Sylvia's 150 sheep. They are mostly East Friesians, which are a dairy breed, crossed with Dorsets for winter hardiness.

RIGHT
Here in the kitchen, a young lamb stands in its crate, waiting to be bottle-fed. Occasionally a lamb under stress will need special care and Sylvia will bring it into the warmth of the kitchen for about a week.

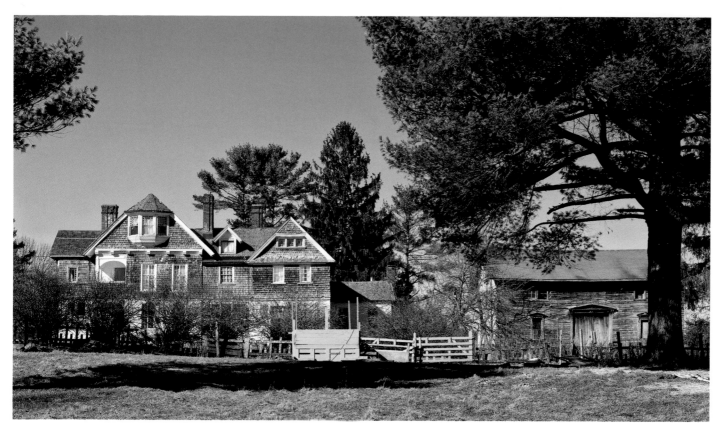

Built in 1885 as a summer house in Delaware County, New York, Greenleaf, the house on Sylvia Jorrín's farm, is built in the architectural style of the Connecticut River Valley. Its multiple gables look out to the barn and gated pastures, where Sylvia raises her livestock. Sylvia had more than forty different gates on the property built from historical patterns.

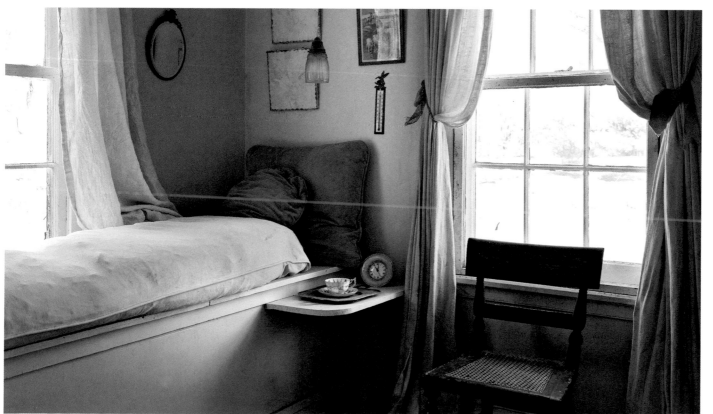

Like many farmers whose houses have extraneous rooms, Sylvia migrates between summer and winter bedrooms. In the former, she converted a window seat into a daybed.

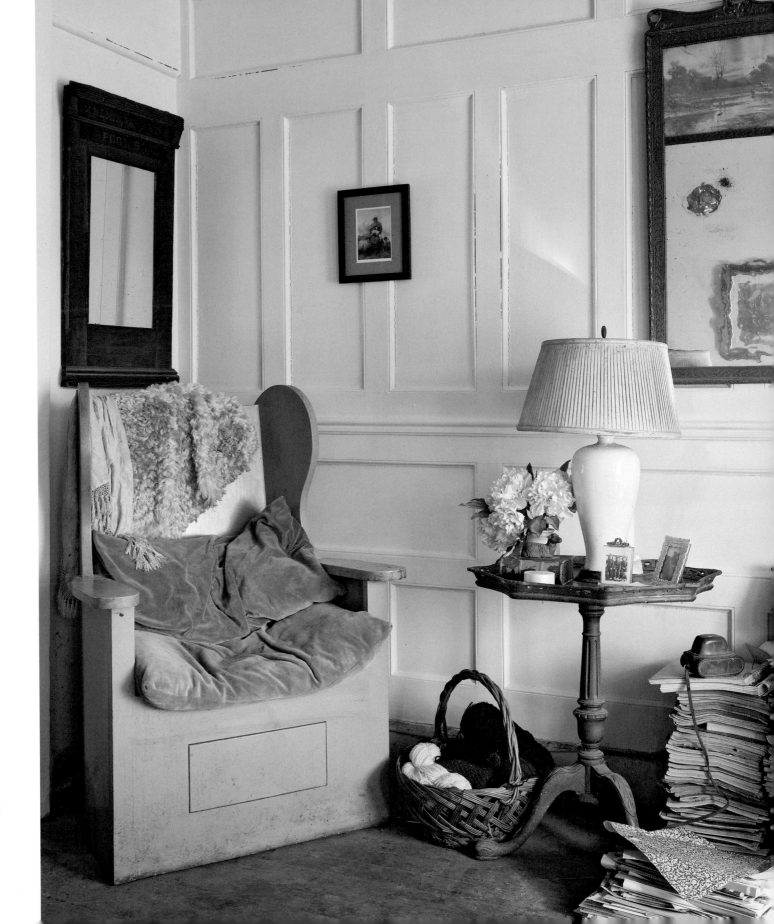

When it was built in the late nineteenth century, this formal room was finished with fancy ceiling-height paneling and ornamental beams supported by carved corbels. Today, it houses Sylvia's lambing chair.

48

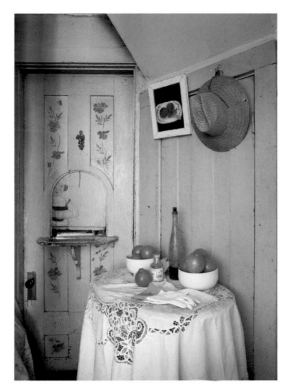

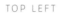

TOP LEFT
Favorite recipes have been affixed to the inside of the kitchen cupboard door, which is painted a soft cornflower blue.

TOP RIGHT
As artistic as she is handy, Sylvia cut and stenciled the floral pattern on the panels of a door, which is itself an unusual piece; in the center is an arched opening with a bracketed shelf that leads into the kitchen.

Above the modern gas stove, well-used kitchen implements are kept handy, and beside it, fresh eggs from her hens are stored in a scale. The Delft tile backsplash is actually contact paper. The door leads to the "north wall larder," a pantry on the cooler side of the house where food supplies are kept.

CLOUDLAND FARM

Cloudland Road, in Pomfret, Vermont, is one of the most glorious country roads in New England. It climbs above the town of Woodstock, winding through forest and crossing mountain streams, as the Green Mountains rise in the distance. And here, on a thousand acres, Bill and Cathy Emmons, owners of Cloudland Farm, raise roughly a hundred head of Angus cattle.

The farm dates to the 1760s; part of it became the site of the Pomfret meeting house in 1795. In the late 1800s, the property was sold and a large dairy operation was established, and numerous houses were built on-site for the workers. Bill's grandfather purchased the property in 1908 and raised livestock, produced dairy products, maple syrup, and fruit, and also harvested ice from the ponds in winter.

The farmhouse itself, known as "Mother's House," started out as a simple late-eighteenth-century Cape Cod house, but in 1908 underwent a substantial remodeling both inside and out. A large front porch, dormers, and cedar shakes were added, along with paneled interior woodwork, including high wainscoting and a modified newel post on the early winder staircase. In fact, at first blush, the yellow house appears to be a bungalow circa 1910 and not the much older building that it is.

If ever there was an iconic farmhouse kitchen, it is to be found here. Two modern stoves sitting side by side enable preparation of large meals and are handy when canning.

The kitchen has remained unchanged for decades and is still the busiest room in the house. Two of the three stoves in the room are seen here, ready to feed the family and workers during the busy farming season. A rocking chair in which to sit down and take a rest is a welcome addition to the farmhouse kitchen.

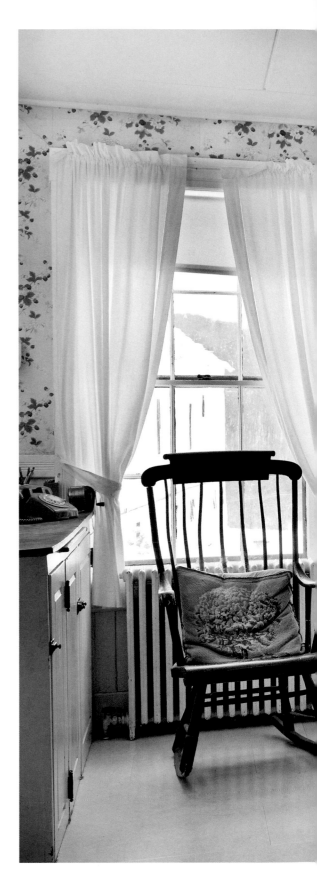

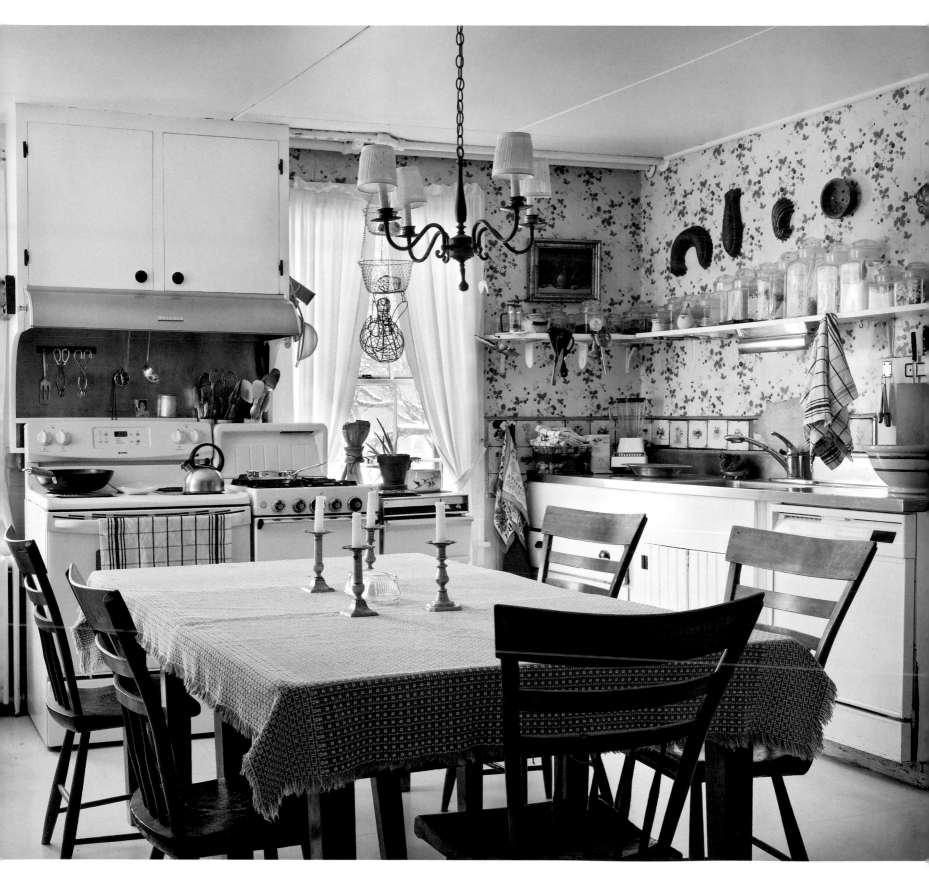

The farmhouse at Cloudland Farm is a two-hundred-year-old Cape Cod that was remodeled a century after it was built. The Cape Cod style was so practical that it has endured through the ages. A central chimney kept rooms comfortable during cold winters, and steep roofs helped slough off the heavy snow.

There is also a spectacular Magee cast-iron stove from 1908. The room is awash in the soft yellow of the cabinetry and charming with its wallpaper of entwining strawberries. It is further embellished with open shelves of kitchen utensils and rock maple country chairs, resulting in a remarkably cozy center of the home. "It hasn't changed much at all," says Bill. "People stop by who haven't been here in twenty years and say, 'Hey, the cookie jar is still there!'" The Emmonses have furnished the rest of their home with a comfortable variety of heirlooms and memorabilia, including a portrait of Bill's mother wearing a string of pearls; it presides over the dining table.

Bill notes that although his family has farmed the land for three generations, he and Cathy are the first to reside there full-time. "Vermont winters are harsh, and folks moved back into the town in the off-season, so it was not a year-round house. The place was always managed as a business, and it was one of the bigger farms in New England. There was a steam-powered sawmill, the butchering was done on-site, and a lot of butter and maple syrup was made here. The rail line came up to Woodstock and my father, who was in the shipping business, shipped a lot of the products down to New York and Boston."

The Emmonses have taken great strides to keep Cloudland a working farm and maintain the diversity typical of a Vermont farm. "Besides the cattle, we raise turkeys for Thanksgiving, and also pigs. Cathy and I focus on the green farm concept; using no growth hormones, our cattle are mostly grass-fed."

To help keep the farm profitable, the Emmonses have recently added a fifty-seat dining room in a brand-new post-and-beam building made from lumber harvested on the farm. "Following the organic philosophy of our cattle-raising, we created a 'green restaurant,'" he says. "It's wood-heated and serves locally grown foods."

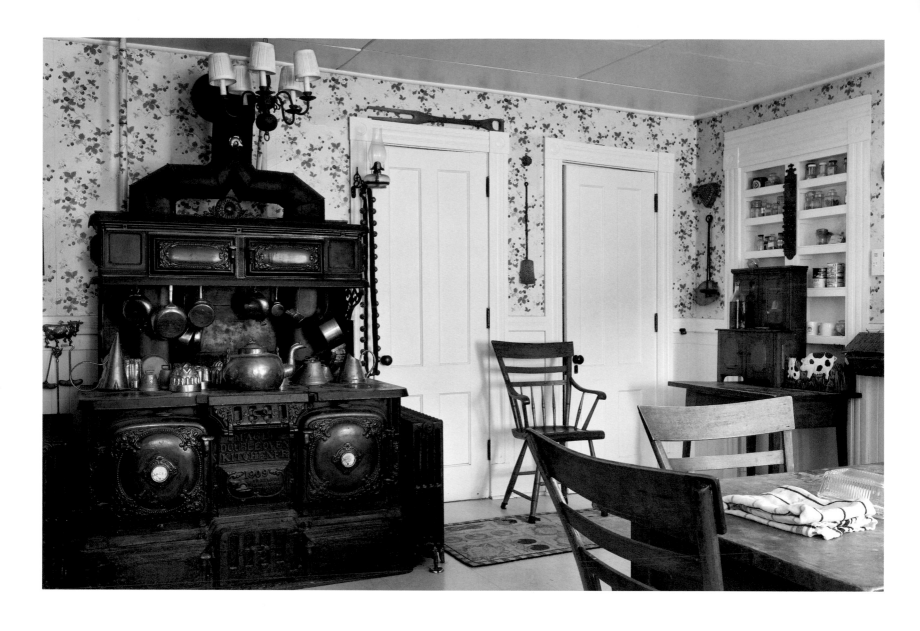

A focal point of the kitchen is a huge cast-iron Magee cooking stove that was installed during the 1908 renovation. Upon it sits a comprehensive collection of copper pots and pans. The rock maple chairs are twentieth-century reinterpretations of a fan-back Windsor.

Vermont winters are notoriously savage. Although many farmhouses in northern New England were joined to their barns to avoid having to step outdoors in harsh weather, Cloudland's large yellow barn is just a short walk away.

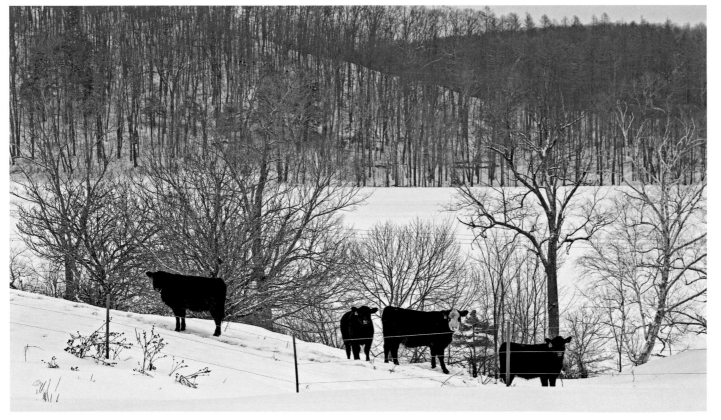

Here are four of the roughly one hundred head of Black Angus cattle at Cloudland Farm. The herd is grass-fed and hormone-free. Handled gently, they are moved from pasture to pasture of sweet grasses and clover throughout the growing season.

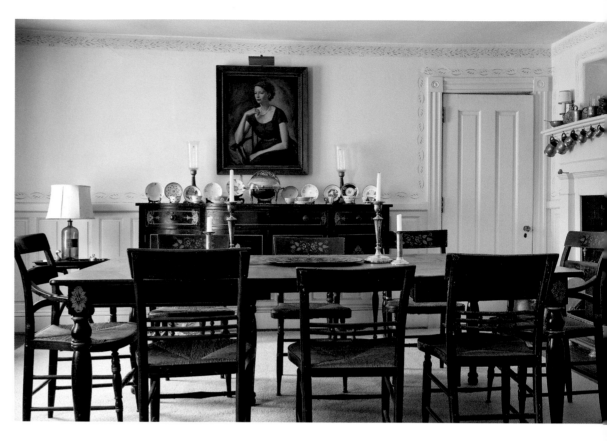

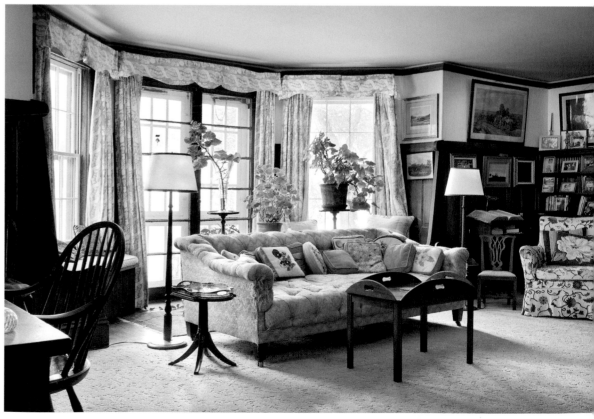

The Emmonses' dining room features a dining set with rush-seated chairs and stenciling on the walls. The portrait on the wall is of Bill's mother, and along the mantel are a series of graduated pewter mugs. Pewter vessels, plain and sturdy, were often sold door-to-door by peddlers and tinkers in rural America.

BOTTOM

The parlor's woodwork was added, including high, raised-panel wainscoting and built-in window benches and bookshelves. The Emmonses have furnished the house over time with some eighteenth-century-style pieces such as the bow-back Windsor chair, a comfortable sofa, needlepoint pillows, and a neo-Colonial coffee table. Geraniums bloom on stands in the bay window.

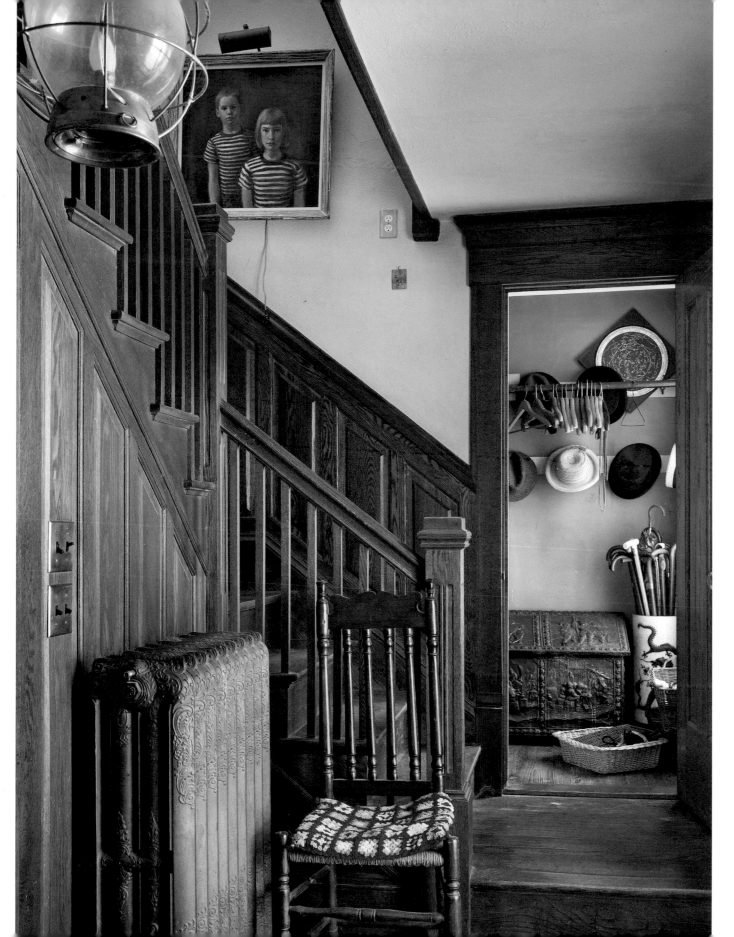

The staircase in the front entry hall still follows the turns of the early nineteenth-century Cape that comprised the original house. In Cape Cod houses, the vestibule is a buffer to keep cold air from the rest of the house. A cloakroom off the hall is used for hats, coats, umbrellas, and walking sticks.

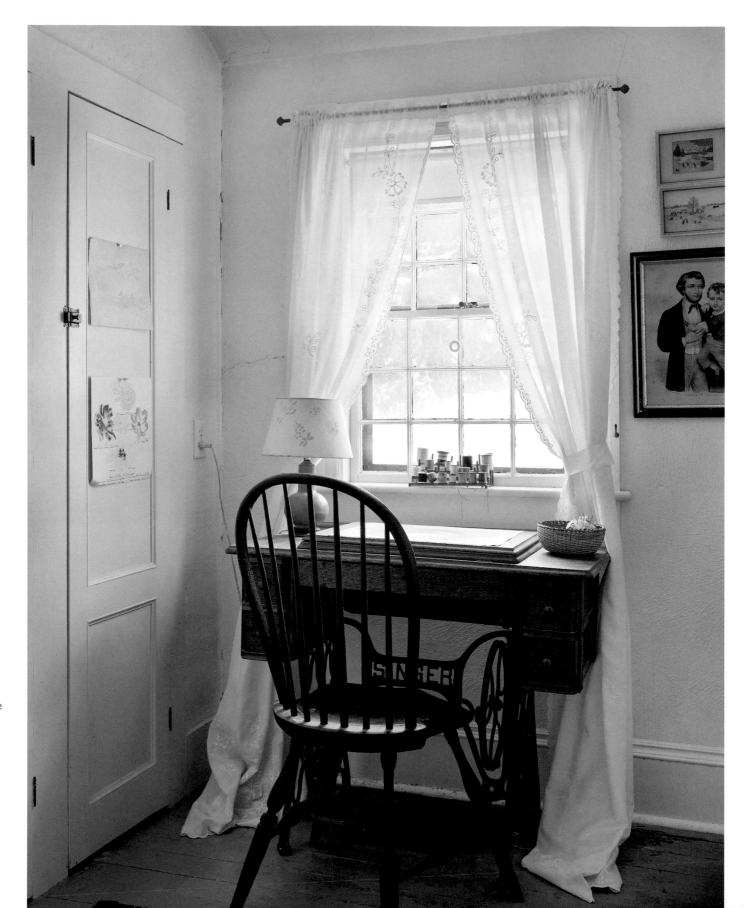

At the end of the upstairs hallway, a treadle sewing machine is placed close to the light from a curtained dormer window. Most farmhouses have a sewing corner where making clothes and mending are part of the everyday chores.

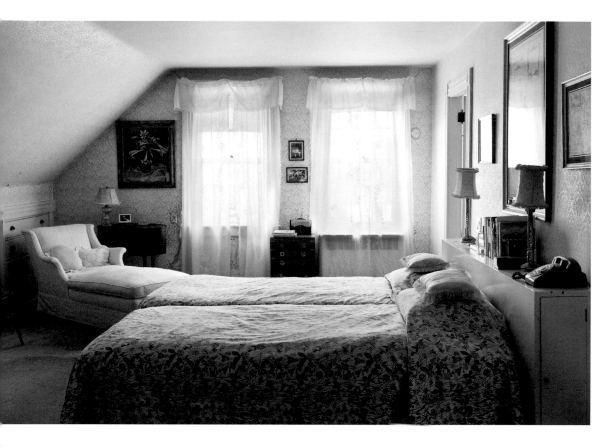

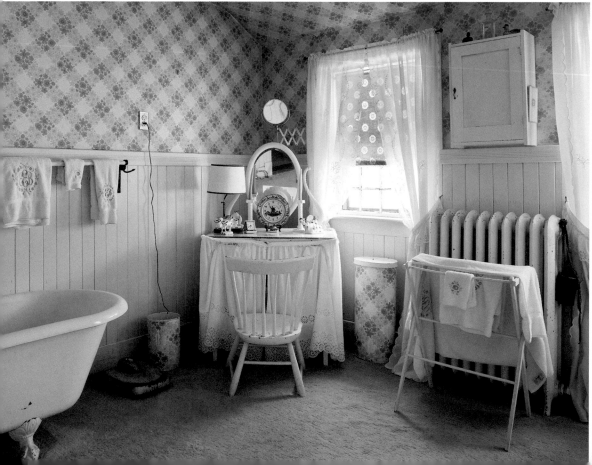

TOP
A chaise longue in
the corner of a
bedroom utilizes
a Martha Washington
sewing cabinet as
a side table, and the
family has arranged
prints and paintings
on top of delicate
damask wallpaper.

BOTTOM
The second-story
bathroom also
dates from the 1908
renovation. The
Emmonses hung the
bright blue-and-white
crisscross paper on the
walls, and a Windsor
chair has had its legs
cut down to conform
to the height of the
vanity table.

MILDRED'S HOUSE

A farmhouse is simply that: a house built upon a farm. It can be large or small, built of stone, brick, or wood; it matters only that it shelters those who work or live there. Farmhouses retain and exhibit their character, and any subsequent modification or redecoration only serves to further enhance its biography.

Such continuity of character exists in North Blenheim, New York, at the home of Mildred King, where farming has been the primary activity since the early 1700s. From the road, the farm presents an iconic view: a handsome white dwelling ornamented with columns, paired brackets, and a matching wing with a second front door and small porch. To the rear of the house, a screened porch looks out on wide fields, and a classic red barn completes the quintessential rural image.

The family purchased the property in the mid-1950s, and today Mildred's daughter, Wanda, oversees it. Mildred, who is in her ninth decade, grew up on a dairy farm nearby and with Wanda's help still plants a vegetable garden every year. The main fields are planted with soybeans and corn on alternating years, only now the land is leased to neighboring farmers. Wanda, who was five years old when the family moved in, remembers a childhood spent waking up every morning and looking out from her second-story bedroom at the broad canopy of sky hanging over the wooded hills.

As in days past, farmhouse life is not one of idleness and simplicity—rather the domain of one who was skilled and

The parlor reveals the lives of its inhabitants with family photographs and mementos prominently displayed on a shelf. A recurring theme in farmhouses is the presence of handwork and crafts that are useful as well as decorative. On the sofa are a vibrantly striped crocheted afghan and some embroidered pillows. An antimacassar protects the back of a comfortable chintz armchair.

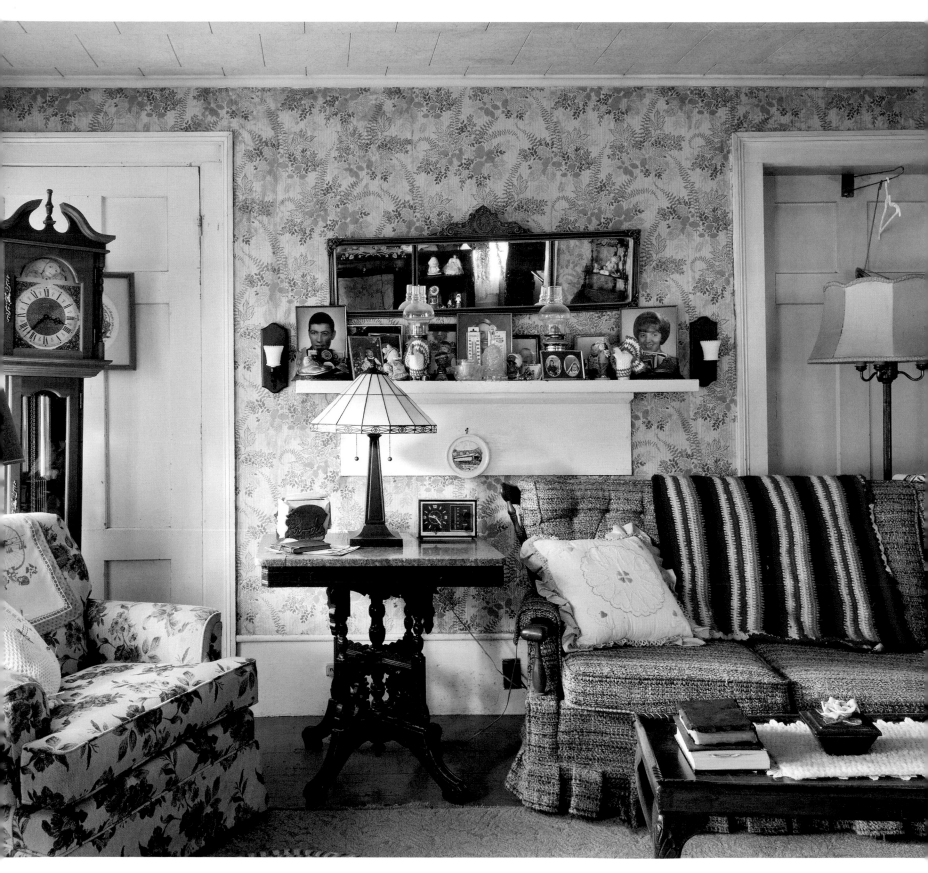

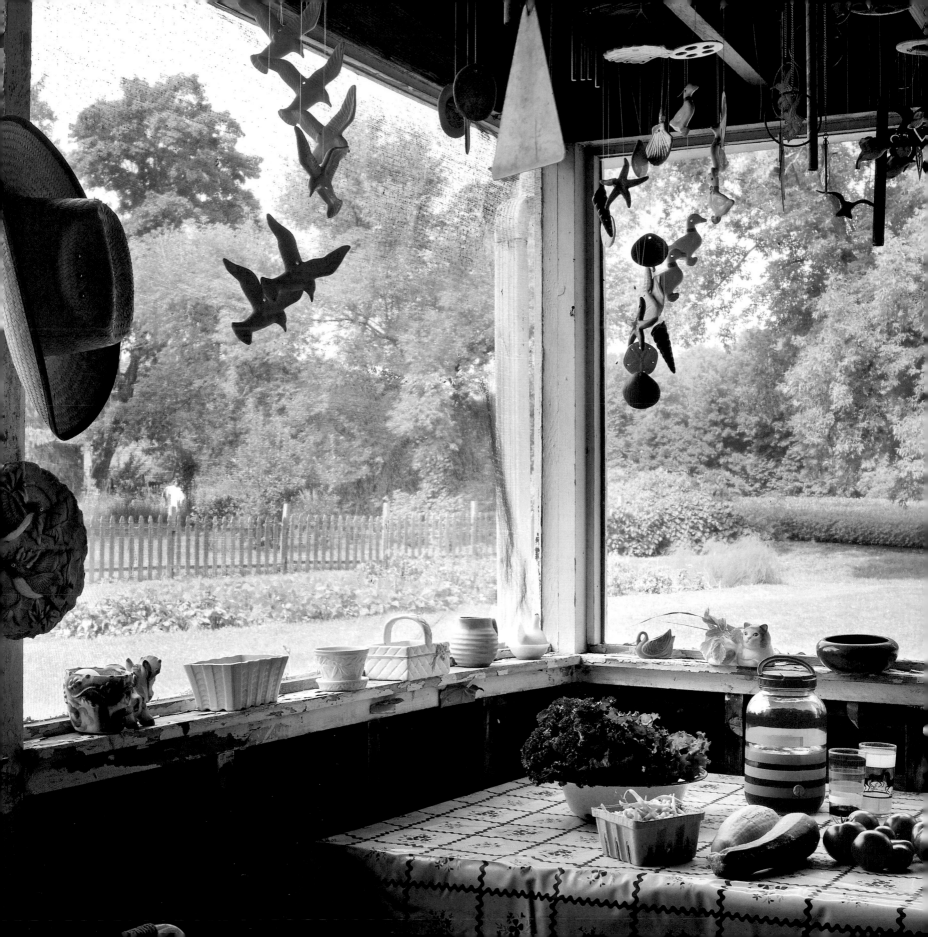

Mildred, who is in her nineties, still gardens every year, and her vegetables are seen growing in the backyard. The windowsills of the screen porch are lined with vintage ceramic planters, and several mobiles and wind chimes hang from the rafters.

knowledgeable in many tasks, from baking, canning, sewing, knitting, and patching and mending to tending a kitchen garden. Through the years, Mildred somehow found the time, in between raising a family and helping to run a small hotel that the family owned in the town, to add cheerful decorative touches to the house, such as trimming the windows with lace and ribbon. As Wanda notes, "We've taken care of the house, but little has been changed over the years, with the exception that we were constantly wallpapering it ourselves." When viewed as a whole, these papers, now more than a half-century old, are a fascinating assemblage of decorative wall treatments from the 1950s and '60s.

The interior of Mildred's house speaks of cozy authenticity; it is a place to come home to and sit in a favorite chair, or to stop by and visit, chat, and have a piece of pie. Her parlor is a comfortable mix of a century's worth of styles: a marble-topped Eastlake table is paired with rock maple seating furniture, while a Depression-era mirror graces a shelf crowded with family photos.

The kitchen reflects the evolution of what some would call country style with its corner cupboard and needlepoint samplers. It appears unaffected and practical; the design is not a retro assemblage, but the result of a life spent in a home, slowly adding the objects and furnishings that appealed to Mildred, as well as the items necessary for daily chores.

Inside the barn, which was designed so that carts could be driven into the front and then through the interior and out the back onto the fields, is a unique trace of past residents: generations of graffiti painted on the barn boards in a variety of archaic scripts and caricatures, including a turn-of-the-century woman in profile with a gathered-up hairstyle and high collar. Someone has written "House Painted in 1900," and here, we sense not just the architecture but also the humanity of the past.

ABOVE
A variety of potholders, scissors, notepads, and salt and pepper shakers are all kept handy and ready to use. The wallpaper from the 1960s is a now-classic pattern featuring country kitchen designs.

RIGHT
Mildred's kitchen, with its simple metal cabinets, has seen thousands of family meals prepared. The red-and-white checked tablecloth, a farmhouse favorite, complements the curtains, and a pull-down copper lamp keeps the room aglow at nightfall.

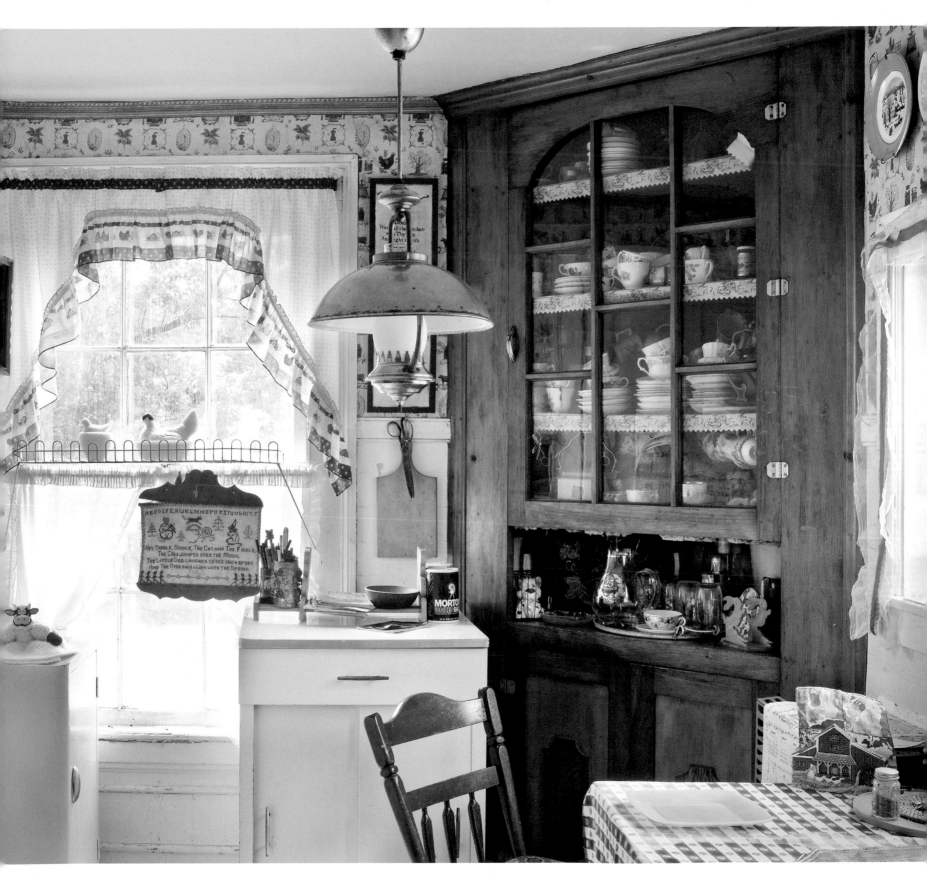

By thoughtfully trimming the windows with lace and green ribbon, Mildred has made the kitchen a warm and homey place. From this window above the sink an old red pump, a device once essential that few of us today have ever used, can be seen.

A whatnot shelf hangs on a parlor wall. The desire to collect and display favorite decorative objects is present in most every farmhouse, grand or humble, yet, as Mildred has said, "You have to know when to stop."

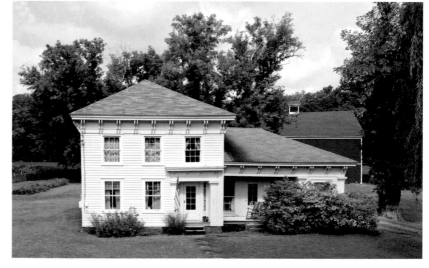

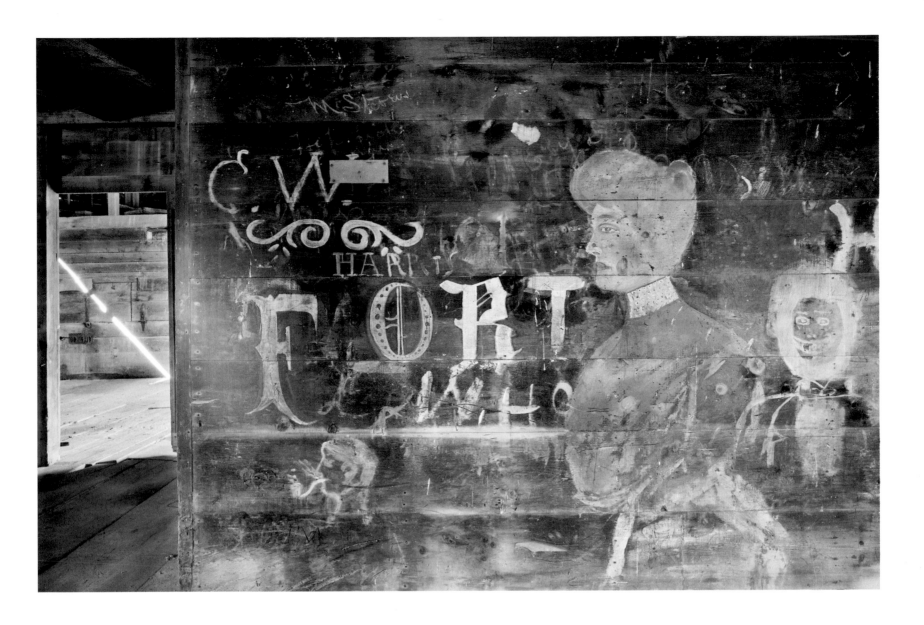

Mildred King's
vernacular farmhouse is
a combination of Greek
and Italianate Revival
styles, the latter of
which is identified
by distinctive paired
brackets.

ABOVE
The presence of those
who have come before
is strongly felt here in
the barn. Around the
turn of the last century,
someone, perhaps a
traveling limner or a
house painter, created
this graffiti on the wide
plank boards.

STILLMEADOW FARM

Sometimes a farmhouse is home to more than just its immediate owner; through good works and writings, that dwelling becomes an iconic reference for those enamored with country life. Such is the case with Stillmeadow Farm, located in Southbury, Connecticut, which was the home of author Gladys Taber and is now home to three generations of her descendants, the Colby family.

As her granddaughter, Anne Colby, tells us, "Gladys, who wrote over fifty books, is best known for her popular Stillmeadow Farm series of books and magazine columns describing rural life in Connecticut from the 1930s through her death in 1980, and now the house is somewhat of a literary landmark for her readers." The property has been continuously farmed since the 1690s, starting with the Stiles family, a founding family of the town. In 2002, the adjacent farmland was rescued from development by a land trust, and Taber fans, who travel from all over the world to visit the settings described in Gladys's writings, contributed funds to this preservation effort. Since then, this greenbelt of protected farmland and open space—including Stillmeadow—has grown to over two hundred acres.

The house itself, a sturdy ground-hugging Cape, dates back to the 1750s and is actually a renovation of an even earlier structure. "In pre-Revolutionary New England, nothing was wasted," Anne says. "Hardware, door latches, paneling, floorboards, and glass were all recycled." And Taber's writing

Block-printed wallpaper lines the panels of the sitting room. The slender arms of the step-back rocker have the delicate grace found on eighteenth-century pieces. On the mantel and in the cabinet are part of Taber's extensive milk glass collection.

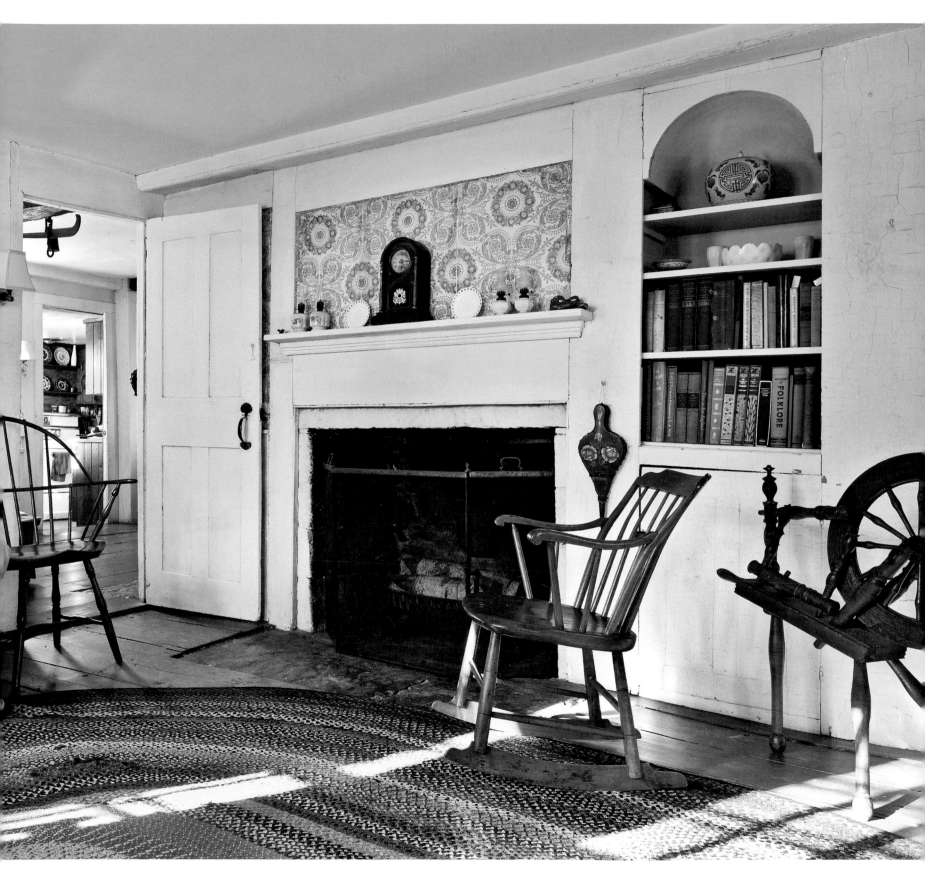

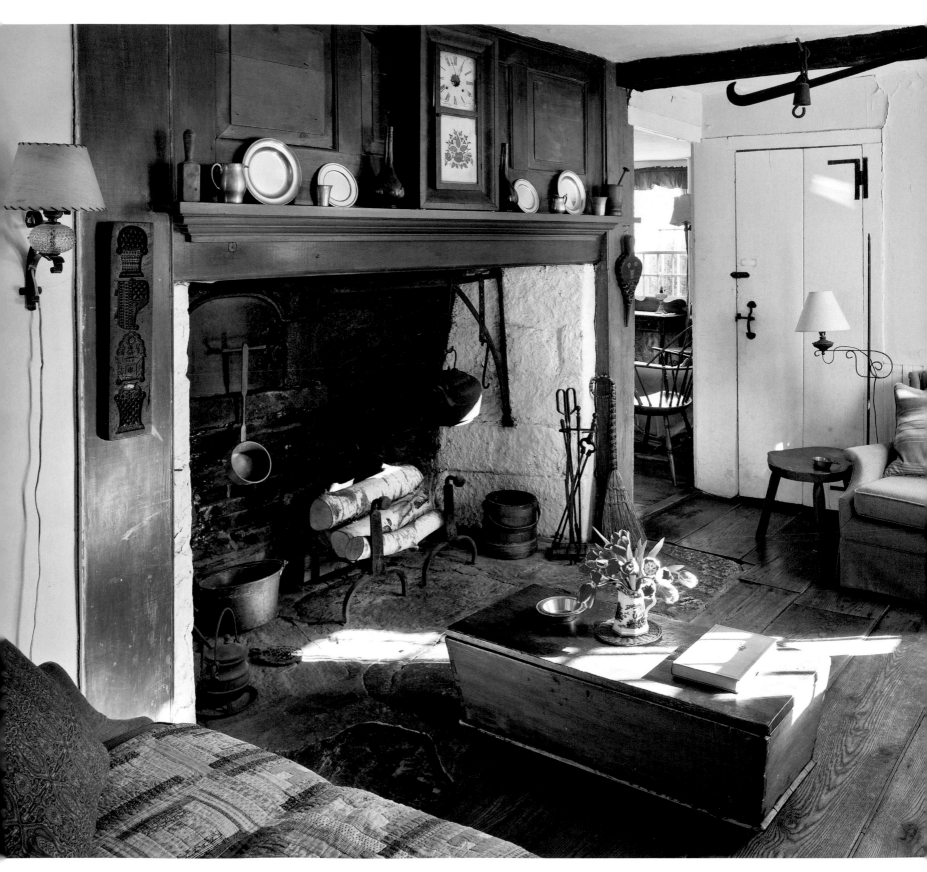

This huge hearth not only heated the room but was where the cooking was done. It has many of the implements that were part of daily culinary activities, such as the crane, the bellows, ladles, and even the wooden mold suspended to the left of the fireplace. In Colonial times, chests served as tables as well as storage.

about farm life is full of such instances of domestic thrift and ingenuity. "One major lesson country dwellers learn," Gladys wrote, "is to make do with what's at hand."

Taber, her husband, and another couple purchased the farm on forty acres in 1934, and the quaint interior stands much as it appeared when they lived there. The early cooking fireplace with its iron crane, the spinning wheel placed in the parlor, the braided rug on wide-planked oak floors, and the Colonial-style wallpaper bring to mind the photos of Wallace Nutting. The building displays its eighteenth-century architecture at every turn with boxed beams and mantels. "In the past, the house escaped modernizing simply because previous owners were mostly farmers who lacked the time and the funds for major updates," says Anne.

Little else in the way of renovations has taken place, save the small kitchen, which was updated, in a 1950s version of Colonial Revivalism by *Ladies' Home Journal,* with vintage blue linoleum installed as a wall treatment. Here, the knotty pine paneling emulates the pine woodwork from two centuries ago, as do the plate racks and rock maple stools.

Besides Gladys's writing, many other prospects were considered as ways to supplement their farm income— everything from asparagus to goats, from geese to honeybees and hens. "At one point Gladys and the co-owner of the farm, Eleanor Mayer, ran a cocker spaniel kennel on the farm," Anne says, "but the kennel failed as a business because they would never sell a dog to anyone they disliked even a little." In the end, their subsistence farming extended only to raising enough vegetables to feed the family, including canning and freezing enough for the winter.

Throughout it all, they managed well and savored all the joys that farm life brought them. Today, those same joys are experienced in the legacy that Gladys left, as Stillmeadow is now passed down to future generations.

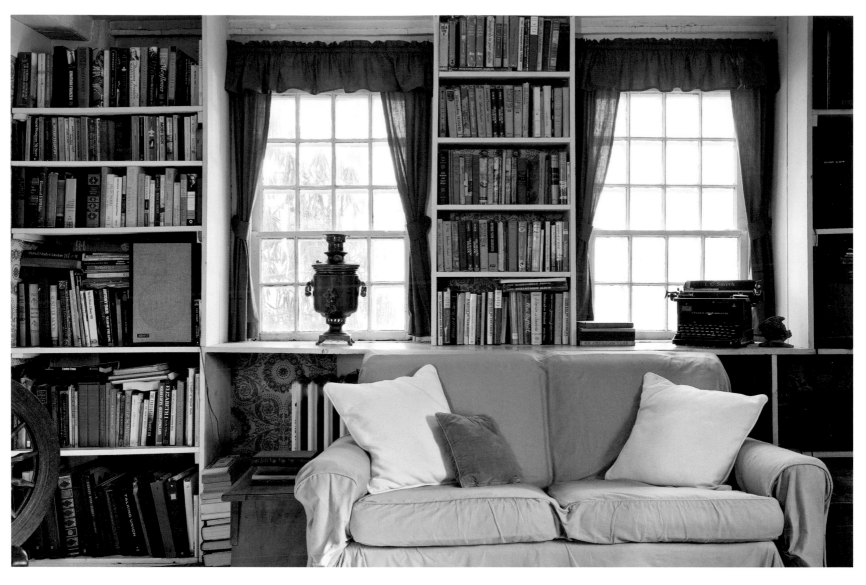

ABOVE

On the wall are shelves laden with books, interspersed with such diverse memorabilia as Gladys's typewriter, a brass samovar, and an antique spinning wheel, a symbol of a persistent interest in the nation's heritage.

RIGHT

The upper-floor bedrooms of Cape houses invariably accommodated the steep pitch of the roof; places where the ceiling sloped too low for walking were used for storage.

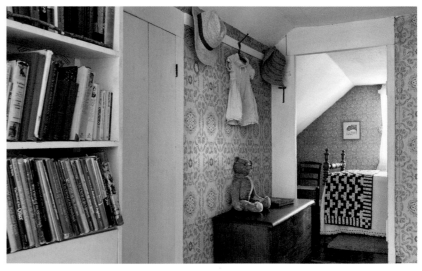

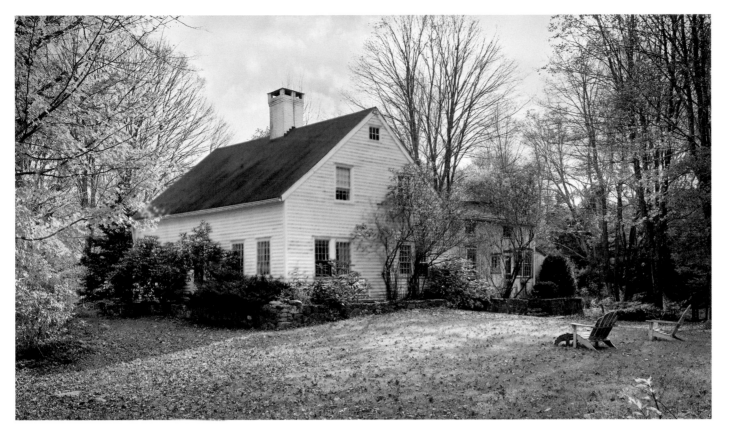

Stillmeadow's farmhouse is a mid-eighteenth-century Cape Cod that features a large brick central chimney and a kitchen ell. The property was the inspiration for many books and magazine articles written by the author Gladys Taber over the span of half a century.

A quintessential vignette of New England farm life: The gambrel-roof barn washed in red paint is set by the road that leads to the farmhouse. It is surrounded by trees carrying the last vestiges of autumnal color, and a white picket fence trails off into the distance.

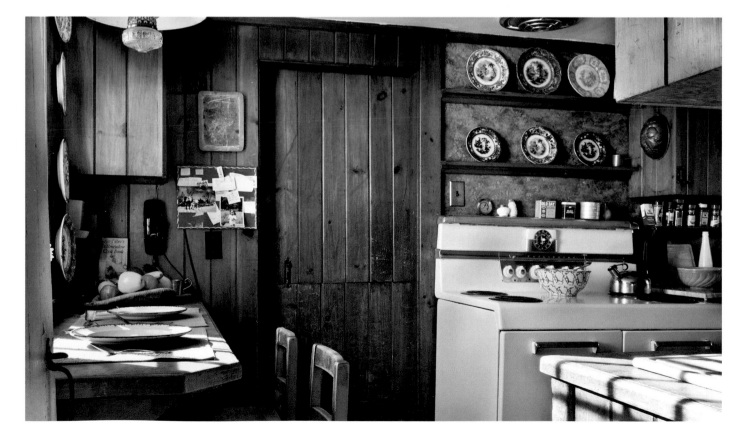

The bedroom is heated by an 1850s woodstove fitted into the chimney, which would have been a dramatic improvement from the original open hearth. A quilt made by the current owner's great-great-grandmother is draped upon an Empire bed with bulbous turnings.

The present-day kitchen was remodeled in the 1950s with a late Colonial Revival style harmonious with the house's existing architecture. This included grooved knotty-pine paneling in irregular widths, a Dutch door, and plate racks, all finished in a honey-pumpkin stain.

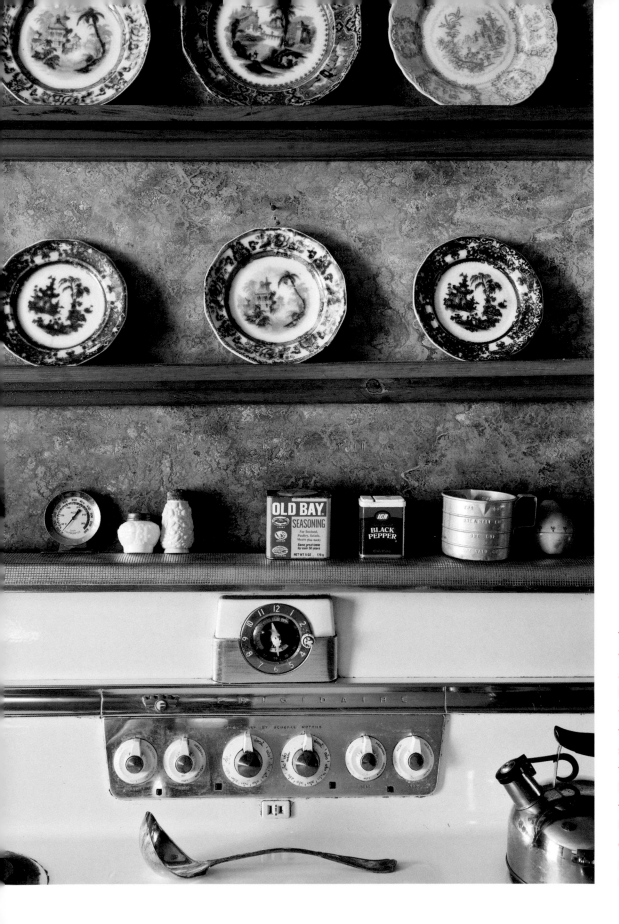

The kitchen update was executed by *Ladies' Home Journal*; blue-swirled linoleum was installed over the stove, which was state-of-the-art at the time. The model is now highly sought after by those restoring vintage kitchens. Staffordshire dining pieces in several patterns fill the plate racks.

THE KARPS' FARMHOUSE

In 1846, Thomas Lamont Sr. built a farmhouse in Schoharie County, New York. He embellished the center-entrance Greek Revival home with a fanlight in its gable and a robust portico framed with sturdy pilasters. A barn was also constructed, and through the decades, this farm yielded dairy products, eggs, cider, and maple syrup, as well as lumber harvested from the land. It remained this way until 1960, when the farm, no longer active, was sold to hunters who used it seasonally. In 1964, it was purchased by Ivan and Marilynn Karp. "This was a typical Schoharie County hill farm," Marilynn notes, "with a shorter growing season than in the nearby lush valley, requiring much labor to sustain a family."

The house was in bad disrepair, and the Karps set about making it habitable. Marilynn adds, "The interior was a wreck; there were twenty-two layers of wallpaper and newspaper used as insulation hanging from the ceiling, a hole in the middle of the parlor where the floor should have been, and a dismembered piano in the kitchen. The cast-iron bathtub spanned the doorway from the bathroom to the bedroom and had to be stepped in to cross the threshold."

With renovations underway, the Karps' focus turned to aesthetics. Most farmhouse residents collect *something*; the mere act of living in an old house is a catalyst for nostalgia, and often their furnishings reflect this fondness for the past. The desire to collect can be satisfied by surrounding oneself

An imposing nineteenth-century table with turned legs and traces of old paint is the centerpiece of the working kitchen; on the end of the table are vintage mechanical devices for uncorking and recorking bottles and two nutcrackers. Also on the table are a large glass dome from a cheese shop and a hand-carved washboard. The walls are enlivened by collections of culinary implements arranged in patterns to reveal the subtle variations of each piece.

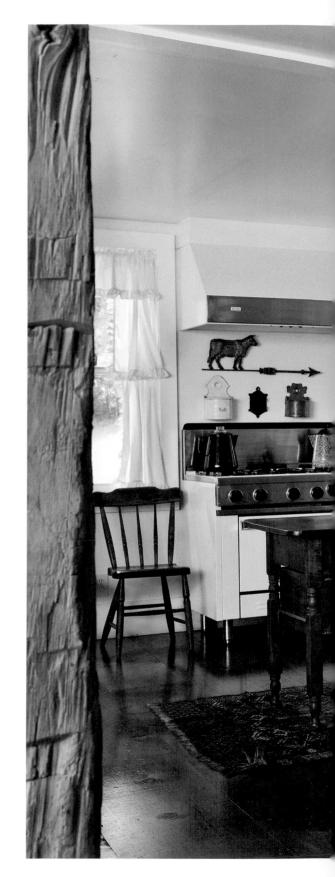

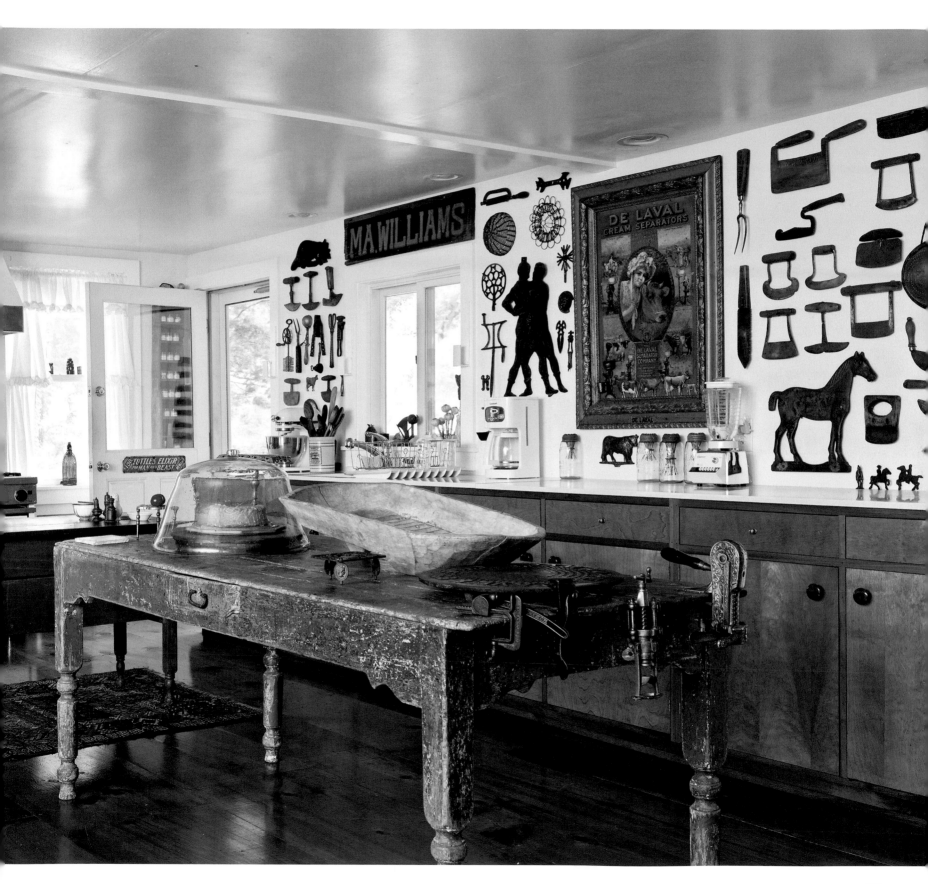

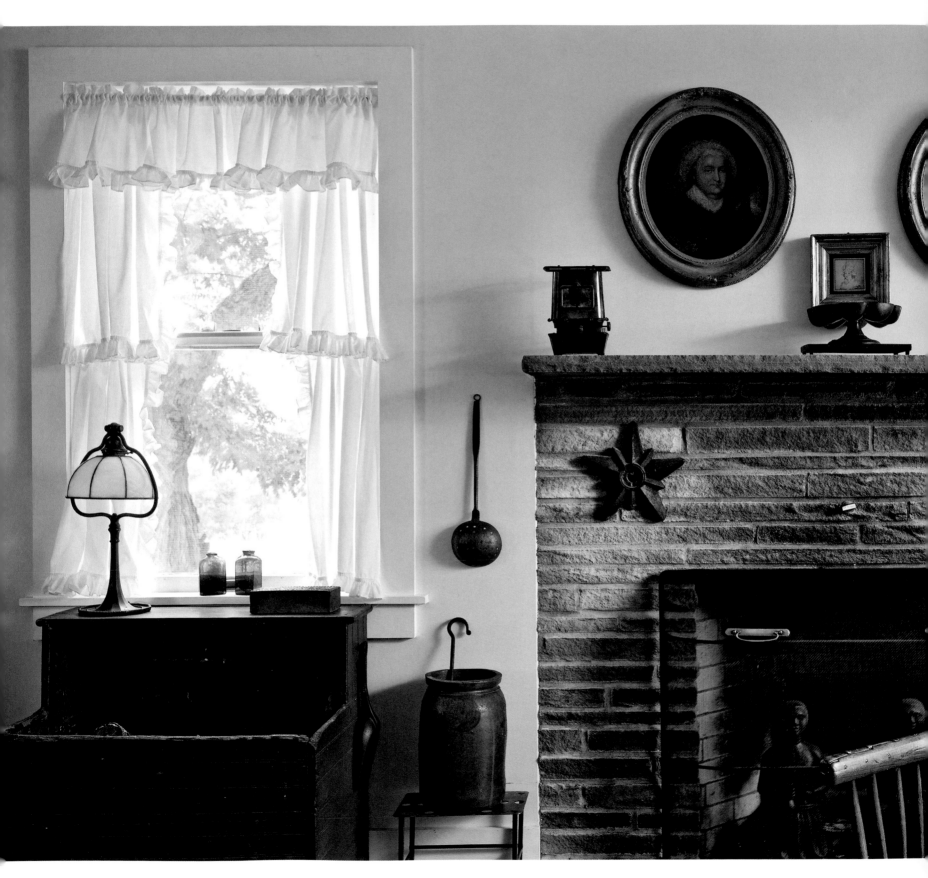

with a variety of antiques, or focusing on a specific category of objects. Then there are those who find the beauty in repetition and any subtle variations therein—when several dozen food choppers are placed side by side, a narrative tale emerges.

"Ivan and I respond to a rich variety of objects, which were acquired for contemplation, in some cases coupled with usefulness," notes Marilynn. "We heard the distinctive voice of each object and felt its vital pulse. From different times and places, these pieces are unified by their aesthetic characters; they harmonize in quirky perfect pitch in their settings, for our ongoing joyful admiration and wonderment. Every object has a story to tell and every collection is a biography."

In a way, the Karps' farmhouse has become a tribute to rural life, or at least a glorification of the artistry of objects ordinarily overlooked. Their multiple collections celebrate the fanciful and mundane, all artfully arranged for contemplation. Tools, molds, utensils, and colorful enameled advertising signs line the walls, and along with these, there are "finer" items gathered about their home, such as vintage maps, nineteenth-century paintings, and samplers. The couple holds a special affection for rescued architectural fragments, and some of these have been used to enhance the grounds of the property. Their furniture reflects a sturdy functionalism paired with a quest for the timeworn. Desks, chairs, and beds each exhibit a graceful decline from their first days as their polish wore off and tracks of their history became apparent.

Success in the discovery of these humble treasures is increasingly infrequent. As Marilynn says, "We are looking at a much-diminished range of vintage objects now, resisting the elimination of what we feel are significant and resounding things. There is adventure in the search for objects of utility that may now be deemed worthy of contemplation and have kinship with other works of art."

A prime example of a Windsor barrel tavern chair has been positioned by the fireplace, inside which two unusual figural andirons hold logs in place. Colonial oval portraits of George and Martha Washington hang above the mantel.

In the second-story hall, Ivan and Marilynn have mounted fascinating and instructive early maps of the United States and New York.

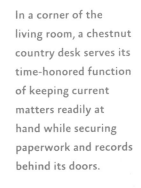

In a corner of the living room, a chestnut country desk serves its time-honored function of keeping current matters readily at hand while securing paperwork and records behind its doors.

In a work shed, a cabinet displays an intriguing collection of nineteenth-century memorabilia such as lamp parts, advertising ashtrays, canning-jar lids, folded flags, pictorial cigar boxes, medals, game boards, and, as Ivan puts it, "odd bits too poetic to be discarded."

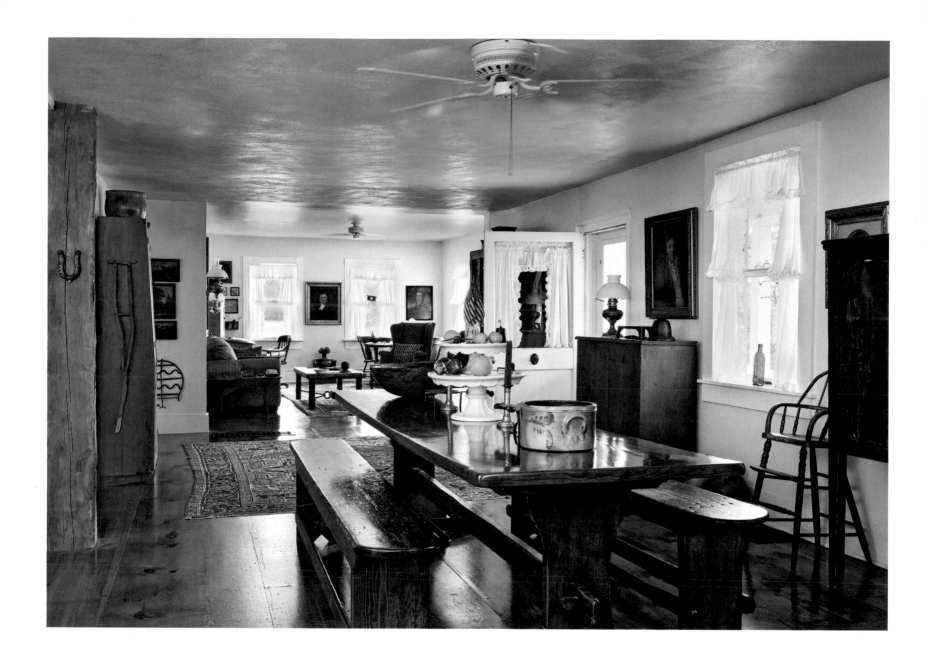

A dark oak trestle table and two old benches are the central elements of the dining area, which also contains primitive cupboards and a Windsor high chair. Each retains its original finish, showing the object's history.

Assembling and positioning humble functional objects and vintage furniture enables a heightened appreciation of both. On this particular wall, the Karps have deployed a selection of tools, toys, kitchen aids, and motto samplers.

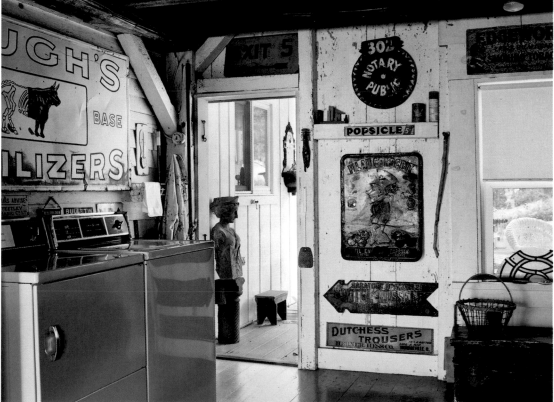

The breezeway shed, open on both ends, is ventilated by crosscurrents of air. It provides an excellent spot for cooling pies, storing apples and potatoes, and drying laundry.

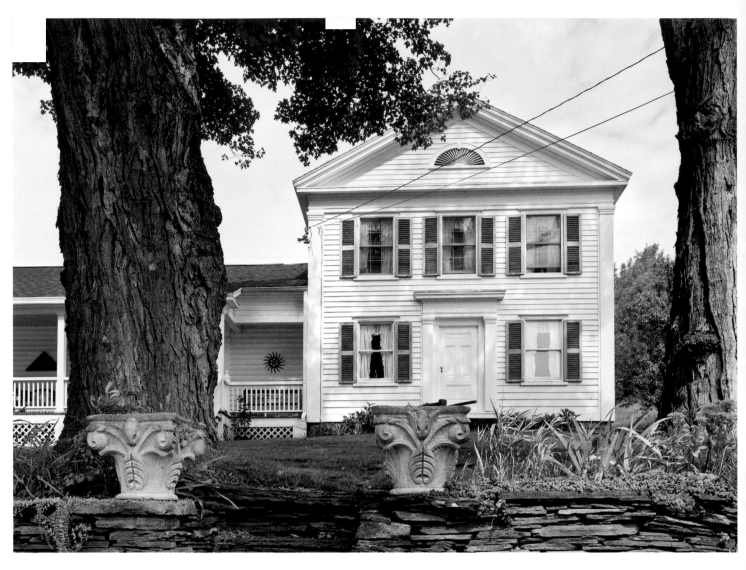

ABOVE

A pair of hand-carved classical capitals flank the laid stone entranceway to Ivan and Marilynn Karp's Greek Revival farmhouse. The Karps have spent decades collecting and preserving architectural sculpture and ornament from demolished New York buildings.

RIGHT

The couple has created a vibrant, terraced perennial garden bounded by laid stone walls. They have augmented the visual drama with several spiral-shafted terra-cotta columns and other architectural fragments suggesting the ruins of earlier cultures.

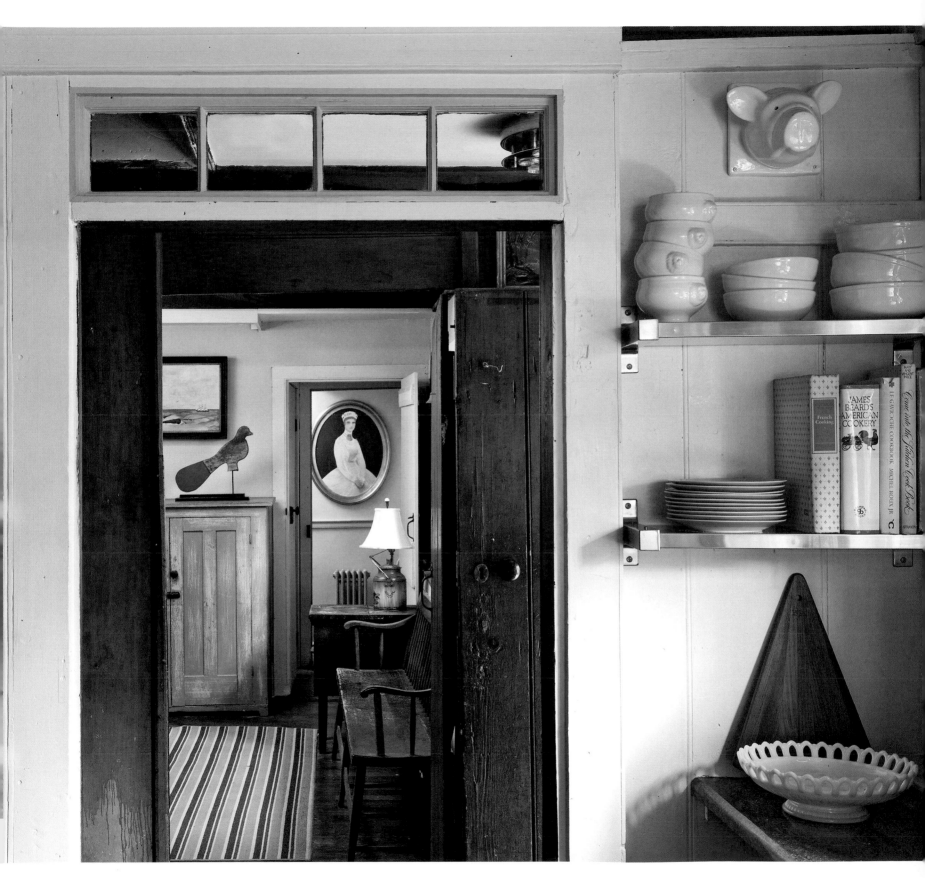

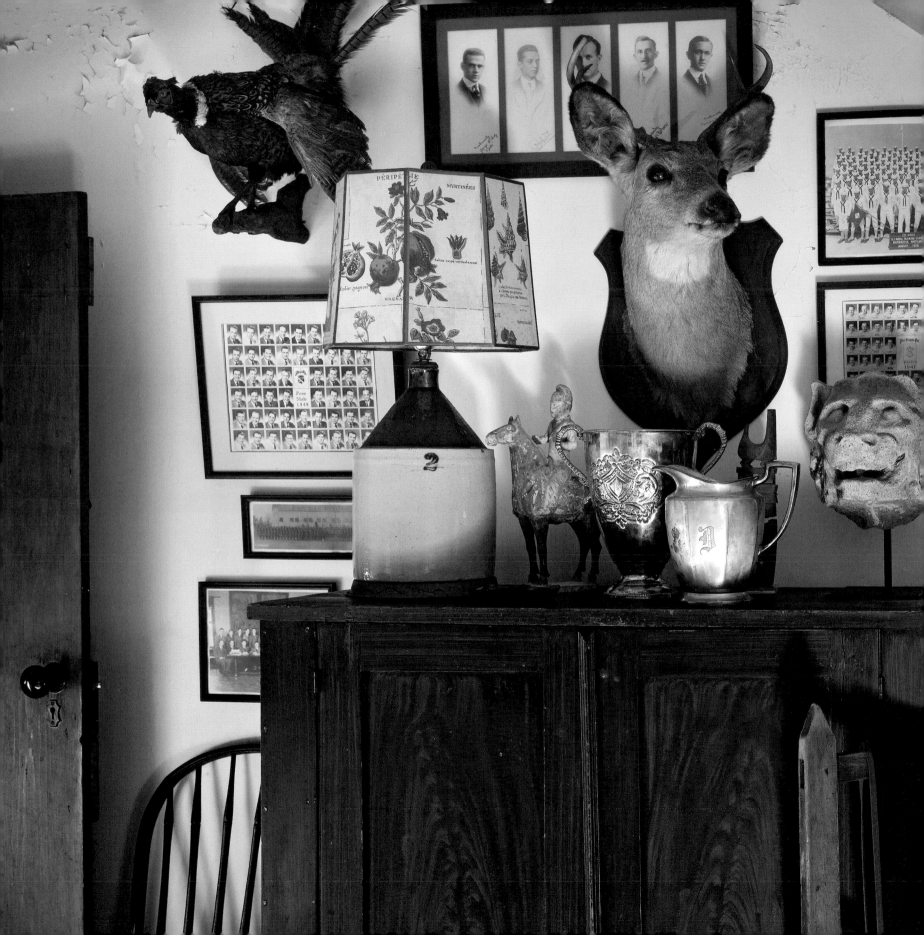

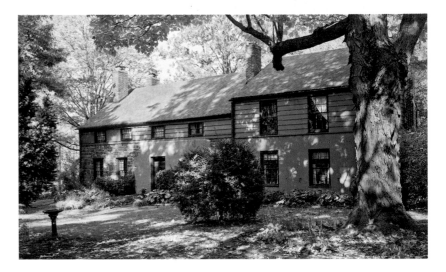

RIGHT

Sydenham, the oldest house in Newark, New Jersey, was built in 1712; the wing on the left was completed in 1812. With few changes in ownership over the centuries, it remains largely original. The house, which stayed in the Sydenham family until the 1920s, retains its five fireplaces, beamed ceilings, and wide plank floors.

LEFT

In an upstairs bathroom, an array of sepia-hued group photographs frame taxidermy, creating an aura whose sum is more magical than its parts. Stuffed animal heads became a common decoration in the late nineteenth century.

Using whatever documentation they could find, Francis and Lance re-created the vivid hues of the house's exterior. To devise an interior color scheme that would prove harmonious with the fanciful ornamentation of their folk art collection, the partners selected a palette of period-appropriate colors with enchanting names such as Rachel Pink and Acanthus Green. "We thought that these historic colors would best reflect the beauty of the house and the wonderful whimsy of the folk art going into the rooms," Francis says.

There are many striking individual pieces in the collection, such as a wooden gate embellished with a five-pointed star and hearts, and a handmade coffee table with a winter scene featuring a horse-drawn sleigh painted on it. Additional color and warmth are provided through the judicious inclusion of hand-stitched quilts and nubby braided rugs.

For Francis, it is the naive but earnest tone of the folk art pieces that he finds so alluring. "To me, the works reflect the very essence of the human soul. They were artfully created by mainly anonymous individuals, many of whom were farmers or tradesmen such as sign makers, blacksmiths, or carpenters. These handcrafted works were made for loved ones as gifts or simply for the pleasure of creating something that was beautiful. They are honest, innocent works, so full of life."

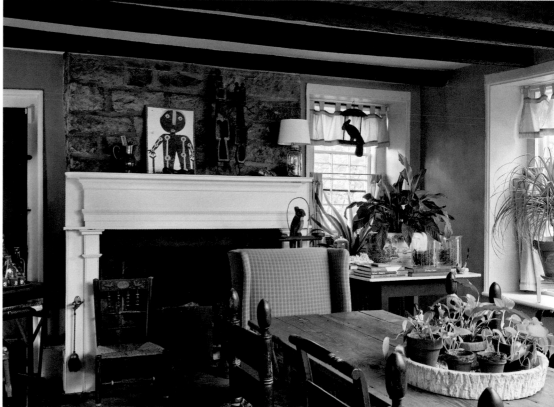

In front of the parlor's fireplace is a rustic table finished in emulation of white birch and embellished with a top depicting a winter sledding scene. Sleds were once used on farms to haul stone and logs, both with and without snow.

The chimney, constructed of mortared fieldstone, has been enhanced with a graceful neoclassical fireplace surround. The couple has assembled a mixed array of antique chairs for the seating arrangement; an assortment of different types of mismatched chairs is a hallmark of farmhouse style.

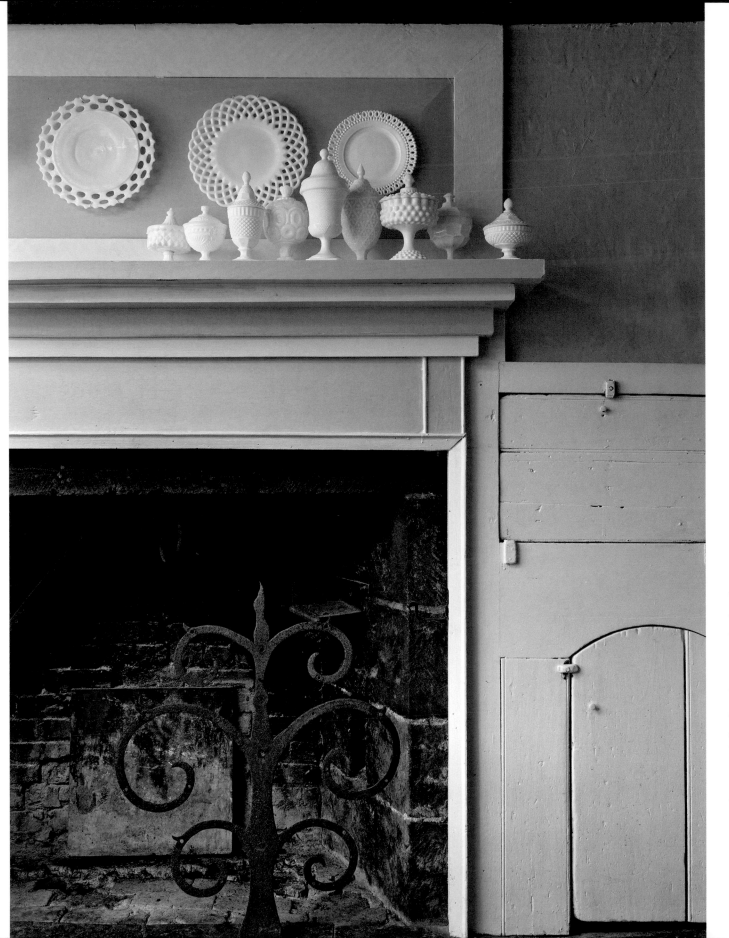

The fireplace wall in the kitchen is painted "Rachel Pink," a color Francis and Lance had recreated for the house. A mantel garniture of lacy milk glass harmonizes with the woodwork, which includes an atypical roundhead cupboard. The delicately scrolled wrought-iron andirons were painstakingly hammered into cascading spiral forms.

The house has unusual
twelve-over-eight
windows and variations
in the dimensions of
the clapboard siding.
The bright exterior
colors were determined
from paint analysis
whenever possible,
as were those on the
interior.

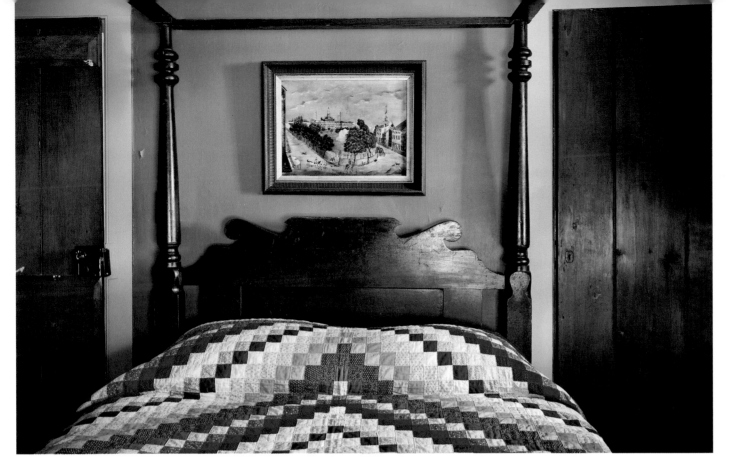

In a bedroom, an Empire four-poster bed with a canopy frame is centered between two early doors constructed of planks with horizontal cleats. A handmade rainbow-hued quilt covers the bed, and above it is a framed mid-Victorian engraving.

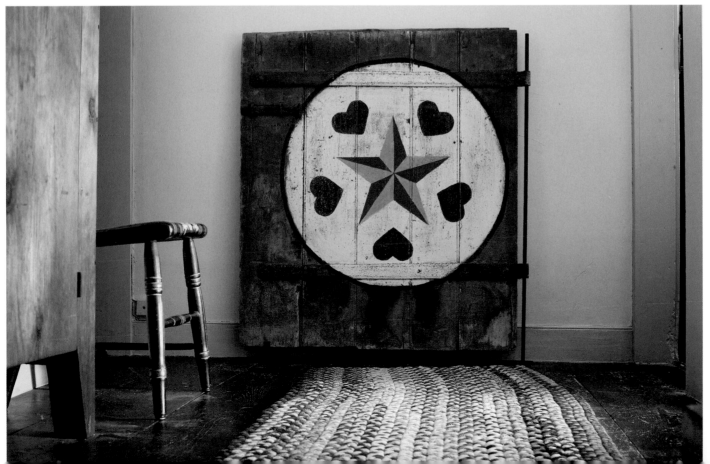

An exquisite piece of folk art, this antique wooden gate with iron strap hinges is painted with the colorful, decorative symbols typical of the nearby Pennsylvania Dutch area. The multicolored braided rug on the hall floor was stitched together from fragments of old clothes.

WISTARIA LODGE

In the first half of the nineteenth century, the Greek Revival movement swept through Upstate New York, transforming the region's vernacular architecture into an emulation of ancient temples and emblazoning its facades with countless columns. Promoted to an agrarian nation by Thomas Jefferson, ever the farmer, the style was adapted to farmhouses everywhere, including the 1840 residence outside the village of Oak Hill, New York, now owned by Jack McGroder, a theater designer. Little is known about the early origins of the property; at some point it was referred to as the Cherrie Hill Dairy Farm, but to Jack, it is Wistaria Lodge, so named for the massive vine he planted that embraces the main structure and then threads through the Ionic columns of the wing's portico.

The farmhouse is surrounded by second-growth forest on land that was once cleared and planted with grains. An avid gardener who plants French lilacs, roses, and irises, Jack doesn't raise any crops himself, but he does likes to shop at the many nearby farmstands. The village of Oak Hill was very prosperous in the early 1800s, with tanneries and later foundries, requiring many shops, such as Tripp's General Store down the road. Although the history is now lost, it is clear that Wistaria was well built and elegantly detailed. Jack was intent on reviving the very aged farmhouse on his shoestring budget and was able to retain the elegant Greek Revival woodwork of his home—notably, a unique

This prime example of Greek Revival architecture, with its pronounced portico and square box columns, was built in 1840 in the village of Oak Hill, New York. When Jack McGroder found it in 1990, the house had been left in its original condition and never modernized. It was surrounded by fields of waving rye grass, grown to three feet tall.

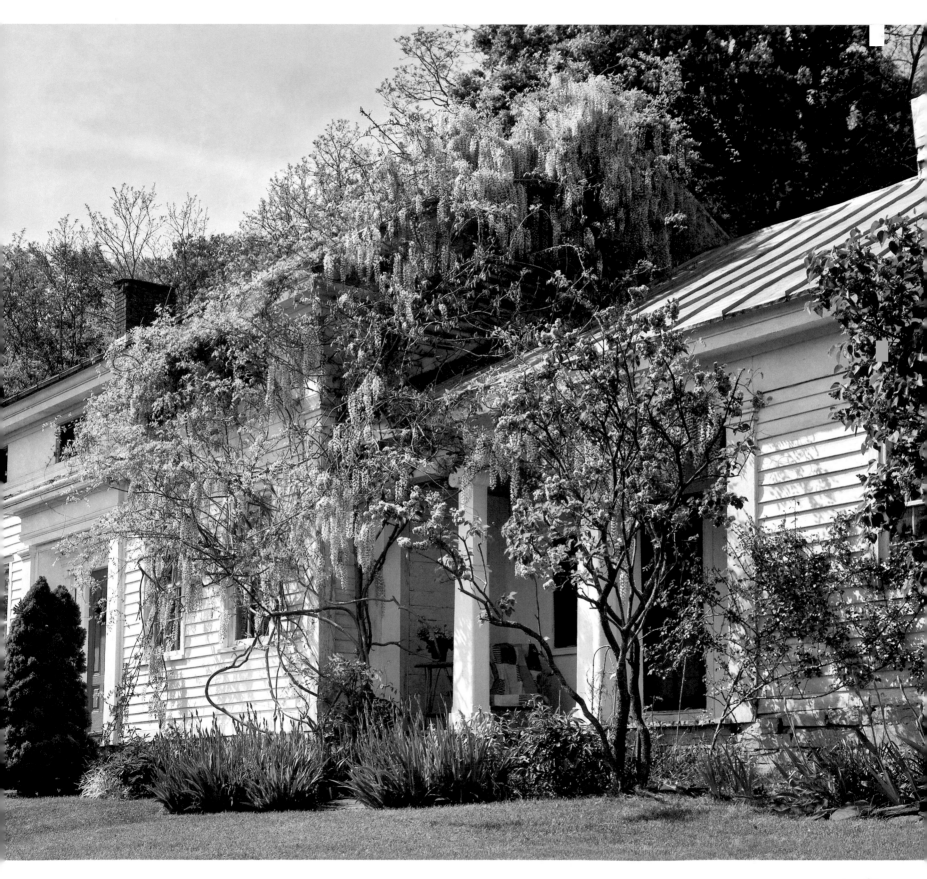

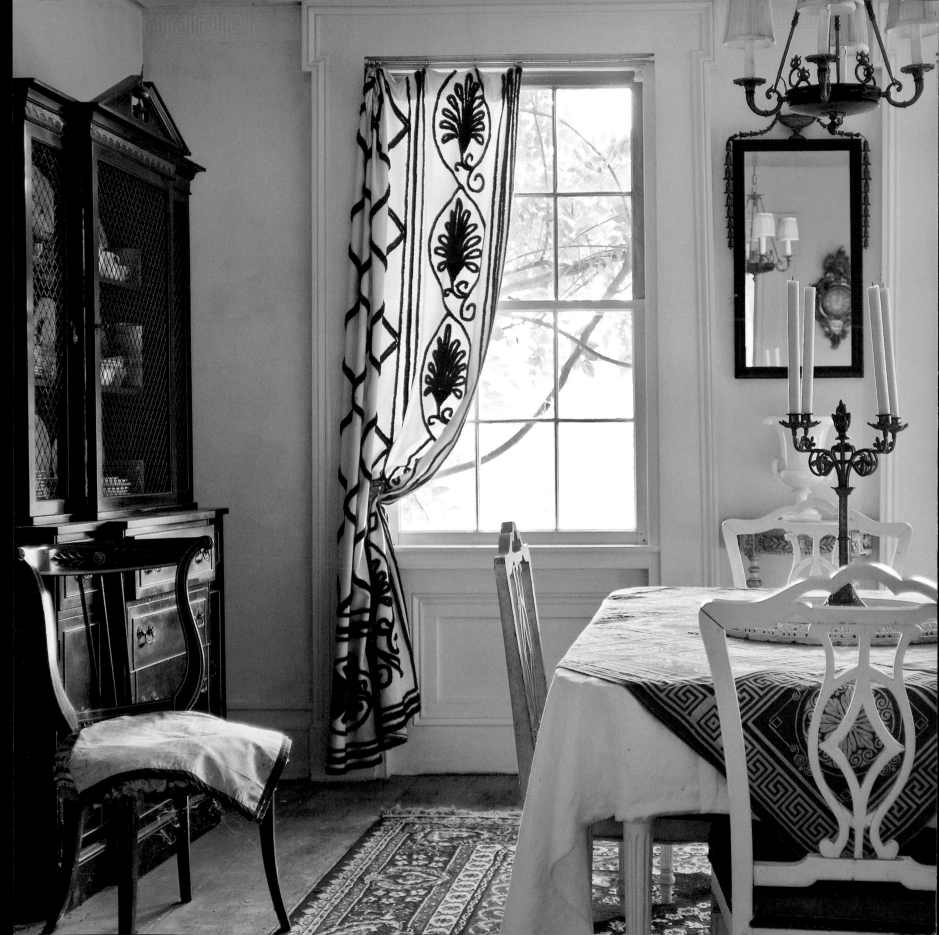

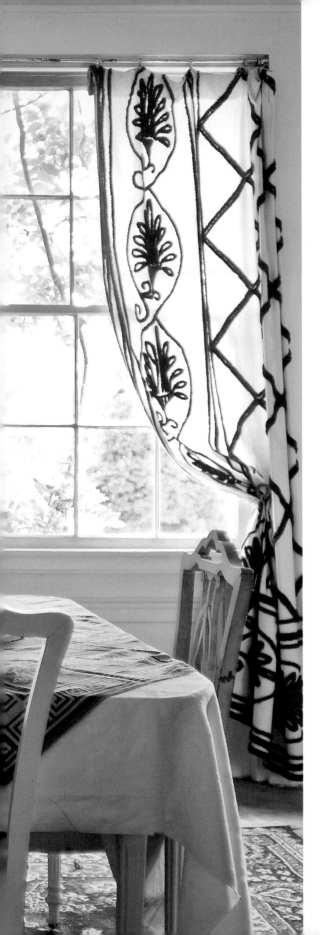

The dignified dining room abounds with some of Jack's favorite neoclassical pieces. Chenille curtains, embroidered with a Greek anthemion pattern, were a lucky find at the Twenty-sixth Street flea market in Manhattan. Jack has painted the interior of the broken-pediment china cabinet Pompeii Red; he found the piece at an East Side thrift shop for next to nothing.

scroll-shaped newel post and a striking classical fireplace surround. He went about his restoration intuitively, "finding things that give an illusion," with objects from local yard sales and flea markets, and making the things he couldn't find or afford.

As Jack, who trained as a fine-art painter, relates, "Being in the design end of theatre, I've always enjoyed going a slightly different route when it comes to my living spaces." Indeed, his striking palette is a bold and joyous combination of sharp chartreuse green, salmon, gorgeous azure, and robin's-egg blue hues, all of which acknowledge the strong colorings of the 1820s and 1830s, but with a very modern twist. His theatrical background is evident in each room's presentation: each one can be seen as a beautifully decorated set piece. The very formal dining room is furnished in a combination of red, black, and white, and the focus is on two swagged curtains created from embroidered chenille fabric. His bedroom is in effect a proscenium; a toile valance and jabots mimic the curtains of a stage, while a brass bed and chaise become players in the cast and heavy gilt frames, some mirrored and some empty, look on.

Jack's rustic, homey kitchen is a colorful play upon farmhouse style. Its potbellied coal stove, simple hutches, rush-bottomed chairs, and wispy chandelier each bring to mind the interiors of kitchens typically found at the turn of the last century. His uninhibited paint choices take their cue from Homer Laughlin's Riviera dishware. Jack possesses the artist's eye, and rather than arranging multiple items of the same type, each vignette is thoughtfully made to draw attention to the specific nuances and interrelationships of the objects. As in nature, the many colors, shapes, and textures of a variety of materials can come together happily in a harmonious balance.

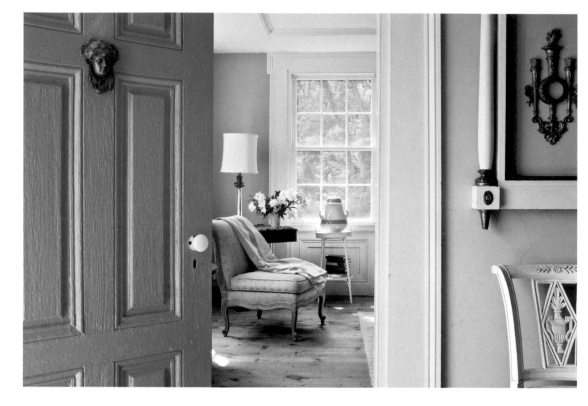

TOP

With a deft eye for color, Jack has painted the front door of his house a striking blue. The 170-year-old door shows its woodgrain and, like much of the rest of the house, is as sturdy as the day it was built.

BOTTOM LEFT

Gracing the entry hall, the mahogany newel post with an unusual scroll motif is a particularly fine architectural element for a vernacular farmhouse. Designs such as this were often chosen by carpenters from pattern books of the day.

BOTTOM RIGHT

The accents on a jasperware teapot combine with those of a spiral-glass lamp shade and Depression-era table linen. Bits and pieces have been picked up here and there from flea markets, yard sales, and thrift shops around the country, yet it seems as though they have always been part of the house.

A fireplace mantel was often the most stylish part of a farmhouse's interior. Jack found this one, ornamented with a bold Greek key entablature, and took it home to lean against a wall in his study. It is surrounded by a diverse array of objects, all of which Jack discovered in his travels.

As many farmhouses were built before the advent of indoor plumbing, bathrooms are typically of a later design. This bath has tongue-and-groove wainscoting, an embossed wall treatment, and a rustic walnut-framed mirror. The sink basin is supported by a fluted pedestal, which lends a stately air to the room.

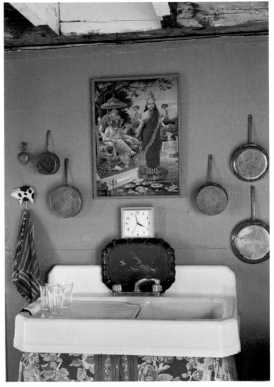

LEFT

Farmhouse kitchens
are intended to be
functional and relaxed.
The rush-seated
country chairs were
given new life, painted
in cheerful colors
taken from the Homer
Laughlin dishware
shown on the table.
The room has been left
unfinished, for now,
with the rusticity of an
open ceiling and the
natural finishes of iron
and brick. The antique
potbellied stove is
currently disconnected
from its chimney.

ABOVE

Copper cookware is
hung on the salmon-
colored wall above the
enameled farmhouse
sink. Floral chintzes,
a staple in many
farmhouses, were
often used to conceal
plumbing below
kitchen and bathroom
sinks. Jack's choice of
vivid fabric coordinates
with a print from India
depicting Ganesh, the
elephant god, seated
next to a lotus-bearing
goddess.

HUDSON BUSH

Just outside of Hudson, New York, in Columbia County, is the finely built Georgian home of Dr. Norman Posner and Graham Farrell. Its stately brick facade is embellished with deluxe fenestration; the first floor encompasses triple-hung, floor-length windows, and a grand Palladian window peers down upon a neoclassical portico. Along with its stylish hipped roof, the sum of the architecture implies that this was never a humble home, but the residence of someone well-to-do.

Norman, who bought the house in 1975 with Charles Baker, his then partner, recounts that although the house dates from 1785, the property was farmed since the early 1700s. The land was part of a large parcel owned by Henry I. Van Rensselaer, a member of the wealthy Dutch patroon family, and on the estate wheat, corn, oats, and livestock for export were grown. The manor would have contained a dairy, icehouse, springhouse, smokehouse, barns and sheds, and many other outbuildings as part of a large commercial enterprise.

The tilling of soil is still a major enterprise at Hudson Bush, and the manor house is renowned for its three acres of formal gardens created by Norman and Charles, which look as if they've been there since the beginning. "There are two large parterres behind the house, divided by brick paths and enclosed by picket fences," Norman says. "Charles and I selected only red, orange, and yellow flowers for one side,

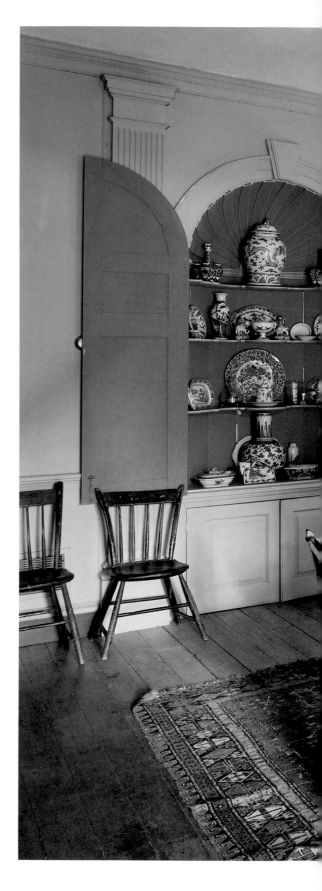

The formal dining room is painted in the bold colors favored at the turn of the eighteenth century, and a pair of fluted pilasters frames the mantel, which is ornamented with neoclassical design elements. Another pair surrounds the shell-covered cupboard, with its scalloped shelves. The cupboard is accented with a brilliant salmon color; Norman has displayed his collection of antique blue-and-white Chinese porcelain in it.

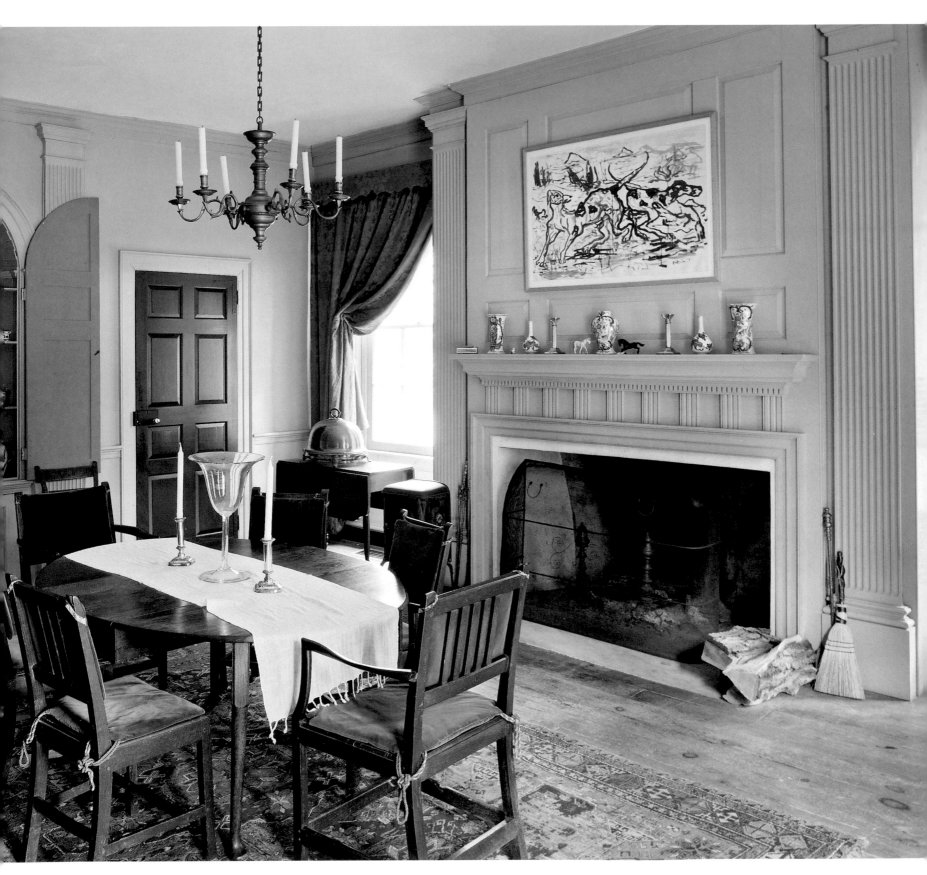

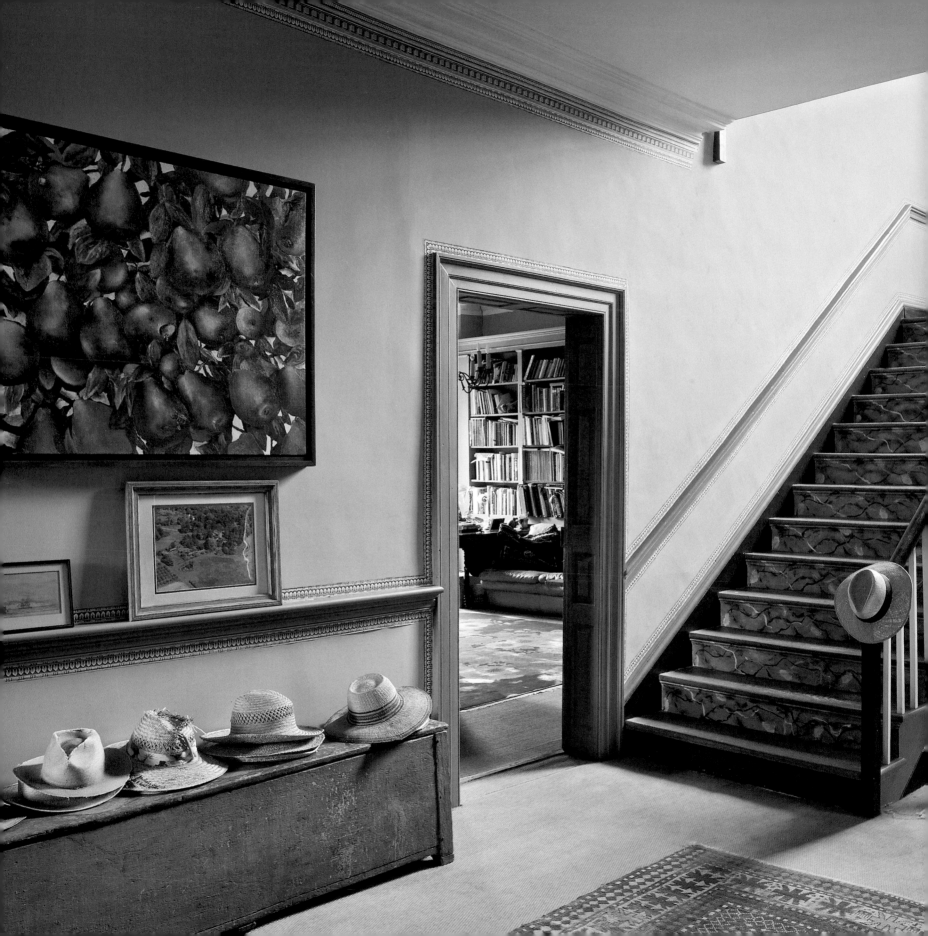

The entry hall was the first impression given to visitors by a host and would often display the owner's taste and interests. In this case, Norman's collection of straw gardening hats, contemporary art, a Klismos chair, and a Chinese pot on the landing reflect several of his passions.

while the other has blue, green, and violet." Additionally, the pair planted various single-color borders, all separated by the pathways and corridors they installed. Norman also tends a large vegetable garden that produces tomatoes, shallots, artichokes, beets, and onions, and raises chickens, selling and delivering the eggs himself.

In accord with the gracefulness of the architecture of the house, Norman has created a relaxed dignity and a tempered, comfortable formality within. Fine antiques are easily combined with contemporary art. An artist has marbleized the elegant stair in the large center hall, where well-worn straw hats are casually arrayed on a weathered bench.

Mindful of the farm's history, Norman and Charles also focused efforts on retaining some of the earliest outbuildings, although relieving some of their workaday aspects. An eighteenth-century smokehouse has survived and now serves as a garden house, while a former icehouse is a pleasant place for afternoon tea.

The aptly named "big kitchen" features a large restaurant stove and modern industrial sink along with old cupboards, a fireplace, and a Dutch door. There are burgeoning collections of baskets, bowls, teapots, and cooking implements. In a corner of the room next to the fireplace, a daybed provides a spot for relaxing and looking out into the garden. There are broad wooden work- and dining tables, and depending on the season, Norman may well be found sorting seeds for an upcoming growing season. A former butler's pantry, now called the "small kitchen" has a window passage to the big kitchen and tall cupboards where glassware and pots and pans are stored. Also known as a serving pantry, it was a place to wash fine china, arrange flowers, and polish silverware for stately dinners served in the adjacent formal dining room.

A place of gracious hospitality still, Hudson Bush remains the center of many public events in the community, hosting annual garden sales, exchanges, and tours.

The "small" kitchen used to be a butler's pantry. Pantries like these were placed between the dining room and the kitchen and provided extra workspace, as well as a place to store china, silver, and glassware.

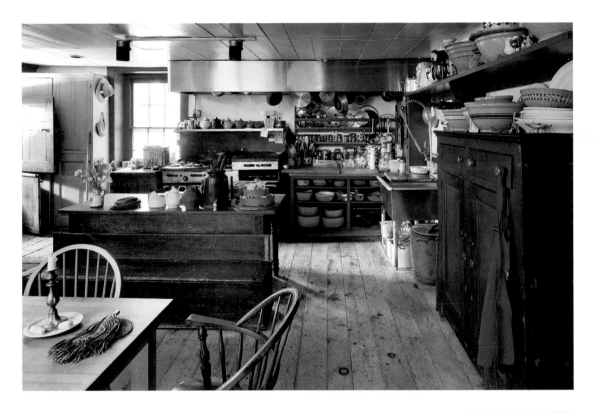

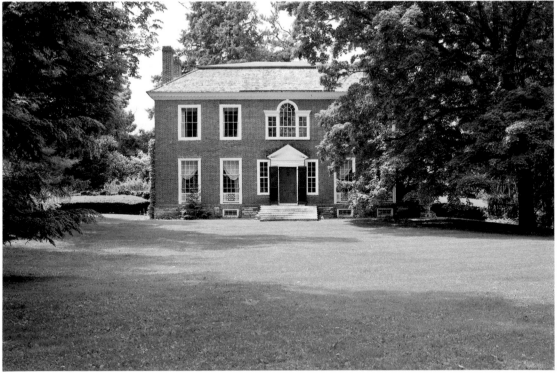

One of two kitchens in the house, the big one is the center of many day-to-day activities, including cooking, dining, entertaining, and garden planning. The original Dutch door is still a useful design, letting in light and fresh air but keeping out the occasional chicken or dog.

Known as Hudson Bush, this well-proportioned Georgian brick dwelling was built in 1785 by a member of the Van Rensselaer family, a powerful clan with vast landholdings in the Hudson Valley. Behind the house are three acres of formal gardens, with trimmed hedges and gravel walks.

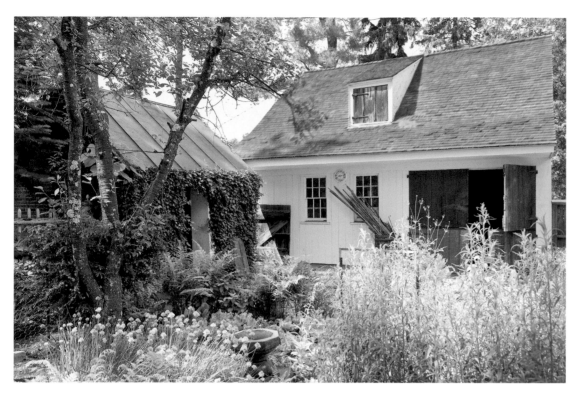

ABOVE

All old farms had outbuildings that ranged from tiny sheds to massive barns and served many different needs. Those that survived were often adapted by subsequent owners to meet more contemporary requirements. The ivy-covered smokehouse is now used as a garden house. A garage had its roof restored with cedar shakes and paddock doors added.

LEFT

In front of the latticed back porch, sunflowers begin their climb.

RIGHT

The high-ceilinged parlor is furnished in an informal variation of late-eighteenth-century style; a Sheraton settee is fitted with a Regency-patterned slipcover and is surrounded by Hepplewhite, Empire, and chinoiserie pieces.

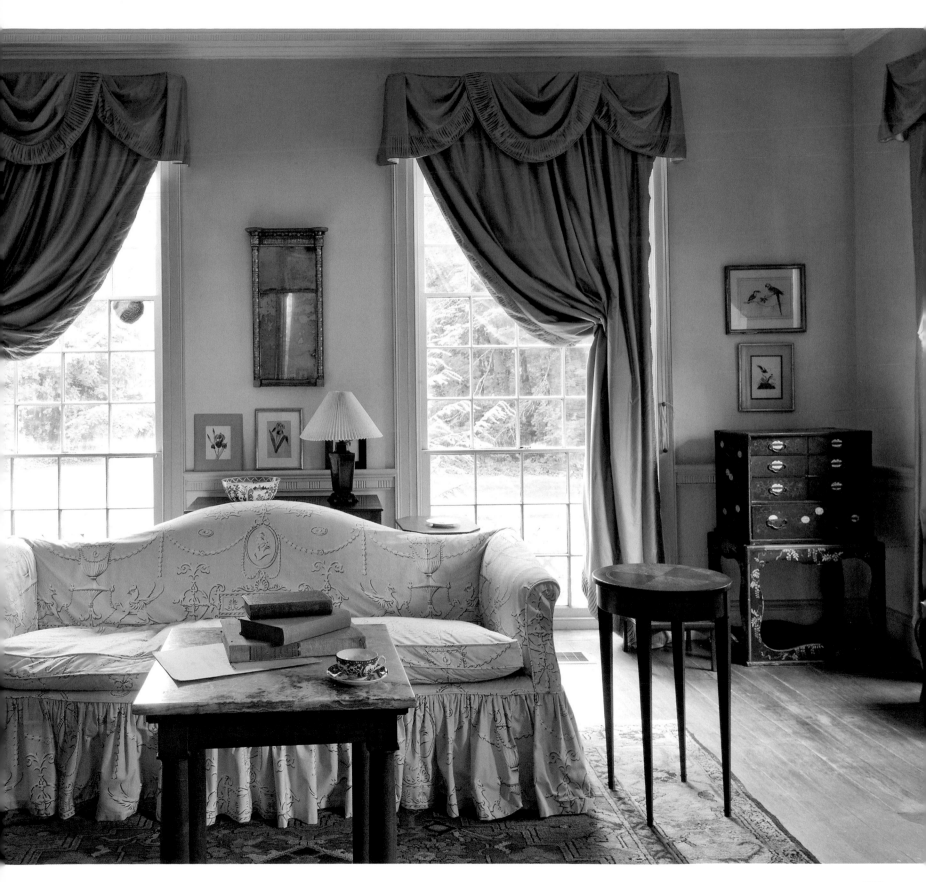

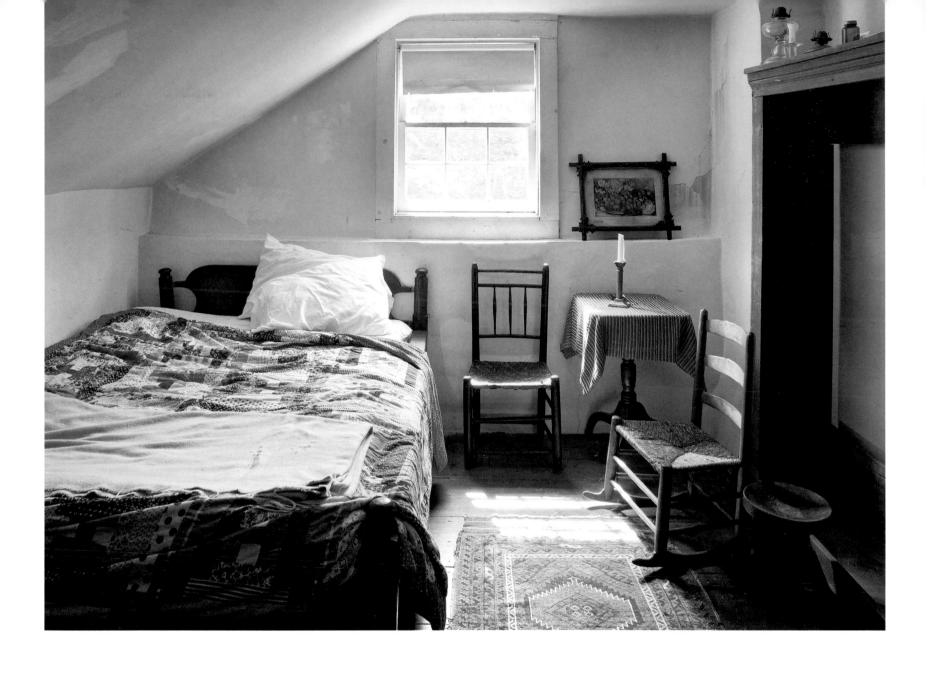

Attic bedrooms, formerly occupied by servants, were often repositories for odd or mismatched furniture that had fallen from current fashion or become worn from use but were not discarded outright.

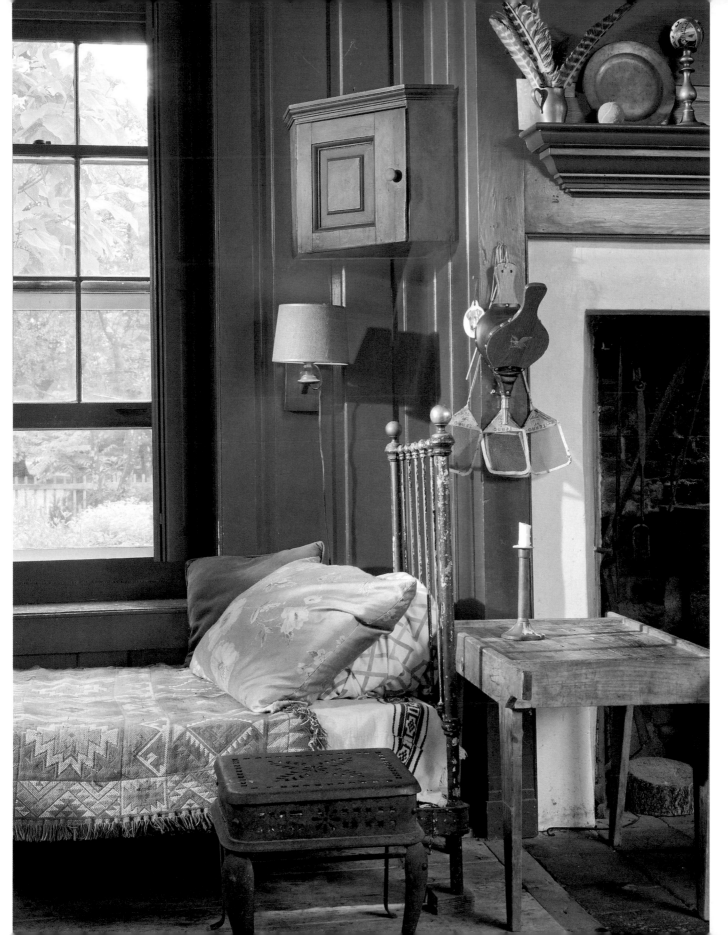

With walls painted a dramatic crimson, this corner of the kitchen features antiques from many eras, like an old brass and iron daybed and a primitive desk. A tiny wooden corner cabinet is suspended from the paneling, and the fireplace mantel is ornamented with assorted brass items such as an old push-up candlestick. Within easy reach are an assortment of fly swatters, a much-used implement of the farmhouse kitchen.

OLD SNYDER FARM

Just outside the village of Cherry Valley, New York, not far from Cooperstown, sits the Old Snyder Farm. This solid Greek Revival structure, with its ample, welcoming porch and sweeping vistas, is now home to Kathy Spitzhoff and Dennis Coluccio. In 2004, the couple sold their Brooklyn brownstone in exchange for full-time country living. "It was becoming too hard to leave my horses every week to go back to the city to work. Also, Dennis wanted a shop where he could do his woodwork, and I wanted to garden more," says Kathy.

The property surrounding the house, which was built in 1840, was farmed by Earle Snyder and his family from the 1920s until the 1970s. "People still refer to it as the Old Snyder Farm," says Kathy. "They had dairy cows and grew hay and crops as well as fruit trees." After the Snyders' tenure, the house fell into terrible disrepair, to the point where its demolition seemed assured, but a local old-house restorer acquired the property and rebuilt it completely.

On grounds that yield to gently rolling hills and pastures, Kathy and Dennis raise a variety of fancy bantam chickens and a rescued paint horse named Lucy, along with several Paso Fino horses. They built a new post-and-beam barn on the site of the original barn with the help of local carpenters and some Amish craftsmen. A small two-story outbuilding with a steep-pitched roof and vertical board-and-batten siding serves as Kathy's graphic design studio. "The building was just a shed when we moved here and we had it improved

The large country kitchen features a Chambers gas stove and cabinets built from reclaimed pantry cupboards. Many farmhouses still possess their early appliances, and these are surprisingly functional; the current owners often prefer them for the homey touch they impart and adapt to their technological quirks. The enameled parakeet advertising sign was a roadside find.

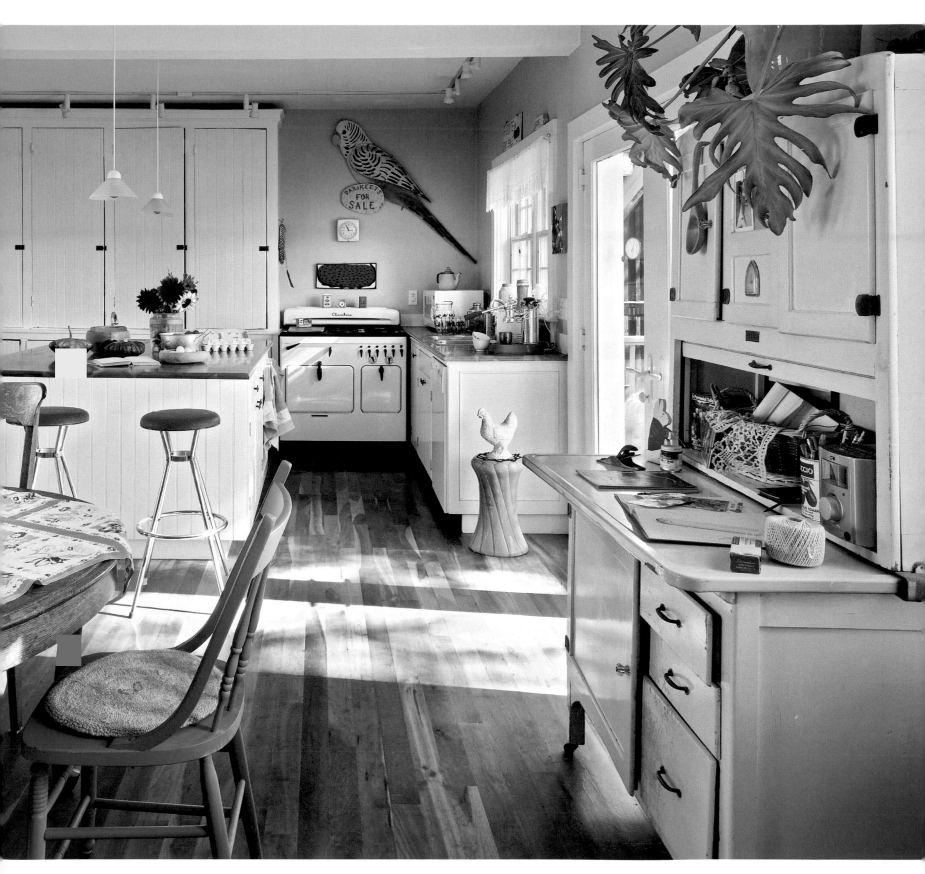

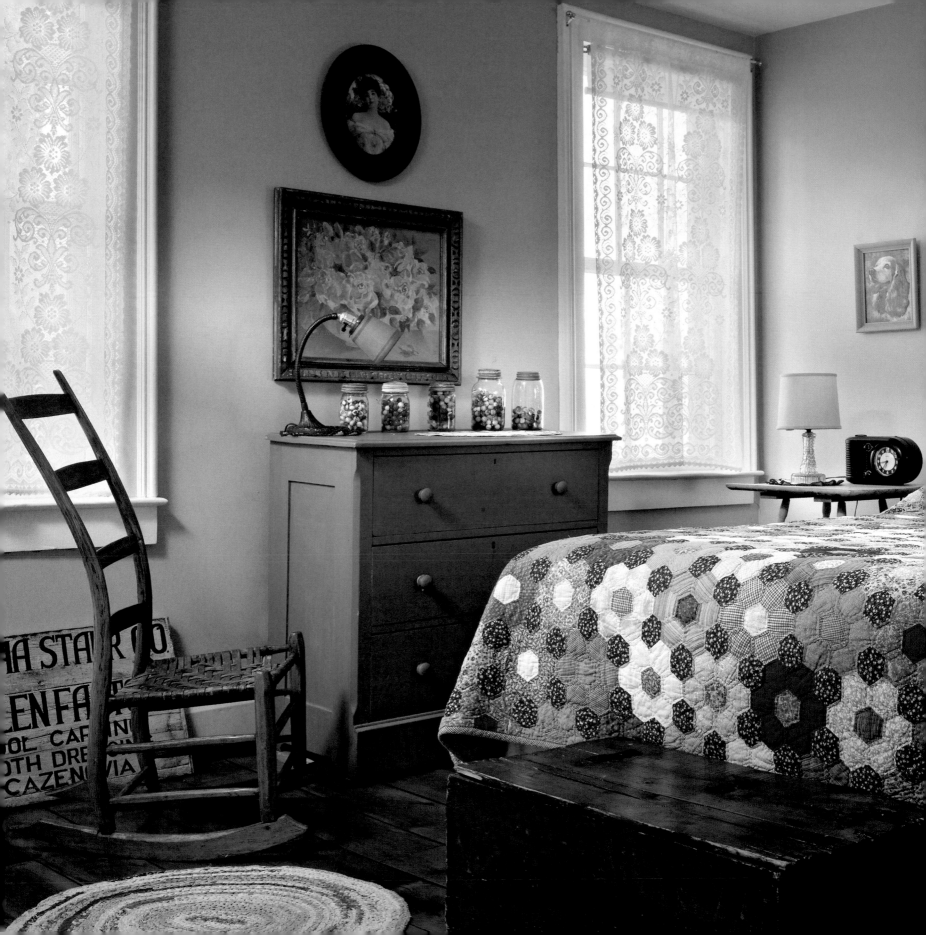

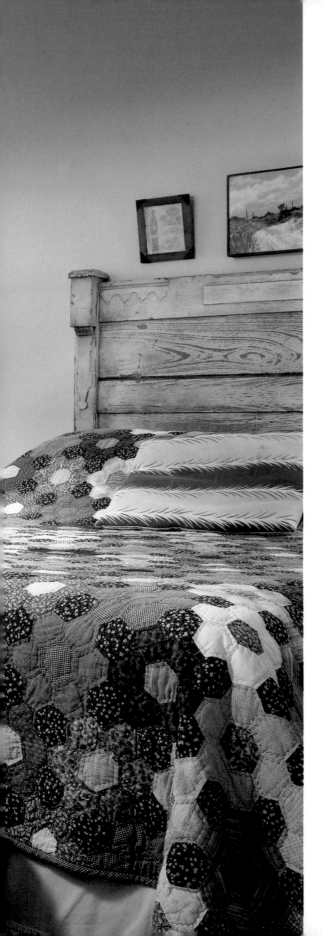

In their welcoming guest room, a colorful hand-sewn quilt covers a chestnut Eastlake bed built in the 1880s. Quilts were cherished objects, assembled painstakingly by hand from collected fabric scraps and handed down from generation to generation.

and finished so I could use it for my artwork and graphic design. It was originally built in the 1970s and people have said things to me like, 'Oh, I went to a poetry reading in that building years ago,'" referring to the time when poet Allen Ginsberg owned a farm nearby and there was a poetry scene in the town, dating to an earlier back-to-the-land era.

Kathy and Dennis have furnished the house with many vintage and pre–World War II pieces acquired over time. "We used whatever happened to become ours along the way," recounts Kathy. "We love old things, and want the house to feel like it is a comfortable and practical farmhouse." The optimistic strivings of a prewar America are conveyed by the furnishings found in the house, and one can easily imagine the Snyders gathered around a crackling radio deep into the evening on a quiet country night.

An ever-convenient Hoosier cabinet, used as a desk, and a Chambers gas stove reside in the large cheerful country kitchen, which itself is fitted with generous beadboard cabinets constructed out of the old pantry cupboards. In the rooms, comfortably worn armchairs and Victorian tables are covered with embroidered doilies and flowery tablecloths that invoke the past. "I've had a doily collection going for years and got a wonderful contribution when my aunt Marjory in Maine died and left me a box marked 'tea linens,' which were given to her at the time she was engaged to be married," says Kathy.

Besides heirloom tomatoes, Kathy has planted Swiss chard, spinach, peas, and lettuce. "I grow the flat Italian string beans, potatoes, onions, eggplants, and squash. I also have blueberries and raspberries. The fruit trees are apples, pears, peaches, and apricots. This year I am planting some nut trees. They will take about seven years to produce, so when I retire I can sell nuts at the farmers' market." Like the farmers before them, Kathy and Dennis are always looking to the future and planning new things to grow.

Seen through a door in an upstairs bedroom, a bath contains a Roman style tub holding a drying rack handy for hanging wet socks. On the wall, a patchwork quilt is displayed above bookshelves and an unusual turned-wood "found" object has been set upon an old footstool as a sculptural piece.

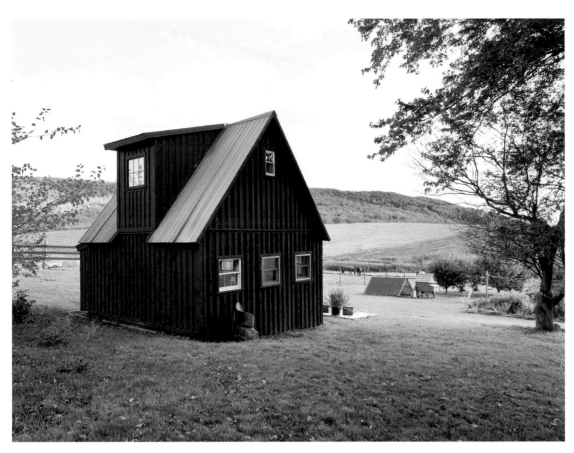

LEFT
The couple converted a shed into Kathy's graphic design studio. The board-and-batten siding and steep pitched roof are reminiscent of the Carpenter Gothic style.

BOTTOM LEFT
Like many rural farmhouses, the Greek Revival home at Old Snyder Farm is a restrained version of the style. Behind the house are the rolling hills and fields of Cherry Valley, New York.

BOTTOM RIGHT
Lucy the paint horse was rescued by the couple and shares the pasture with several Paso Fino horses.

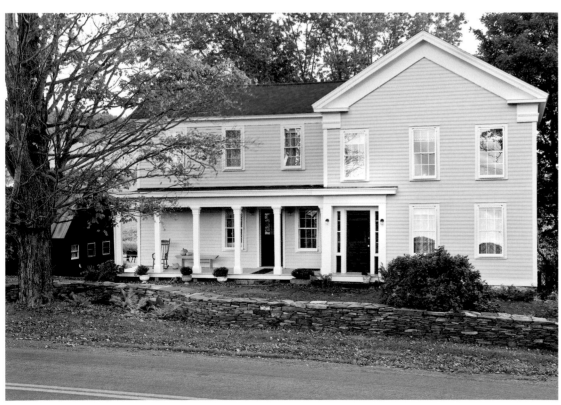

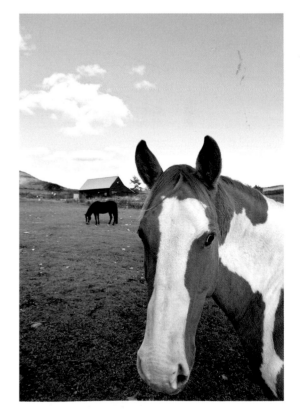

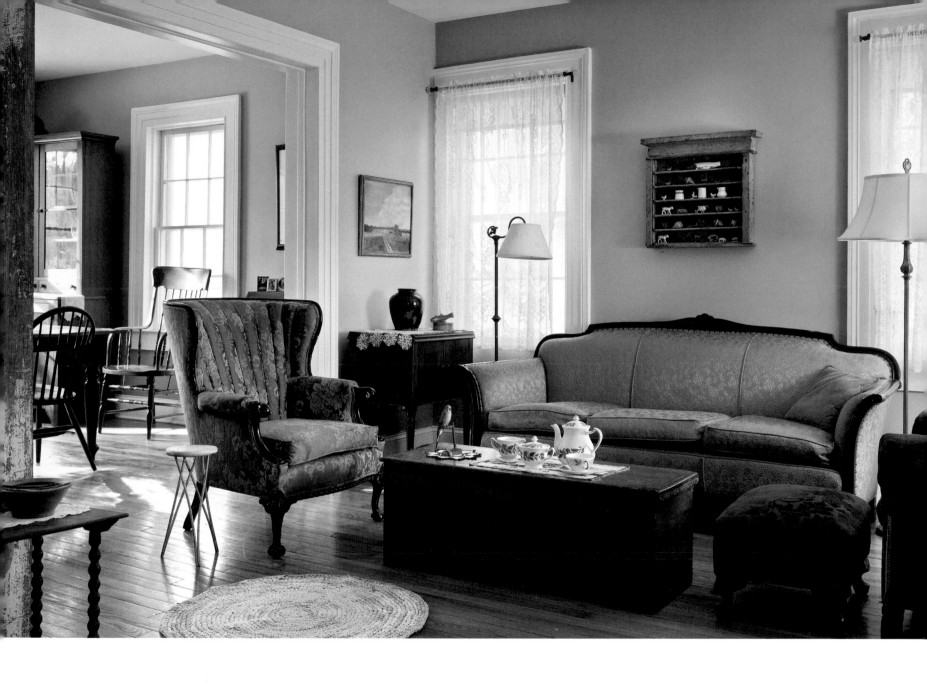

The parlor is a
comfortable mix of
vintage furniture and
antiques; the couple
favors pre–World
War II furnishings
that conjure up a
sense of American
life in the 1930s.

A Hoosier cabinet is employed as a desk in the kitchen. This item was found in many a farmhouse kitchen. Favored for their multifunctionality, Hoosiers contained built-in flour sifters and organized racks for ingredients and utensils, all in a single compact unit.

M.H. MERCHANT STONE HOUSE

At the end of the nineteenth century, a new style quickly rose to the forefront of architecture and interior design; referred to now as Craftsman or American Arts and Crafts, it promoted an aesthetic based upon simplicity and the lack of extraneous ornament. Its leading proponent in the United States, Gustav Stickley, grew up on a small farm and was later headquartered in Syracuse, New York. Hailing from that same city was one Melvin H. Merchant, an inventor and farmer, who in 1900 erected a handsome, sturdy stone farmhouse in the tiny hamlet of Cornwallville, New York, and proceeded to raise chickens and sheep there with his family.

Four years ago, artist Stephen Ellwood purchased the property as a country house, enchanted by the setting in a quiet forested corner of Greene County, New York. He speaks of being smitten by "the beautiful craftsmanship of the stone walls of the house that use fieldstone and hazelnut mortar, as well as the quality of light that streams into the rooms, and the contrast of the dark oak floors against the white walls. M. H. Merchant built it of his own design, in a vernacular manner that does not reference the older Dutch stone houses in the Hudson River Valley."

Stickley's design ideas were published in his magazine *The Craftsman*, which was the bible of the Arts and Crafts movement in the United States. Dispersed throughout the country and appearing in many a farmhouse, it emphasized spare design, hand-crafting, and the importance

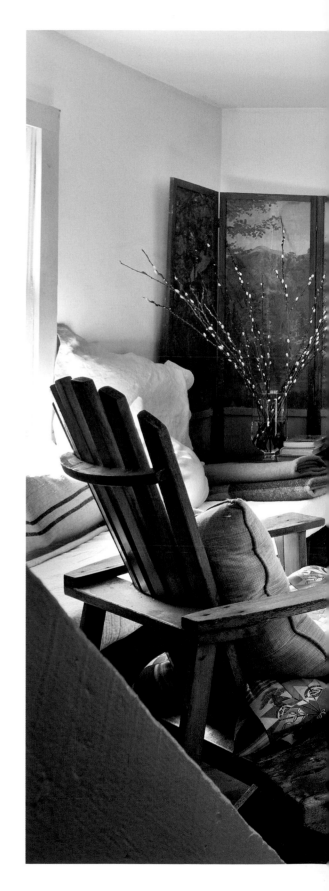

In the sitting room off the kitchen, a pair of Adirondack chairs forms the central seating arrangement. By bringing this outdoor furniture inside, Stephen has melded the exterior and interior environments in a pleasant rusticity that showcases the best of both.

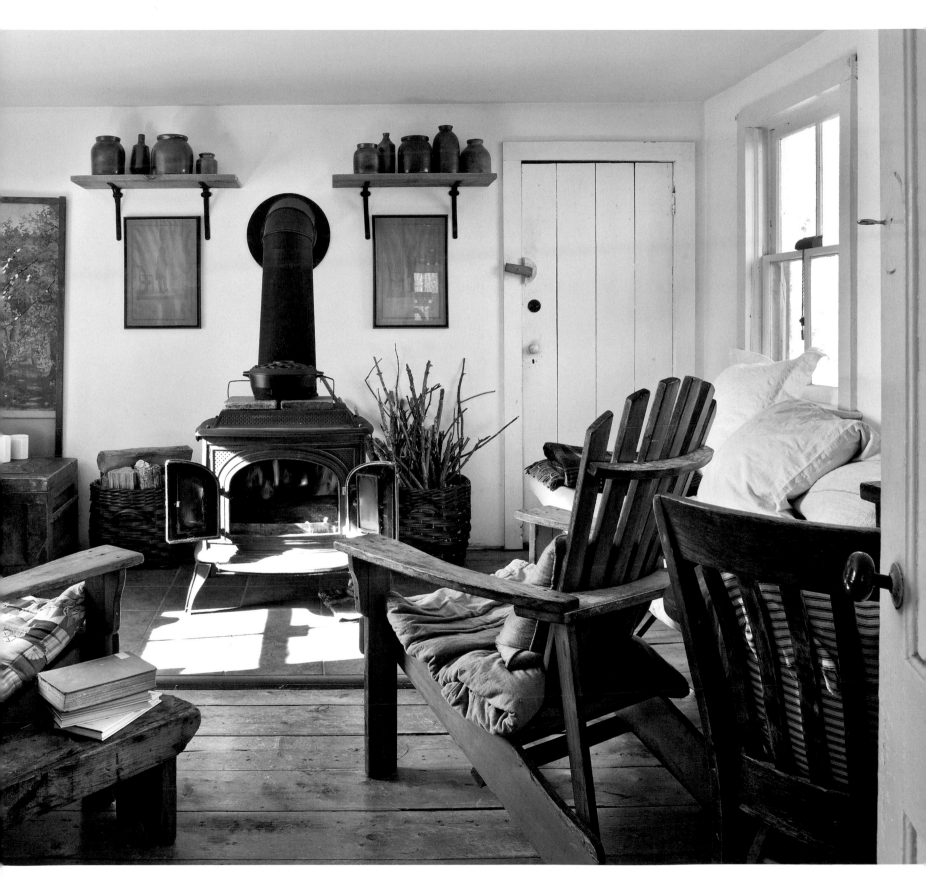

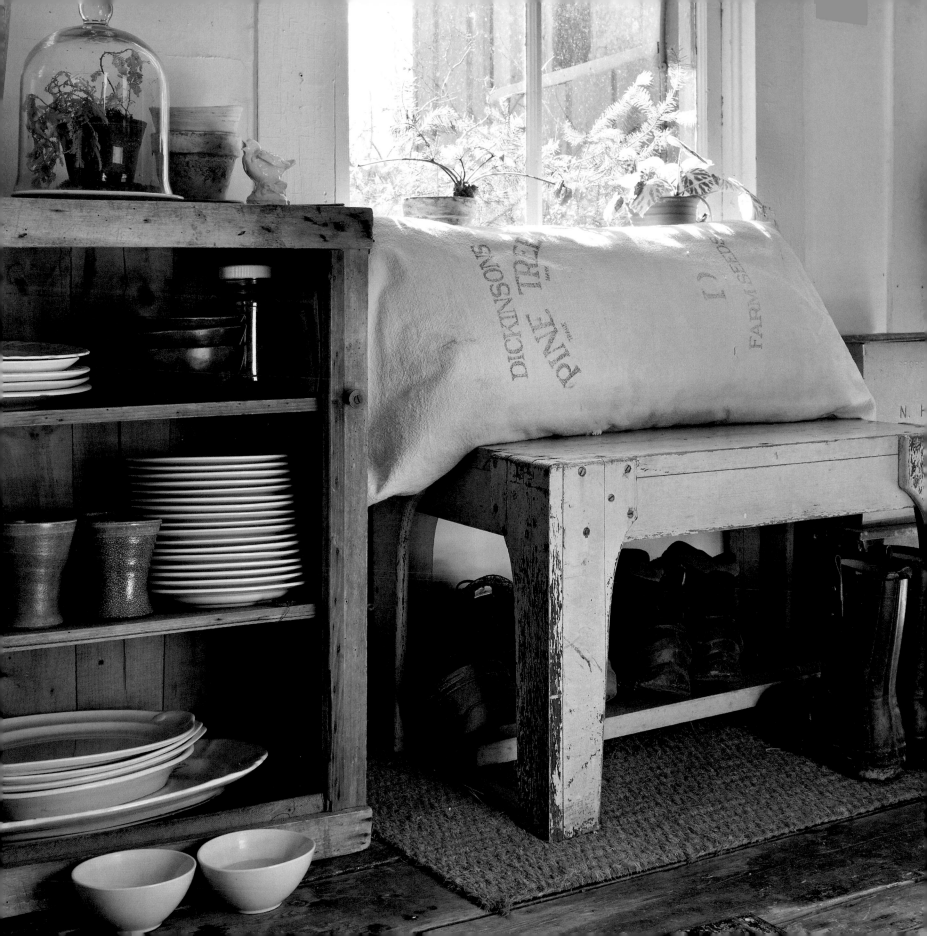

En route to a small enclosed porch where wood is stored, a vintage milking stool serves as a convenient spot to remove muddy boots. The unornamented pottery and plates, held in another recycled cupboard, resonate with the naturalistic aesthetic of the home.

of the vernacular, all the while rejecting Victorian over-ornamentation. Stickley's furnishings greatly appealed to many farmers for their durable, solid sensibility.

Stephen's home, while not literally Craftsman in theme, shares this same appreciation for simple traditional handcrafted forms that echo the Stickley tenets of honesty and lack of pretense. Handmade pottery is displayed on shelves, and runners of natural fibers cover the tables. Arrangements of pussy willows are placed in front of hand-painted screens, and sepia photographs of waterfalls hang on the walls.

The long wooden kitchen table, once a workbench, has been repurposed for its utility and beautiful simplicity, and a table behind the sofa is an assemblage of vintage iron pipes and fittings that support a plank top. Small carpenter's benches serve as window seats and side tables for books; each item stresses its utility with restrained, clean lines. Stephen's fabric choices are muted and natural, with few repeating patterns to be found, and two fan-backed Adirondack chairs, now stripped of paint, are made comfortable with linen-covered down pillows. Equally humble is the metalwork of the lighting and candlesticks, which, coupled with the woodstove's fragrant warmth, all contribute to the serene ambience of the rooms.

Stephen has also worked hard to landscape the overgrown property, in collaboration with the garden designer Todd Carr, and has planted sweeping perennial beds and a large vegetable garden.

As he says, "A main theme of the interior is its connection to horticulture, as well as a connection to the surrounding landscape. The deep-set windows of the stone house act as framed views to the outside. If anything, above all, there is a natural feeling of lightness, simplicity, and expanse that delights one's heart and mind."

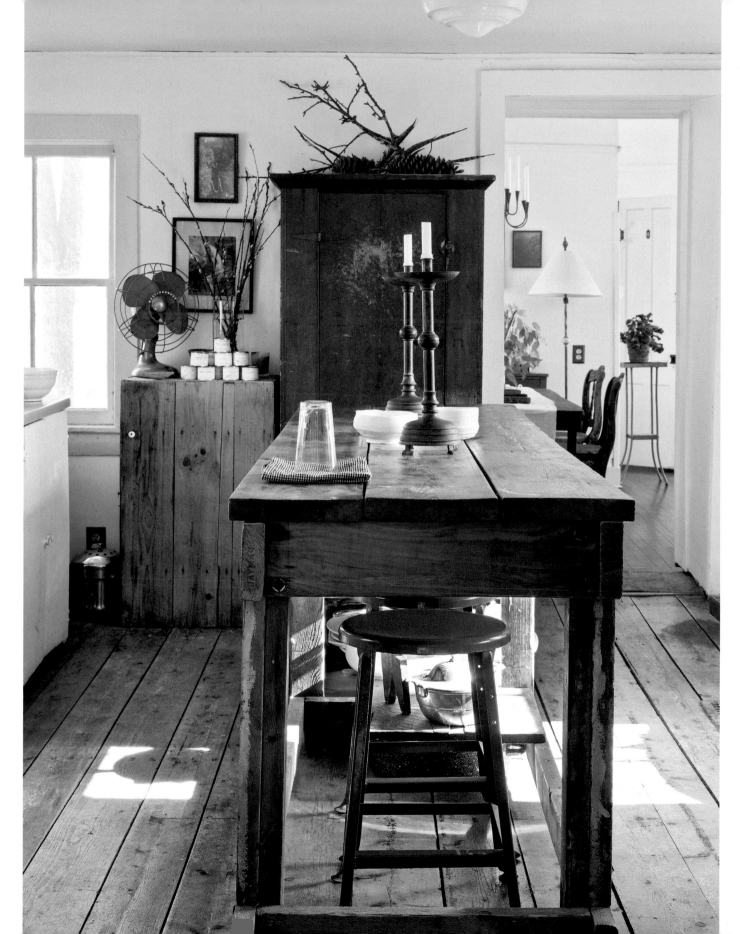

The farmhouse kitchen is centered with a table that was once a workbench in a shop. With industrial stools, two rustic cabinets, and a careful selection of aged and textured items, the kitchen is a room that is both functional and attractive. Black-and-white photographs of local waterfalls hang around the room.

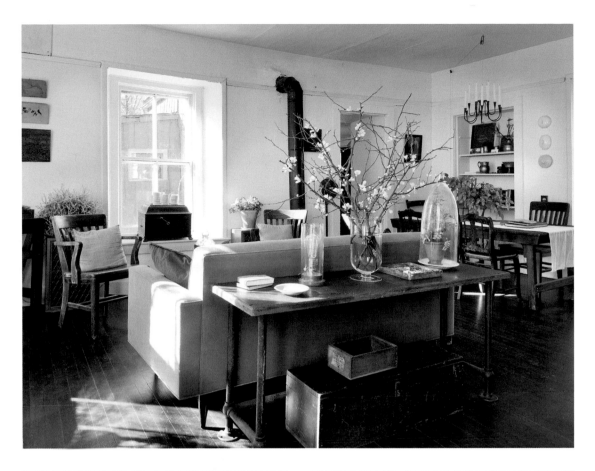

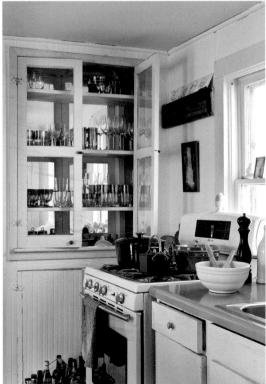

TOP
By liberally interspersing plants with manufactured items, Stephen has made his living room a vibrant space. The presence of the past is felt through the placement of antiques, such as the tabletop Victrola and the Bank of England chairs.

BOTTOM RIGHT
Built-in cabinetry was typical in many farmhouse kitchens; it made use of the pockets of space between the stove chimney and exterior walls. These glass cabinets pass through between the kitchen and sitting room. Beadboard was a preferred material, as it was resilient yet decorative.

BOTTOM LEFT
Stephen has assembled a collection of antiques and simple castoffs into a stylish, cohesive whole. Behind the Adirondack chair is a tall wooden bookcase holding pottery, feathers, maps, and books on nature. The gray-painted stairs lead to a dormer bedroom above the kitchen.

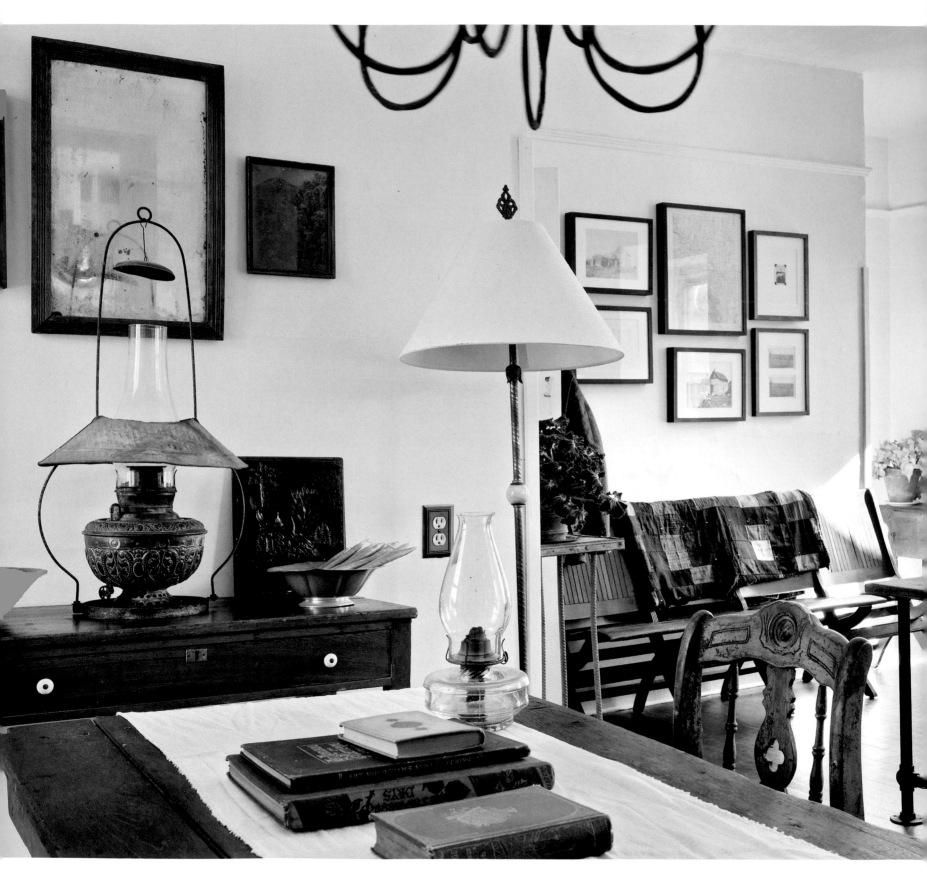

LEFT
Stephen collects metal lighting of many vintages and forms, including the Art Deco bridge lamp and late-nineteenth-century hanging kerosene lantern.

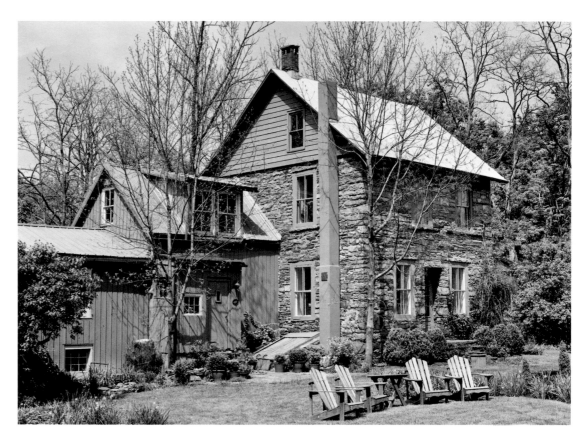

TOP RIGHT
The wood-frame sections of the house actually predate the stone house's construction and contain the kitchen, a dormer bedroom, and a sitting room, as well as an attached coop.

BOTTOM RIGHT
In one of the three upstairs bedrooms, a gentlemanly patchwork quilt was made of old wool suiting pieces.

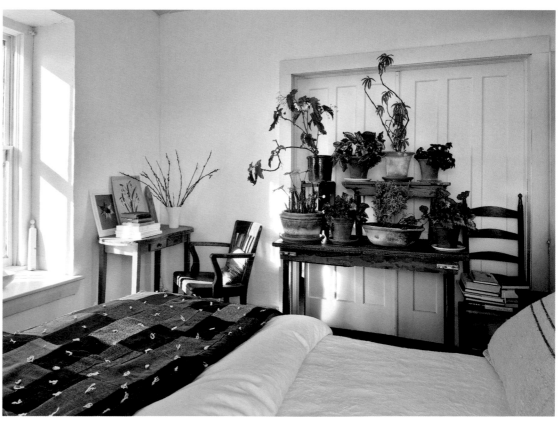

BRADFORD HOUSE

The desire to possess a farmhouse and embrace rural life is hardly new. In 1919, a couple found their way to Bradford House, an upland farm in northwestern Connecticut, above the Housatonic River Valley, and it has now remained in the family for nigh on a century. The four granddaughters who now own the house have chosen to use it collectively as they've raised their families.

Though they grew up in New York City, the sisters spent their summers and vacations in the house, and it has been the site of countless celebrations, including three generations of weddings. "As kids, our favorite thing was the privy, with its four holes in graduated sizes, and the three attics in the house," one of the sisters says. "Both the privy, which was retired from service in 1958, and the attics were continually adapted for our own uses." In the summers, the sisters built natural history museums and clubhouses for themselves and roamed about the woods and fields. The family never farmed the land; instead, other local farmers used the fields for hay and corn and grazed their cows there. One long-time local farming family cuts the fields in exchange for the hay to this day.

The seven-bedroom Federal house, built around 1800, was modernized slowly. As a sister recounts, "In the early 1970s, if we came up in the winter, the plumbing would be off, so we had to use a hand pump for the well. When our mother was a child in the 1920s and the barns were being built,

Wooden antiques, colorful hooked rugs in floral patterns, and a bright throw make this an enchanting bedroom. The unusual chair at the foot of the bed may have been fashioned from a sleigh seat and then had legs added later in the Victorian era. Armoires were often used in old farmhouse bedrooms, which usually did not contain closets.

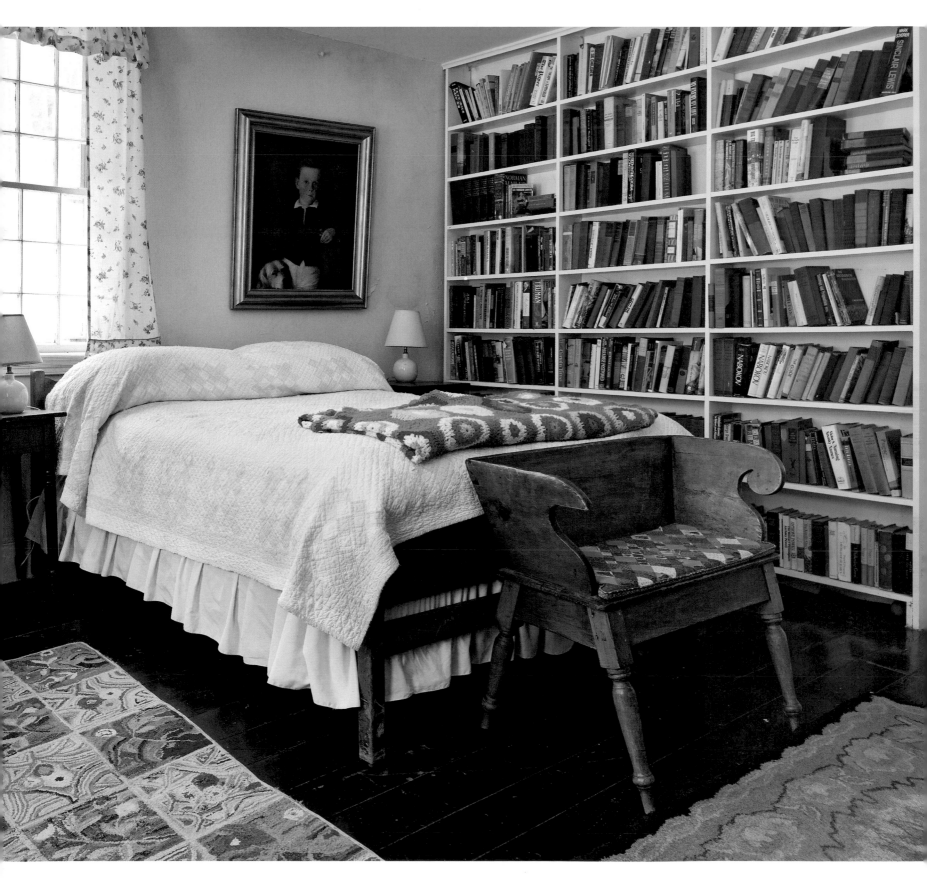

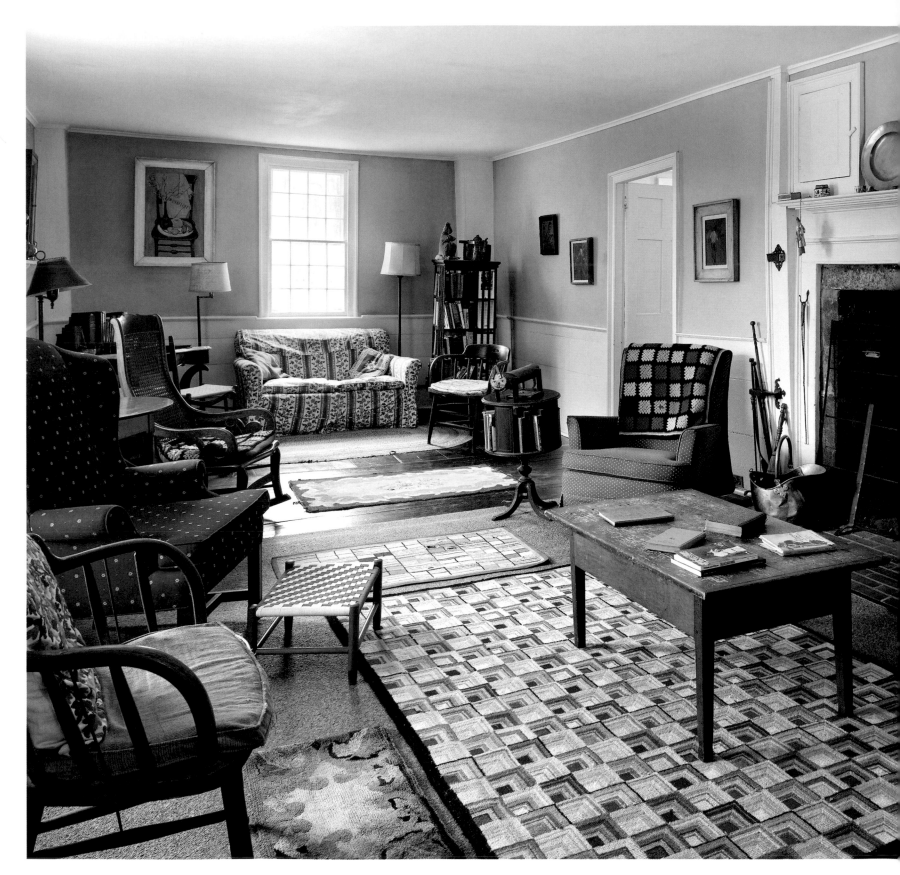

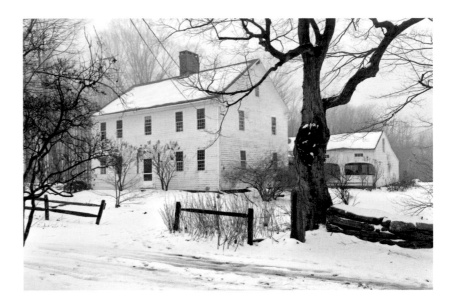

RIGHT

Bradford House, more than two centuries old, has been home to five generations of the same family; the grandparents of the four sisters who currently co-own it purchased the property in 1919. Now using the house as a weekend and holiday home, the sisters are watching their own grandchildren savor the same rural experiences they had here when they were young.

LEFT

The original fireplace has warmed generations, including the current owners, whose parents would warm flannel sheets by the fire before sending the children to bed. The furniture, representing many decades, has been selected for comfort and conviviality. A multitude of patterned hooked and braided rugs cover the floors throughout the house, enlivening the spaces.

the carpenter lived at the house, and she remembers him sharpening his saws every night."

The dwelling is furnished tastefully with antiques and abounds with family memories. "The fireplace in the living room, with its bread oven, is my favorite. When we were little and would come up for a winter weekend, we would eat dinner in front of the fire. Then my mother would hold up flannel sheets in front of the fire to warm them, and then she'd wrap us up in them before we went upstairs to the freezing bedrooms." She continues, "There's a sofa in the living room where four generations have sat and been read to. I can remember my parents reading to me there and reading to my children and my grandchildren there. Likewise, the claw-foot bathtub has seen numerous generations of children be bathed, been the subject of endless child photos, and always reminds us of the generational flow."

It is this sense of continuity that defines the house. "We have been more created by the interior, than creators *of* it. We have left it exactly the way our parents did, and they left it pretty much the way our grandparents did. I guess our vision at this point is to just leave it the way it is, making repairs as necessary and loving the way we feel enveloped in family history when we are there."

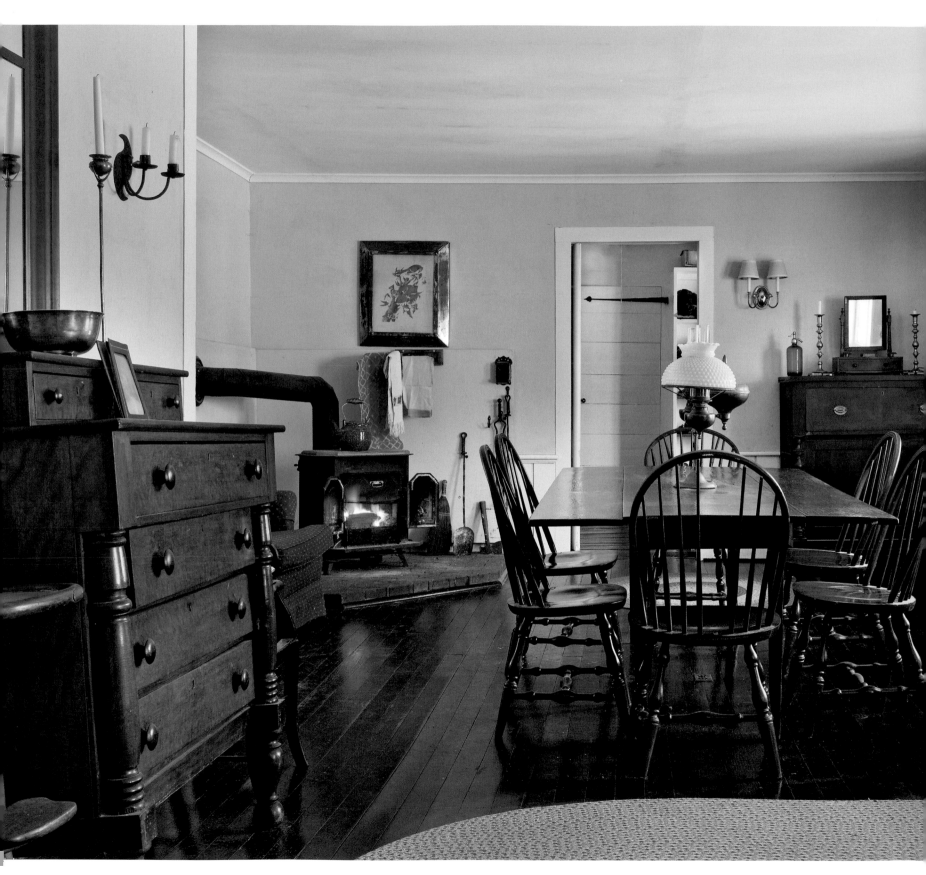

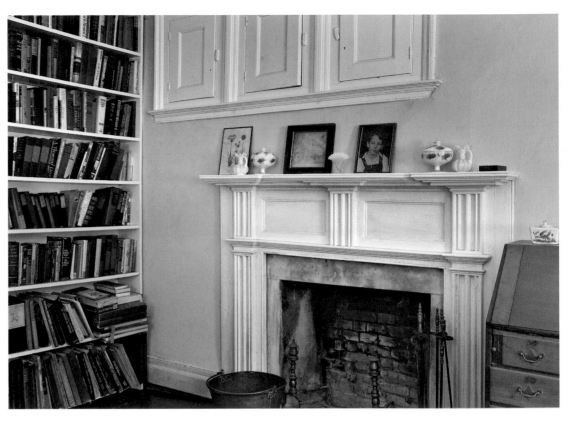

LEFT
A half dozen bow-back Windsor dining chairs surround a wide-planked table in the dining room, and two Empire chests act as sideboards. This room, like many others at Bradford, is heated by woodstove or fireplace. The massive, leather-bound trunk dates from the nineteenth century and retains its original dyed-blue finish and decorative brass tacks.

ABOVE
The bedroom fireplace surround, embellished with reeded pilasters, is a fine example of a local woodworker interpreting Greek Revival style. The cupboards above it utilize voids formed by the chimney framing. The house is filled with books and many of the rooms contain floor-to-ceiling bookshelves to accommodate them all. In a large extended family, favorite volumes rapidly accumulate and are passed down to generations of readers.

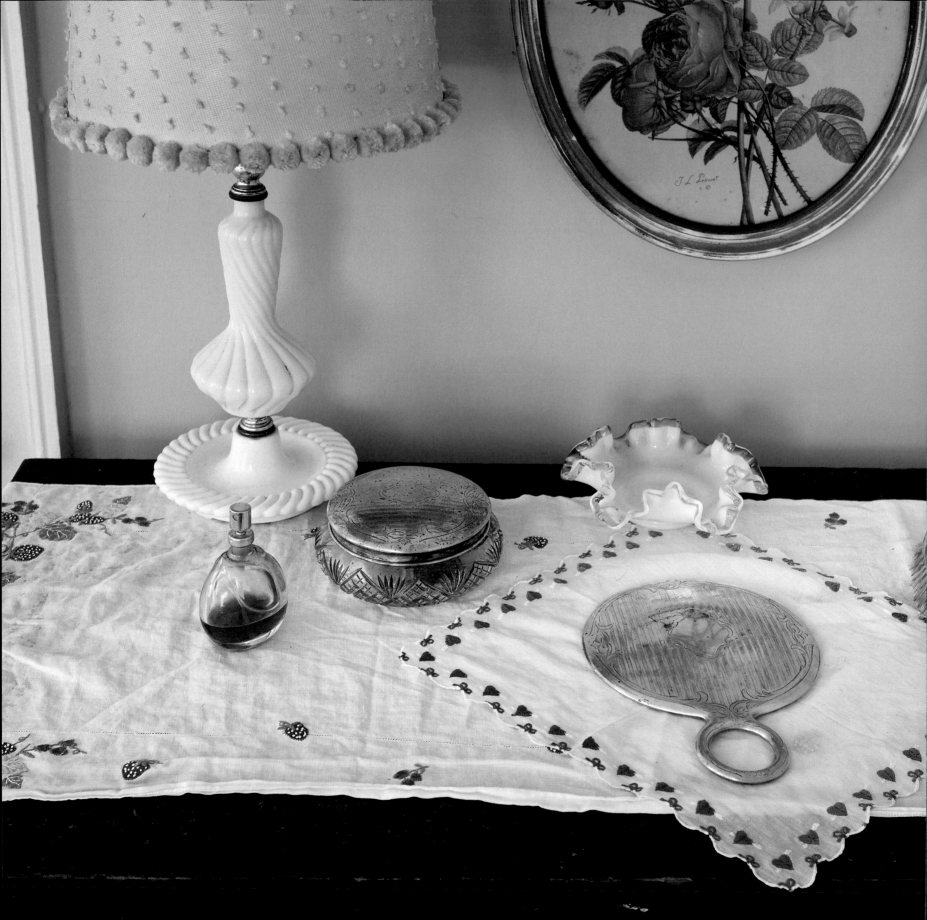

LEFT

The simple act of arranging objects on a dresser top forms a portal to the past. Here, milk glass and a silver hairbrush and mirror set tell a tale of ancestors and their lives.

TOP RIGHT

A handmade quilt sewn in a wreath pattern covers an acorn finial bed in a guest room. The mismatched pillowcases and linens show the comfortable mix of a variety of styles accumulated over the years.

BOTTOM RIGHT

A pencil-post bed and massive Empire chest anchor the master bedroom; all of the antiques have been in the family for generations. The sheathed braces and gunstock posts seen in the corner are a feature typical of post-and-beam houses. These architectural elements protruded into the room and could not easily be concealed with plaster and lath.

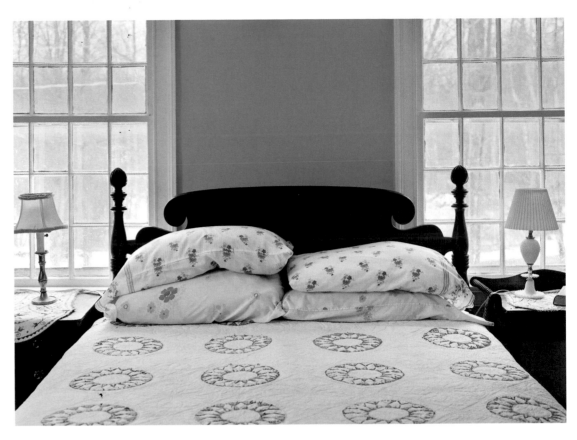

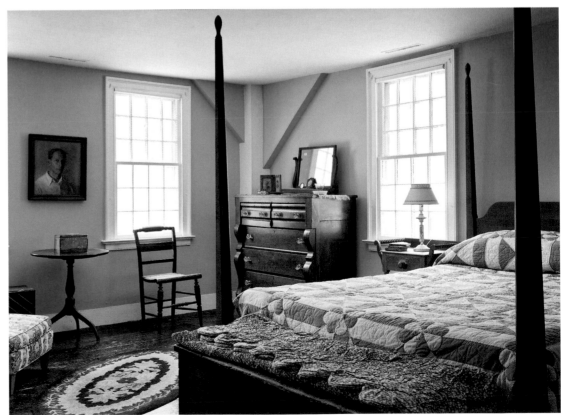

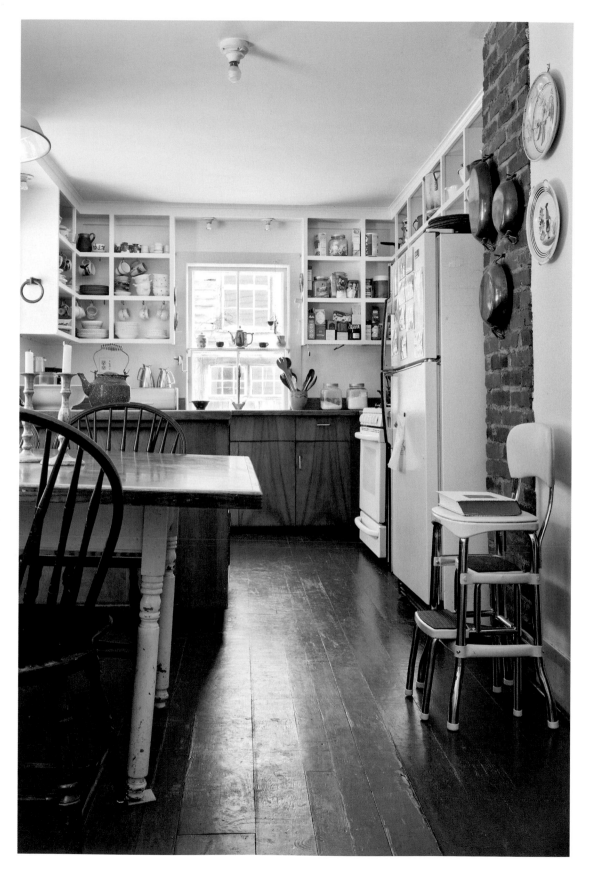

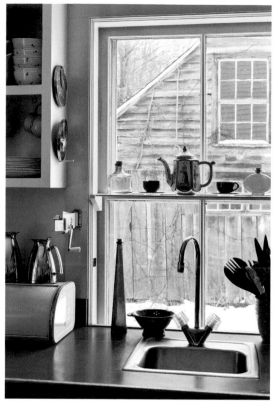

LEFT
The kitchen is the site of countless multigenerational meals; indoor plumbing was late to arrive here, and as recently as the 1970s, water had to be pumped by hand in the winter. Each open cupboard is filled with kitchenware, and the chrome and yellow vinyl step stool from the 1950s comes in handy for reaching the top shelves.

ABOVE
Placing colored glassware in sunny windows is a common practice in many farmhouses; here, amethyst, rose, and turquoise pieces brighten the kitchen with their rainbow hues.

Old barns and outbuildings blend with the landscape as only weathered wood can. Because the family never farmed the land themselves, the outbuildings became a series of playhouses for the children; endless diversions were to be found in each of them. Farms like this one were often purchased in the early 1900s by city families who wanted to spend summers in a more healthful environment.

OLD FARM

While some homeowners go to great lengths designing a dwelling that is evocative of only one specific moment in time, there are others who prefer a more relaxed approach. They are gentler in their persuasion, preferring their residence to reflect their own tastes as well as the aura of those who lived there before them.

Such is the case in this friendly yellow farmhouse in Upstate New York at the edge of an ancient forest. Built in the Federal style with later Victorian embellishments, it is a place of happy circumstance, reflecting each owner's tenure in a cozy mélange of styles. Indeed, the later architectural additions could be considered quaint or naive, yet they are practical and charming. For example, the front bay window, instead of being symmetrically paired, creeps toward an outer corner and brings more light into the house, while the lacy, two-story front porch, an obvious later addition, tempers the austere classicism of the facade.

The current owners, a painter and a musicologist, purchased the property forty years ago, and now reside there with a menagerie that includes a dog, cats, and chickens. "Our dream was to find a house that had a fireplace and a stream on the property; this one has not only the stream, but *four* fireplaces," notes one of the owners. As the couple worked on restoring the very dilapidated house, they were intent upon preserving as many of the earliest features as possible: "One of the pluses was that nobody had done anything for

Porch ceilings have traditionally been painted blue; legend has it this was done to give nesting bees the illusion that this was the sky, and not a suitable site for colonization. Seen in the yard behind the swing is a chicken coop that came with the house, where hens now lay blue eggs for the owners' breakfasts.

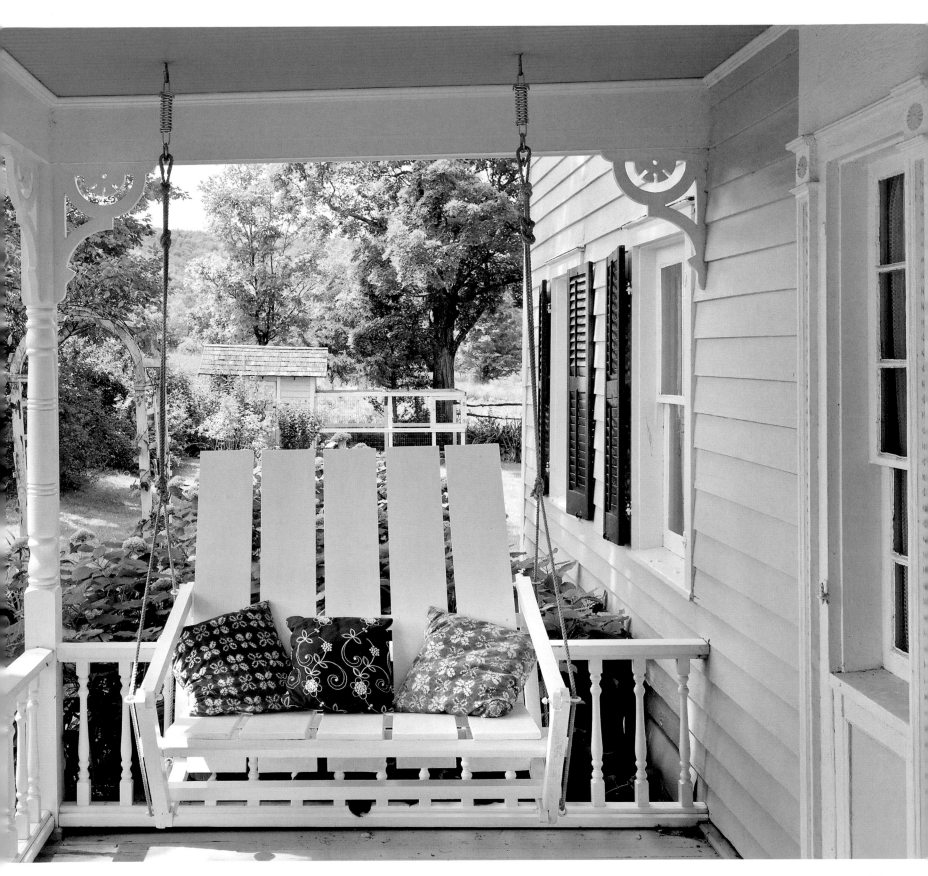

The couple devotes much time to gardening and landscaping. Because the land behind their house was peppered with springs, they were able to create a pond seven years ago. They also built terraced beds retained with fieldstone walls, as well as steps and a patio. The arbor has a grapevine growing over it to provide shade for those sitting at the café chairs gathered around a simple bluestone table the homeowners constructed.

fifty or sixty years, and so we were able to maintain the Federal architecture without excessive renovation. The back of the house was a primitive collection of built-up sheds and shacks with no windows. We removed these and added large windows to take advantage of the magnificent views of fields."

The kitchen retains a rustic flavor with a woodstove, open ceiling timbers, and a plank floor. It is now a place to sit with morning coffee while observing the birds at their feeders and other passing wildlife. A capacious pantry filled with all manner of supplies was constructed out of a passageway that used to lead out to a summer kitchen. The pantry, an essential part of rural self-sufficiency, is used for stocking up on hard-to-come-by items and to house the couple's many well-worn cookbooks.

The house is furnished mainly with hand-me-downs and gifts from family members and friends, along with found objects the couple discovered while walking about the streets of Manhattan. A few items came along with the house, including an iron bed and a large cupboard nailed into a wall that had at least five coats of paint on it.

An eclectic mix of art adorns the walls throughout the house, ranging from the abstract geometrics painted by one of the owners to quirky portraits and still lifes, all executed by people the couple know. There is a true farmhouse feel to the choice of furnishings: simply a comfortable assemblage of pieces, constantly evolving, arranged as if each previous owner has left something for the next.

Throughout Old Farm the owners have created places for pastoral respite. A sturdy arbor, laden with vines, overlooks distant hills and the pond they made, while the sheltered front porch holds rockers and a swing to while away the warmer days. As they sum it up: "Spending time in the garden, feeding the chickens, sitting under the arbor, it's a tactile, visceral experience of feeling connected to times past."

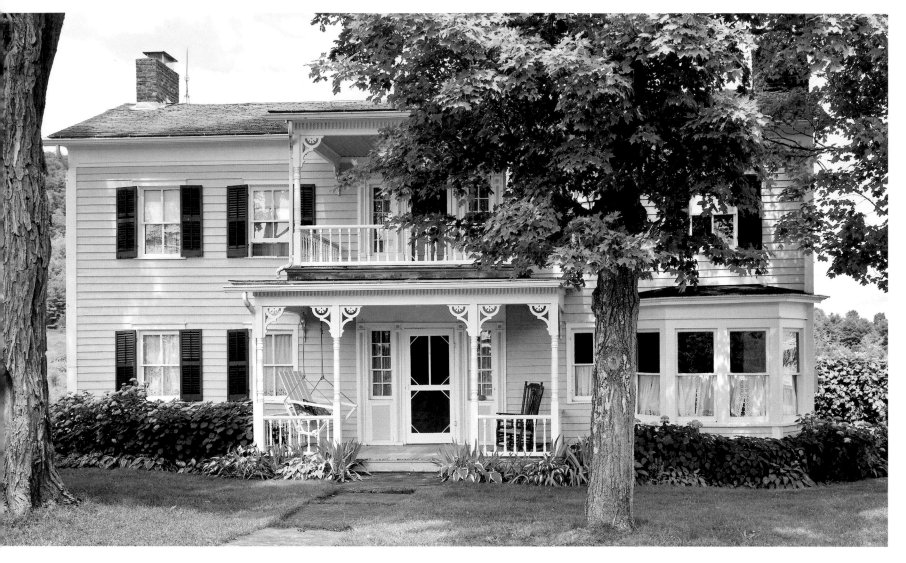

Both the interiors and exteriors of farmhouses evolve over time to suit the tastes and needs of their occupants; this one was built as a Federal-style residence and had first a mid-Victorian bay window and then a two-story gingerbread Queen Anne porch added around the turn of the last century.

The farm's massive gambrel-roofed barn still stands, its wooden siding now weathered to gray. It is increasingly rare to find these largest of outbuildings, as fewer farmhouse owners keep sufficient livestock to warrant their maintenance.

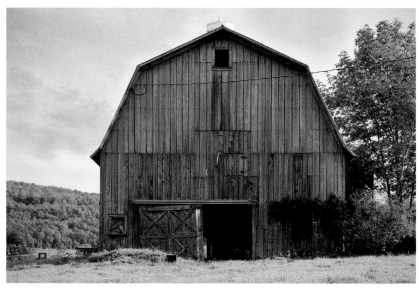

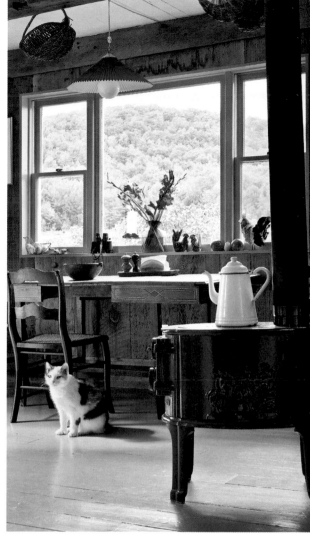

ABOVE LEFT
A well-stocked pantry is a critical part of every farmhouse kitchen; this one is no exception. One of the main satisfactions of farm life comes from the ability to make provisions for the future. Having a large supply of canned goods on hand is a necessity in remote rural areas.

ABOVE RIGHT
The simple, barn-boarded kitchen is heated by a Lange stove from Denmark. The room is furnished with an oak table that once belonged to one of the owners' grandmothers.

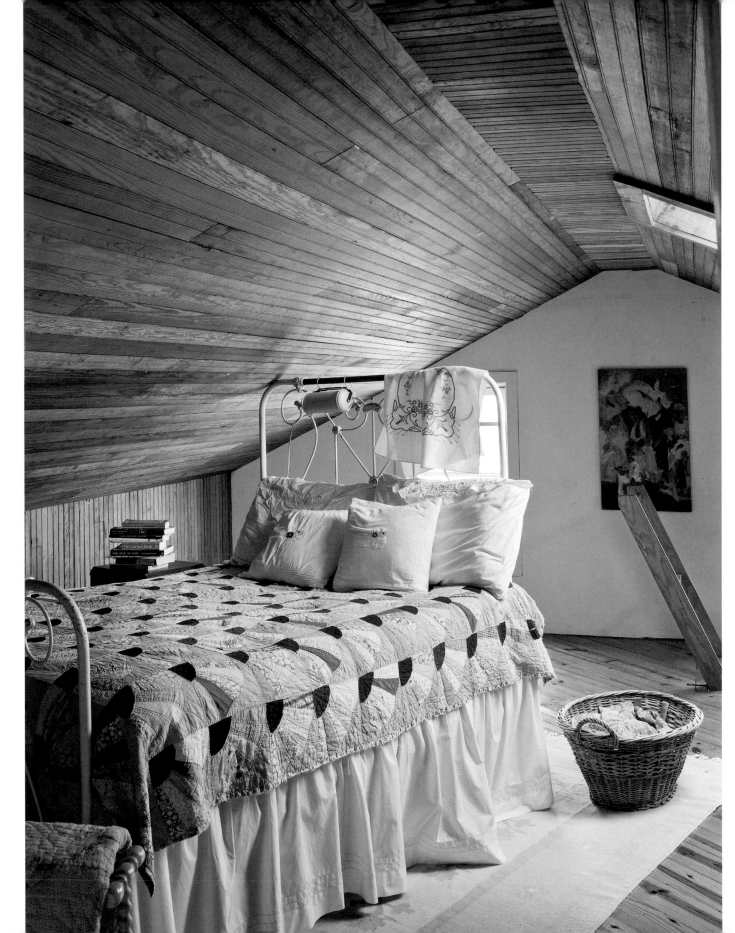

An upstairs bedroom is sheathed in wainscoting and illuminated by a window and a skylight. The antique iron bed, which came with the property, has a vintage light fixture attached to the headboard for evening reading pleasure. A ladder stair leads down to the kitchen below.

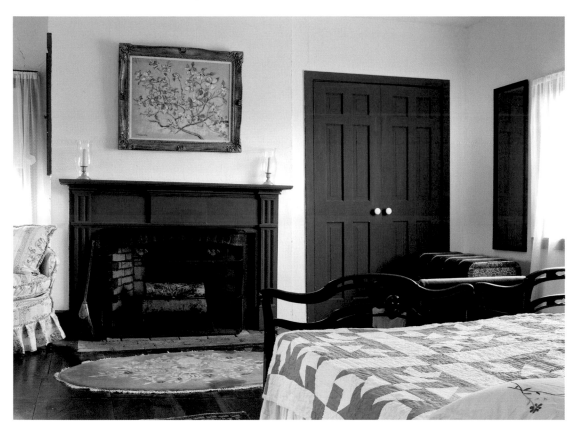

TOP
Various shades of blue and pink in the sprays of dogwood in the painting above the mantel are mirrored by the colors in the floral-patterned hearth rug.

BOTTOM LEFT
A mahogany Colonial Revival rocking chair, complete with carved feet, presides over the parlor. The paneled front door, painted yellow and white, is original to the house.

BOTTOM RIGHT
Vintage perfume bottles and cosmetic containers form a still life on a bedroom dresser.

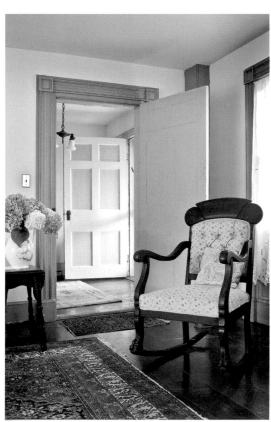

THE FARM AT MILLER'S CROSSING

Many farms, unfortunately, seem to drift away from their original purpose; the families die off, tire of the arduous lifestyle, or succumb to the economics required to keep a small farm profitable. The farmhouse remains as mute testimony to the past, overlooking the now dormant fields. There are exceptions, of course, where the land has been constantly worked, but rarer still are the farms that have lapsed only to reestablish themselves as viable enterprises later.

In a small Hudson Valley hamlet, the home and farm of Jim and Meg Cashen has undergone just such a rebirth. The Cashens moved from Long Island to this former dairy farm once operated by Jim's parents and his brother Anthony, raised a large family, and then approached retirement. The property's agrarian days seemed permanently past, but then one of their sons, Chris, and his wife, Katie, decided to pursue their passion for organic farming and began working the fields once again.

Today, the two-hundred-acre Farm at Miller's Crossing grows certified organic vegetables and flowers, raises a small beef herd, and supplies local farmers' markets and restaurants as part of the Hudson Valley's burgeoning farm-to-table movement. It is also a community-supported agriculture (CSA) farm where people join together in paying a membership fee at the beginning of the season that supports the buying of seeds and the expenses of planting

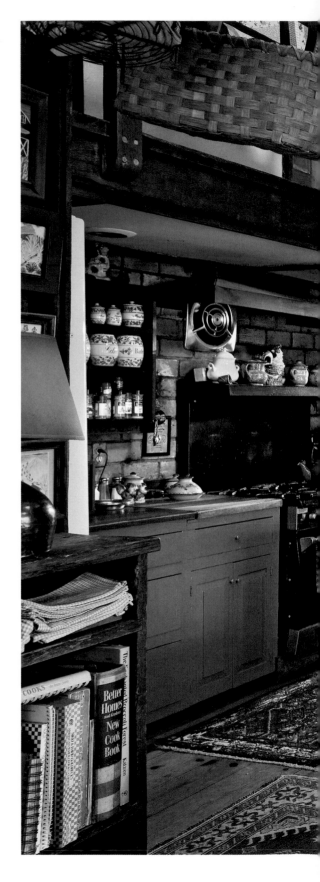

When the Cashens moved in, the existing mid-twentieth-century kitchen was insufficient for their large family. Adding to the house, they salvaged the lumber from an old barn and created a more than ample new high-ceilinged kitchen that is sympathetic to their home's original architecture. Above the main floor is a loft walkway that leads from the kitchen to additional sleeping areas.

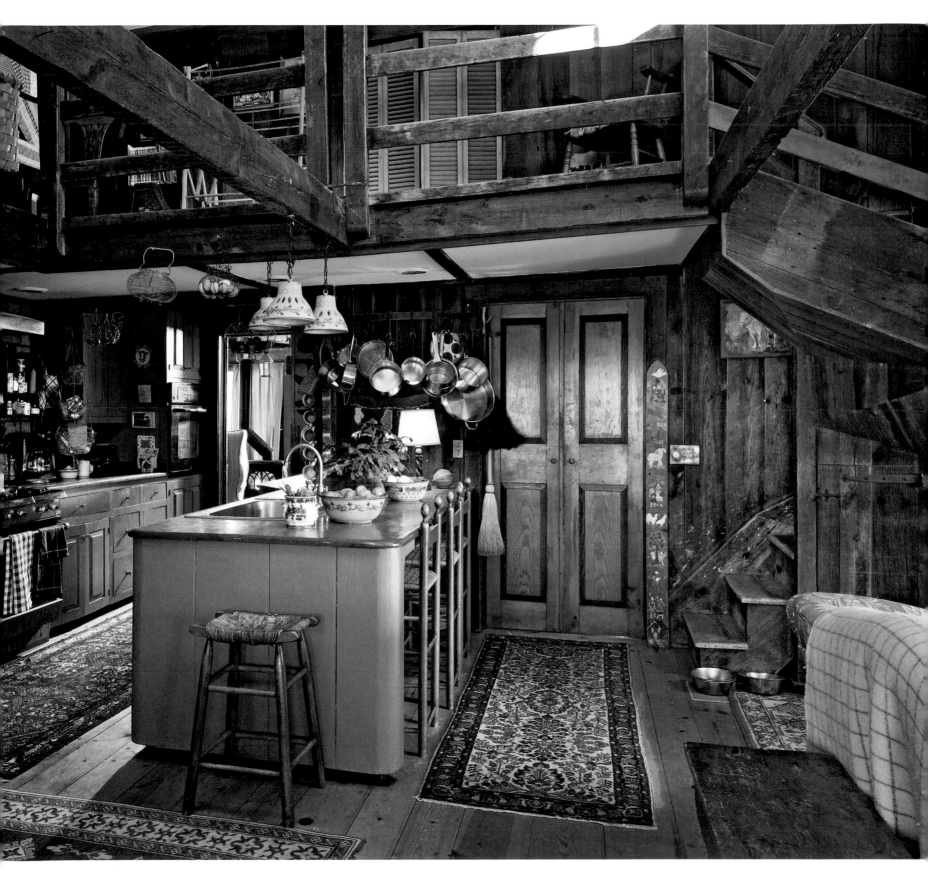

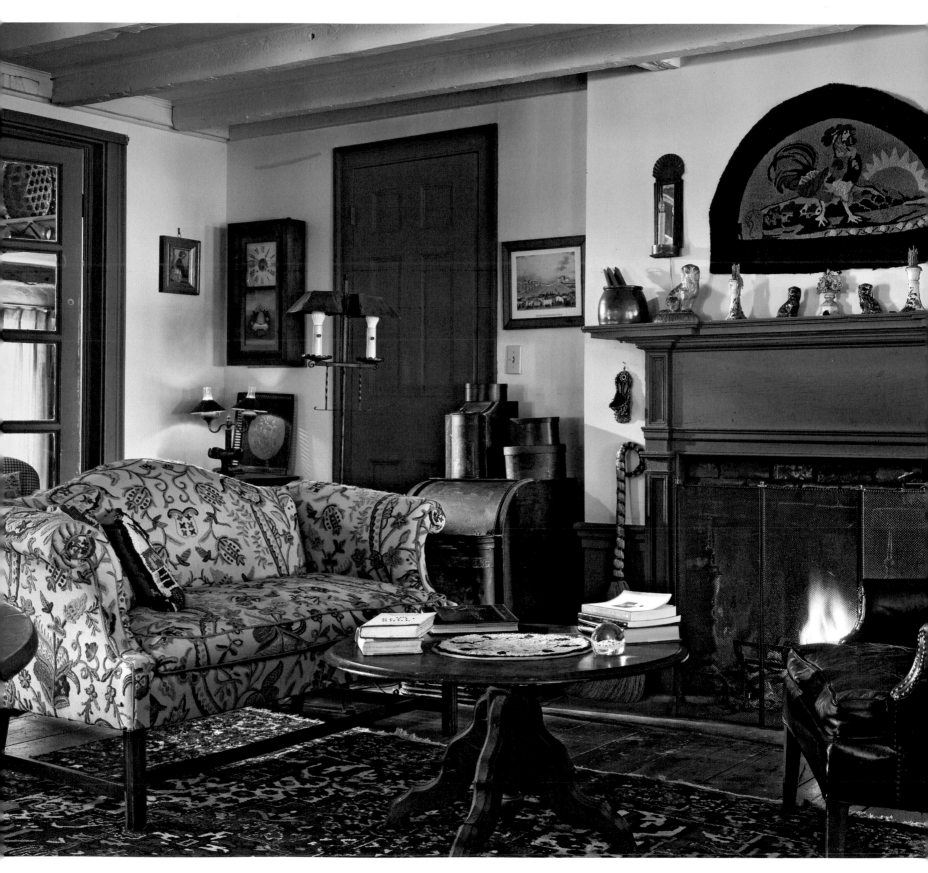

The Cashens' sitting room furnishings reveal a long-term love of visiting antique shows and estate sales. Above the mantel is an unusual arched hooked rug with a crowing rooster worked into the pattern. The overall scheme is Colonial with subtle Victorian touches, and combines pieces from many decades in a cozy, unified way.

a crop, and then receive produce throughout the growing season in return. From the early spring, when baby arugula, collards, mesclun, and other lettuces start to come in, to late November, when everything from carrots to daikon, celery root, kale, potatoes, onions, and cabbage fill the fields, four generations of the Cashen family continue the tradition of an extended family working the farm.

The original farmhouse, built during the 1820s, is a simple structure with Greek Revival aspirations. For the front hall, the couple commissioned a painted mural depicting the farm and the Hudson River. Rendered in the manner of the great itinerant muralists of the late eighteenth and early nineteenth centuries, it lends a harmonious backdrop to the historic design of the interior. Here, the couple have anchored their rooms with such perennial favorites as wing chairs, primitive chests, and cabinets, and have ornamented the walls with pictorial hooked rugs and mirrored tin sconces. The mantels and shelves were augmented over time with daguerreotypes of family members, odd bits of china, and other mementos.

The kitchen is a large, barnlike space that is comfortably functional and rustic. "When we inherited the house, it was a very dated renovation from the 1960s," Meg notes, "and it was just too small for such a large family. We took down one of the old barns on the property and reused the timbers and siding to create a room that ties in to the old part of the house." The rough lumber has been artfully used to create a loftlike area with a stairway to the upstairs bedrooms. Skylights keep the kitchen bright during the day, and Meg frequently cooks large meals, using the family's own produce and herbs, for family, friends, and the farmworkers, who often live in the house during the busy season. People often stop by, and a friendly group of farm dogs is let in or shooed out, the lucky ones curled up next to the woodstove in this very comfortable house.

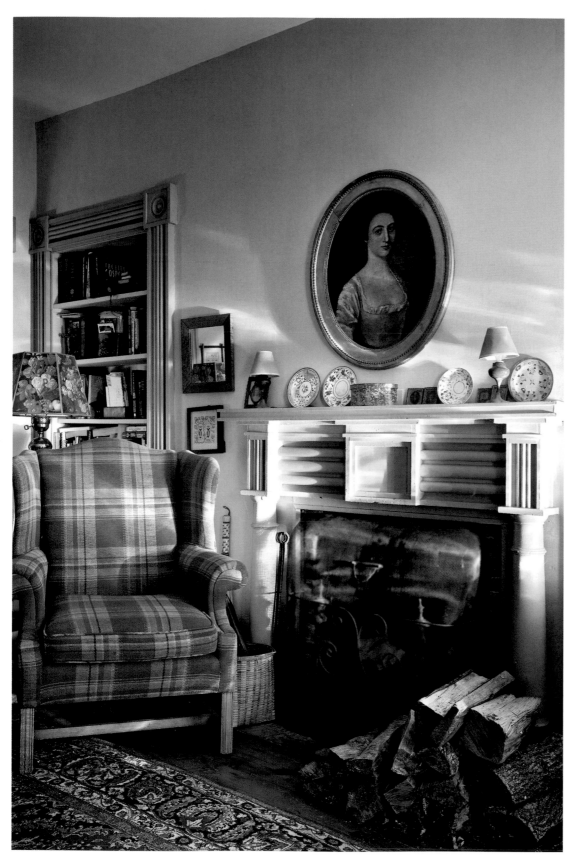

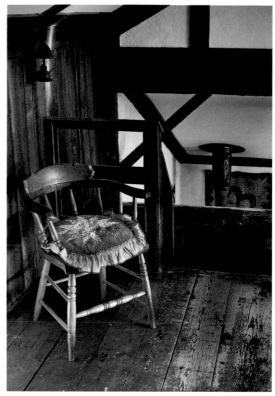

LEFT
In the master bedroom, the intricate Greek Revival mantel and woodwork are a fascinating example of how architecture was individually interpreted in rural areas during the eighteenth and nineteenth centuries. Carpenters often worked within a narrow region, and indigenous variations emerged.

ABOVE
In the loft area that overlooks the kitchen sits an old armchair with a quilted cushion. It provides a quiet spot for reading or reflection, away from the hubbub of farm life.

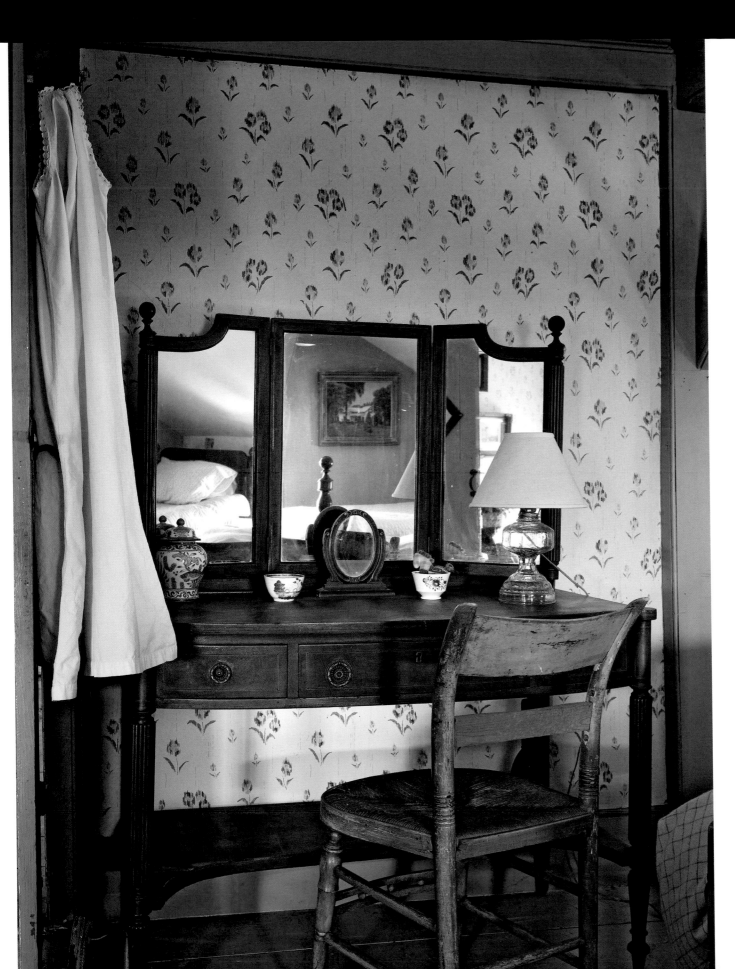

Colonial furnishings have long been associated with farmhouse style; here, a mahogany Sheraton Revival vanity from the early twentieth century is paired with a thumb-back Windsor chair that was crafted a century earlier. The wallpaper pattern is derived from antique block prints, which often featured simple, bright florals in short repeats.

151

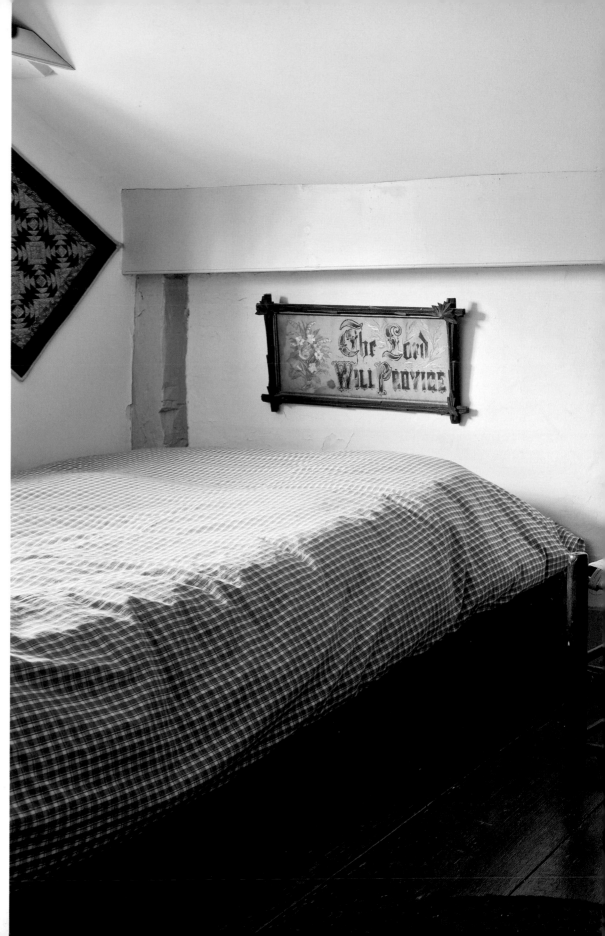

ABOVE

A graduated chest of drawers fitted with Chippendale willow pulls retains its old red finish. Often termed "primitive," these pine pieces were simply painted or embellished with graining to emulate more expensive hardwoods like tiger maple, mahogany, or walnut. The hand-hooked rug is of a nostalgic winter sleighing scene.

RIGHT

There are numerous bedrooms in the Cashens' home and all have seen steady use, first with their children and now with farm workers who reside there during the growing season. In the foreground, a single bed is tucked into a gable. Hanging above it is a perforated paper sampler from the 1880s in a rustic walnut frame.

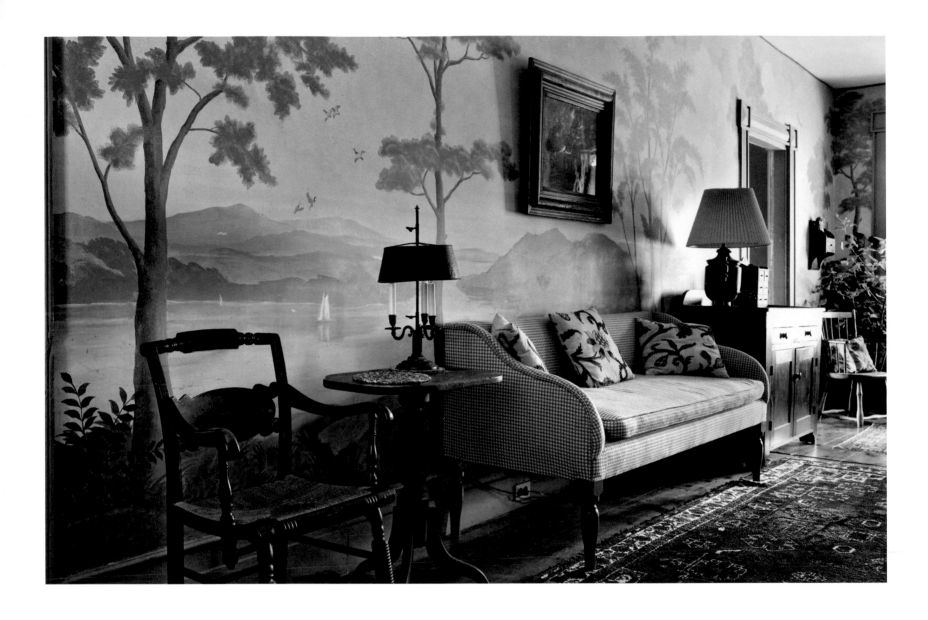

The sweeping hand-painted mural, which was commissioned by the Cashens, depicts the house and its environs in the Hudson River Valley. Murals and family portraits painted in a naive or vernacular style were traditionally created by itinerant artists in rural areas.

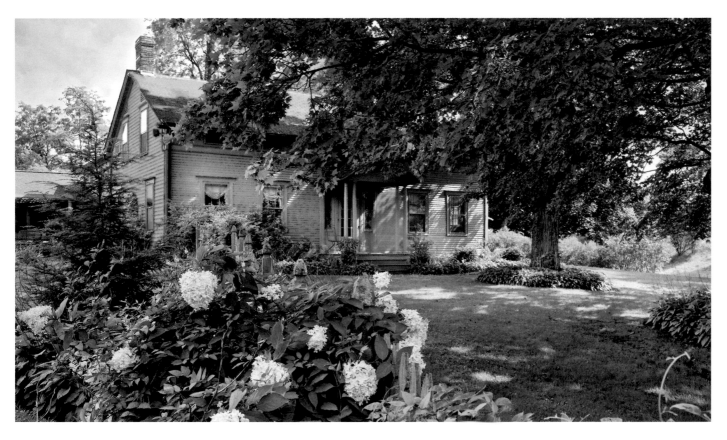

Instead of facing the road, the Cashens' 1820 farmhouse is oriented toward the old Albany–Boston railway line. The train stop was known as Miller's Crossing, which lends the farm its present name. Pre-automotive farm life often revolved around railroads or waterways, explaining why a property's location might be far from a present-day highway.

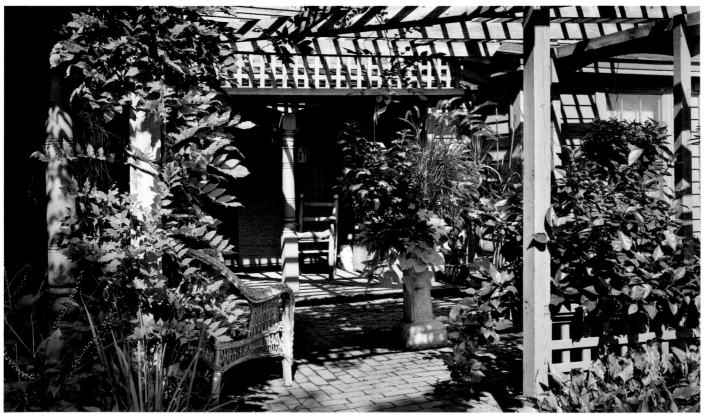

This ample pergola provides extra space for outdoor leisure. Whether freestanding or attached to the side of a building, these architectural devices have long been used as a transition from inside to outdoors, and when covered with vegetation, they offer cooling partial shade and dappled sunlight.

HARRISON FARM

Old farmhouses are never static; they must constantly adapt to the needs of those they shelter, accommodating advances in technology and changing times. Sometimes, these changes in architecture and design are a quiet evolution, an imperceptible shift over the passing of time, but at other times these transitions are sharp and clear. A concise time line of three distinct styles during the tenures of three different owners awaits us in Connecticut's Litchfield Hills. The house was built by a family of subsistence farmers named Harrison, eventually grew to become a dairy farm, and finally became the spacious, light-filled home of two artists. The three stages are seen in the original structure dating from 1790, with central fireplace and post-and-beam framing; the larger 1830s Greek Revival addition with classical ornamentation; and finally, a modernist renovation of the 1790s that acknowledges the house's history but meets the needs of contemporary times.

The current owners—Tim Prentice, an architect and sculptor who creates kinetic art, and his wife, Marie, a potter and poet—are only the third family to occupy the house; each of the aforementioned iterations is unique to one family's tenure. When the couple purchased the house in 1964, there was no indoor plumbing and only minimal electrical service. Aside from bringing the systems up to modern standards, they have made minor additions to enlarge the kitchen and create a first-floor bathroom.

The sitting room is a study in classic American furnishings paired with Tim's kinetic sculpture. The warm wood tones of the former provide a counterpoint to the contemporary lines and colors of the latter. Throughout the house, there is an affinity between the early American directness of line and serviceability and the straightforward functionality of more modern design.

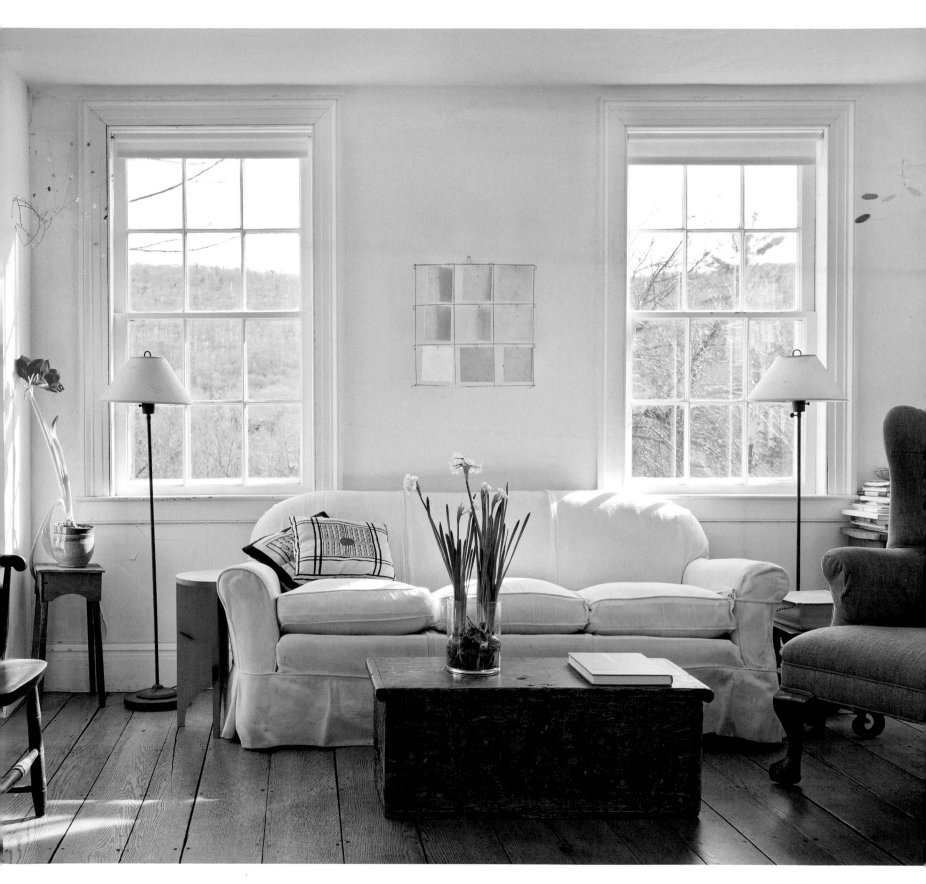

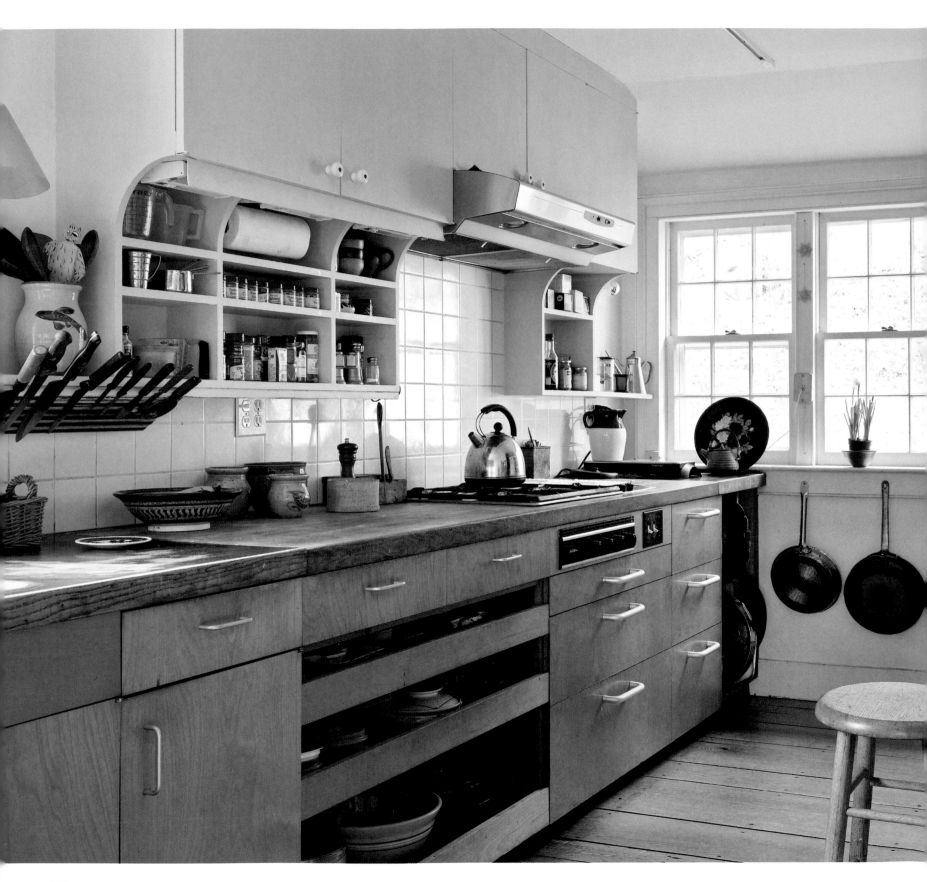

The kitchen is composed of many open shelves and racks, allowing quick access to utensils and pans. While not spartan, the room is a study in utilitarianism, with no extraneous flourishes on the cabinetry. At right, the orange counter with a draw-front writing surface also serves as a desk.

It was in the eighteenth-century section of the house that Tim, as architect, made his mark: "All the rooms are as we found them except for what is now the living room. This section was initially four small rooms downstairs and two upstairs. We opened it up and added a sleeping loft with a view of the old icehouse, large dairy barn, and mountains beyond."

In the eighteenth century, as now, the common rooms were typically multipurpose: the kitchen became the dining area with the push of a table; the best room, or parlor, would contain a bed. In deference to this, when opening up the older section, Tim designed the space to serve a variety of needs, all based around the central fireplace with its four sides. There is an office behind the fireplace, sitting rooms on either side, and a small loft bedroom above.

Conversely, the early-nineteenth-century part of the residence is comfortably traditional. There are large, elegantly simple fireplace surrounds and solid door and window casings. "The three fireplaces in the newer portion are fitted with unique iron castings," Tim adds, "which suggest a Franklin stove but are backed with masonry." Another architectural quirk is the small cupboards built into several chimney walls; these were common in old farmhouses for safely storing valuables such as family bibles and deeds.

Starting in the Depression era, many artists and sculptors were drawn to these old farmhouses and barns, which offered generous and inexpensive studio space along with the promise of solitude and the quiet beauty of a rural setting. The Prentices set about devising the house's interior and outbuildings to accommodate their work: Tim's kinetic sculptures are created in the converted icehouse and hang from the high ceilings in the main house, while Marie works on her pottery on the porch overlooking the meadows and distant hills, Tim's sculpture winking in the woods.

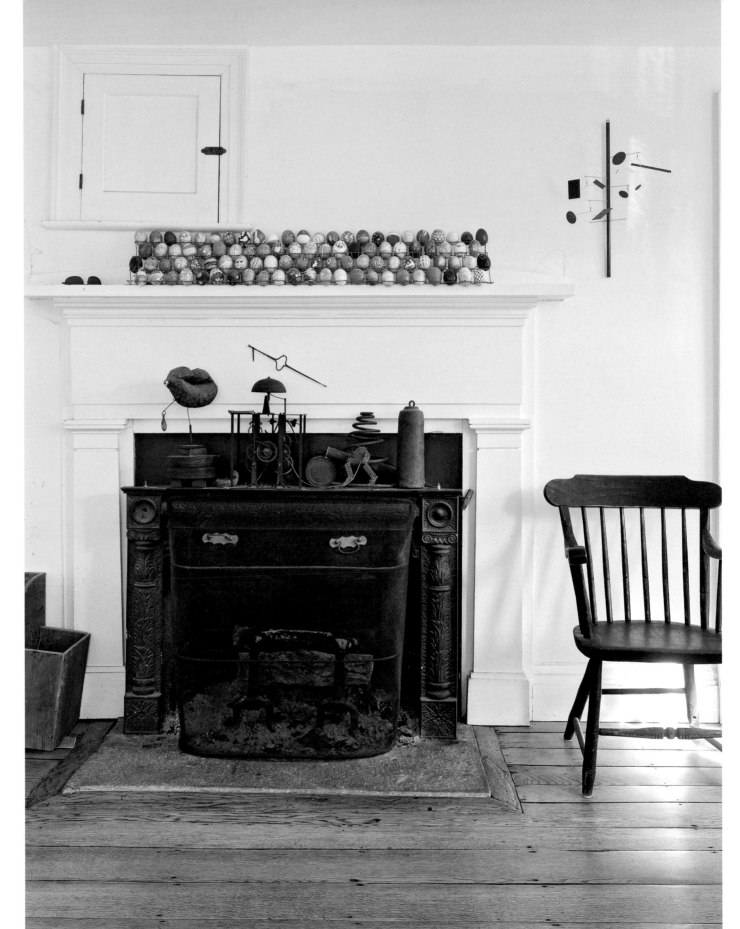

In the sitting room, the fireplace is fitted with unique iron castings suggesting a Franklin stove, topped with old clock parts and other sculptural items. The Greek Revival fireplace mantel is embellished with polychrome eggs that the family dyed over the years, later arrayed as an installation by Tim. The small cupboard at upper left is one of several "bible cupboards" found in the house.

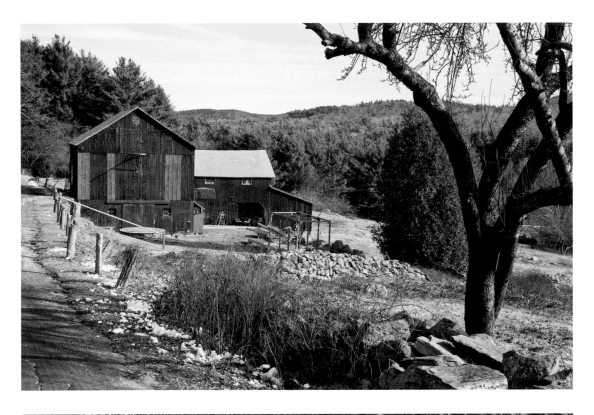

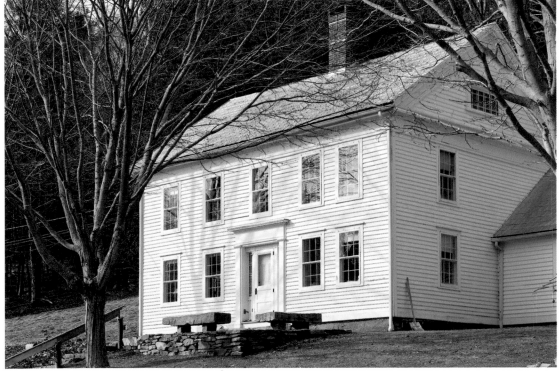

TOP
The big red dairy barn sits across the road from the house. The Prentices are fortunate to have many original outbuildings on the property. They removed some walls from a smaller barn near their pond to repurpose it as an outdoor living room, while an old icehouse is now used as Tim's art studio.

BOTTOM
Located in northwestern Connecticut, the Prentices' center-entrance Greek Revival farmhouse stands on a hillside, above the road and overlooking the fields.

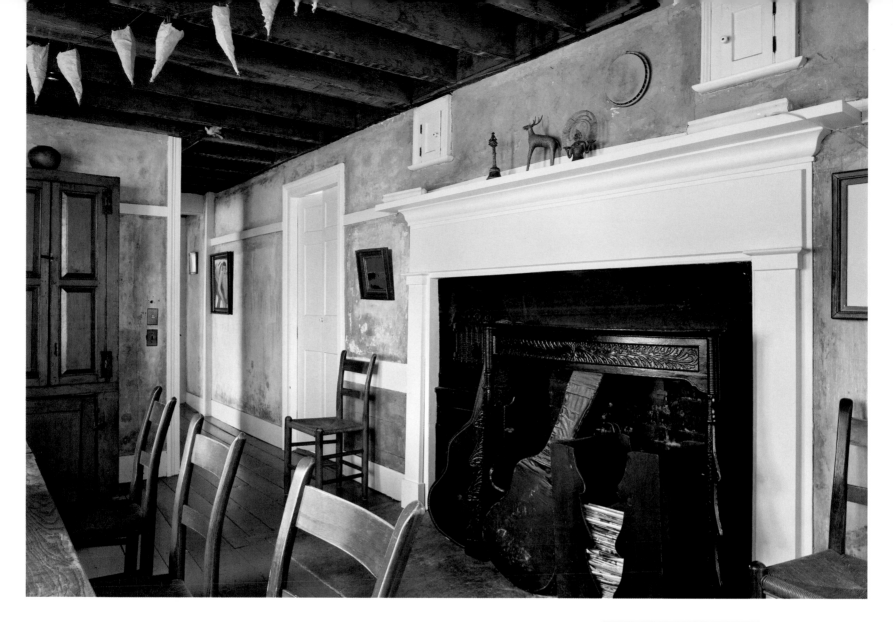

ABOVE

The rustic feeling of the long dining room has been accentuated by tinting the old plaster walls and exposing the ceiling joists. Two guitars lean against the handsome fireplace; in the past, the couple performed as a folk duo.

RIGHT

In a bold move, Tim, an architect, removed the interior walls of the eighteenth-century section of the house, a feat made possible by the post-and-beam construction, and exposed the old-fashioned center chimney so that each hearth was visible.

A late-Victorian piece has been cut down for use as a coffee table and set next to a mushroom-capped Shaker rocker. Delicate, airy sculptures break up the flat planes of the walls.

The striking open staircase reveals the basic framework of the treads; this in turn resonates with the visible posts and beams of the farmhouse. The couple is partial to strong colors set against white, as seen in the orange sofa and blue lamp with a shade made of recycled plastic milk jugs.

SYLVESTER MANOR

There are not many farming estates in North America whose history may be traced back through eleven generations of a single family still farming there. Sylvester Manor, situated on Shelter Island, New York, is such a place; additionally impressive is the fact that it remains a working farm today. Now encompassing 243 acres, the property originally spanned all of this entire 8,000-acre land mass, which is located between the eastern forks of Long Island.

The manor house, constructed in 1735, has several outbuildings; one of the most notable is a wind-powered gristmill that was built in 1810 and moved by barge to the island in 1839. As the manor's landscape was described in a 1923 address to a historical society, "It was like a Southern estate with its row of outbuildings—the granary, the woodshed, the icehouse, the smokehouse, the corncrib, the stable, the henhouse and poultry yards, the carriage house and piggery." Today, there is a privy, still standing, constructed in the same Georgian style as the house.

Sylvester Manor has a storied agrarian past. Before its European owners started farming it in 1652, the land was a Native American encampment, where it is believed that corn, squash, and beans were grown and stored in grass-lined pits. The first European settlers developed the land as a provisioning plantation; during the Enlightenment, it became a farm, and then later was the home of one of the first American food industrialists, Eben Norton Horsford, chemist,

The elegant woodwork, with its intricate carving on the pilasters and arched casings, has only been painted twice in its history. The fireplace surround is covered in blue-and-white Delft tile. A family portrait from 1810 above the mantel shows Mary L'Hommedieu Gardiner, aged about four, with a blue-and-white creamware fruit dish that is still in the family's possession.

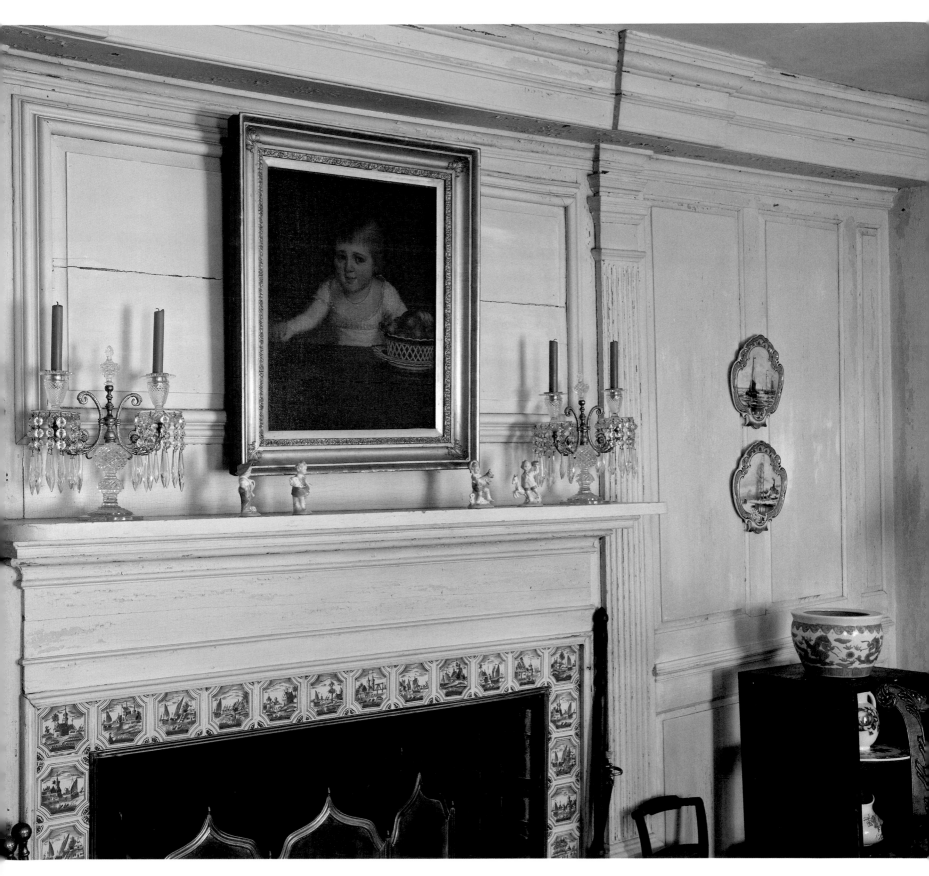

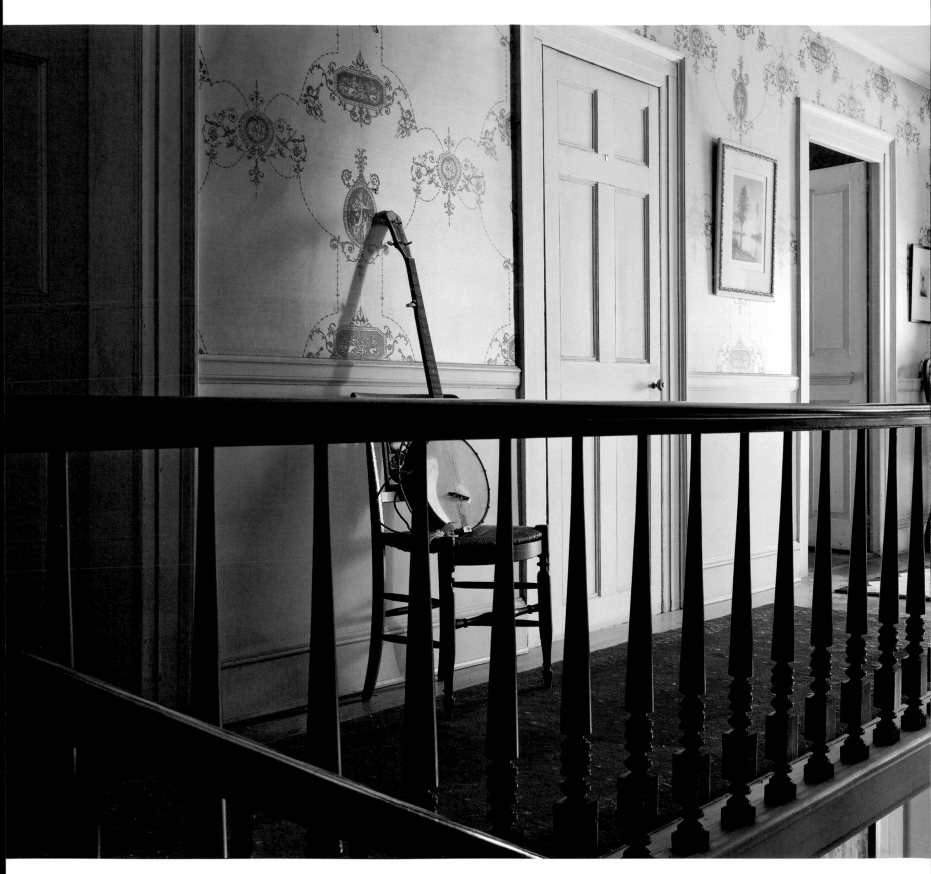

In the long upstairs hall, the sound of banjos and guitars can frequently be heard. Bennett Konesni, a descendant of Nathaniel Sylvester, is a musician with a love for folk and bluegrass music, and he has established a program of concerts and workshops. Visiting musicians, poets, and artists often stay in the several upstairs bedrooms.

Viking scholar, and the inventor of a greatly improved baking powder. Today, the estate serves as an educational farm that produces fields of flowers and organic fruits and vegetables. There is also a farmstand that offers organic produce to local residents.

The sprawling Colonial-era structure contains many original possessions of the family members who have resided here. The parlor, with its exemplary woodwork and Delft fireplace tiles, is striking; as Bennett Konesni, who represents the eleventh generation of his family, notes, "The paneling is original to the house, and has been painted only twice in that time."

For all of the preservation efforts and the presence of so many fine pieces of decorative art, Sylvester Manor is not a stiff, static place; objects from each generation happily coexist. There is a consistency to the interior, because everything here, regardless of age, is a cherished possession, accumulated over time and handed down to the subsequent owners.

The gardens at Sylvester Manor, which include corridors of the nation's oldest boxwood, are being restored to their former glory. Alice Fiske, who moved into the manor house in 1952 as a newlywed, found a garden that had lain fallow long enough to go wild, with catbrier and bittersweet running amok. Alice would point out to visitors the garden beds where Grissell Sylvester might have planted her seventeenth-century kitchen garden of onions, herbs, fruit trees, and dye plants.

Today, visitors can experience the revival of the gardens and learn about the arts of field, kitchen, and table and how they are connected. As Bennett says, "It is about farmers and eaters bringing joy to their kitchens. It is about learning to sing in the fields and tell great stories around the table, all creating a cultural landscape that is joyful, meaningful, and fair."

The grand Georgian residence known as Sylvester Manor was constructed in 1735. Today, it remains the center of a working farm that encompasses 243 acres of fields, forests, gardens, and estuaries and dates back to 1651, when Nathaniel Sylvester and his family first arrived.

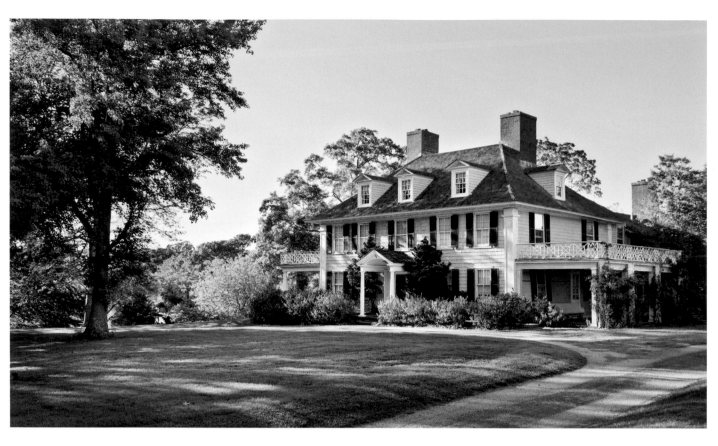

Relocated to Shelter Island in 1839, the shingled windmill, now missing its sails, was the gristmill for farmers on the island. Built in Southold, New York, in 1810 by the carpenter Nathaniel Dominy V, the mill's octagonal body was dismantled, loaded onto a barge, and floated to Shelter Island. The windmill stands now in a field of cosmos, amaranth, zinnia, and other flowers, which are sold at the manor's farmstand.

LEFT
Sylvester Manor is still a working farm, and goats share the land with chickens. As a provisioning plantation, the manor originally grew food and livestock and provided timber for the Sylvester family's sugar plantations on Barbados.

ABOVE
Reached by a steep, winding stair, the eaves atop the house hold remnants of the fashions and furnishings of the eleven generations who have lived here. Amid the worn, whitewashed boards of the attic are wicker-covered demijohn bottles that were used for wine or cider.

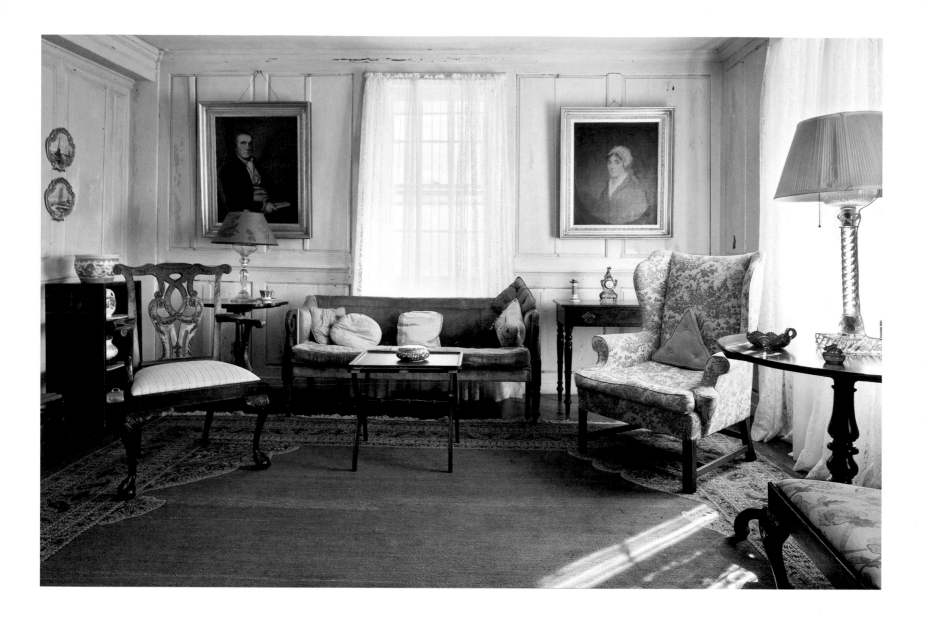

The furnishings of the parlor display an array of eighteenth- and early-nineteenth-century styles. On the raised-panel walls hang portraits of ancestors. The antique mahogany furniture includes a Chippendale carved armchair and piecrust table.

LEFT

While most privies and outhouses were a humble assemblage of planks, the surviving one at Sylvester Manor was constructed in the same Georgian style as the house.

TOP LEFT

In a dormer window in the attic, a prim set of ruffled curtains hangs solely for the benefit of those viewing the house from the drive.

TOP RIGHT

In the library, traces of each generation through the centuries are visible in the form of furniture, numerous leather-bound books, prints, engravings, and memorabilia.

A Victorian angel print, framed in gilt oak, hovers over a single bed covered with a tufted spread and pillow. The wallpaper and tied-back draperies date from the latter part of the twentieth century. Although these furnishings are more recent than what we consider antique today, they will be antique in their own right soon enough, and their presence will become a part of the estate's history.

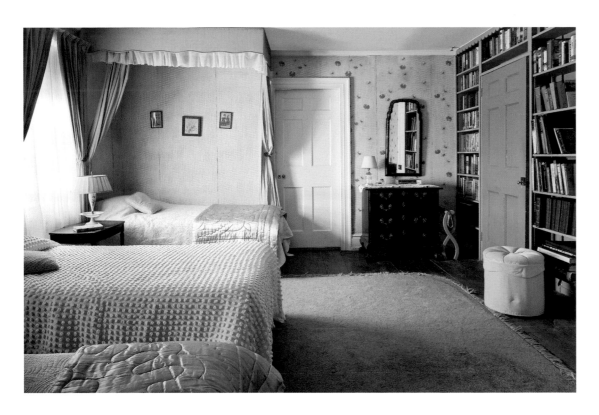

In many farmhouses, if the room was large enough, three or more beds would be found in a bedroom to accommodate children, visiting relatives and friends, or perhaps workers and boarders. This bedroom is furnished with a comfortable mix of chenille and Chippendale.

BOTTOM

This sunny bedroom is furnished eclectically with an Empire bureau and its matching ogee-framed mirror, a late Victorian rocking chair, and an upholstered chaise longue. These pieces are accompanied by lilac-motif wallpaper, once a popular choice for farmhouse bedrooms.

SADDLEBOW FARM

Bridgewater, Vermont, is nestled into the Green Mountains, and there we find Saddlebow Farm, the lifelong residence of Coleman (Bill) Hoyt and his wife, Cecilia. Bill maintains a keen interest in agriculture, forestry, land conservation, and Vermont history, and has documented his family's farm from its very origins: "In 1779, the land was granted to Asa Jones, the town's first pioneer settler. Jones sold it in 1786 to Joseph French, a Revolutionary War soldier, who built the house shortly thereafter. By 1815, it was approximately 190 acres, and the French family occupied it until 1845, when it consisted of 140 acres, which is its acreage today."

From 1845 to 1931, the property passed through several families and was steadily farmed with a wide variety of livestock, crops, and timber, as were most self-sufficient Vermont hill farms of the era. It was sold in 1931 to Mrs. Frances Weed; she converted the farm to an inn that catered to skiers, who were flocking to the area to try out the newfangled innovation of being pulled up a tow rope by a Model T Ford engine at America's first mechanized ski slope.

The Hoyt family's tenure, which is the longest of any owner, began in 1937 with Bill's parents. Shortly thereafter, in 1941, Saddlebow Farm became a United States Army encampment in the summer before Pearl Harbor. Bill eventually bought out his three older brothers in the 1960s and took sole ownership of the farm. "I ran it as a family ski lodge and summer home until the early 1970s," he says,

Much time is spent in the "outdoor living room," a four-season room heated by a woodstove inserted in the fireplace and fitted with removable doors. The massive mantel employs a boulder as the arch's keystone, a unique touch. Around the fireplace and on the walls, iron woodworking tools and the implements of the many different kinds of farm chores are displayed.

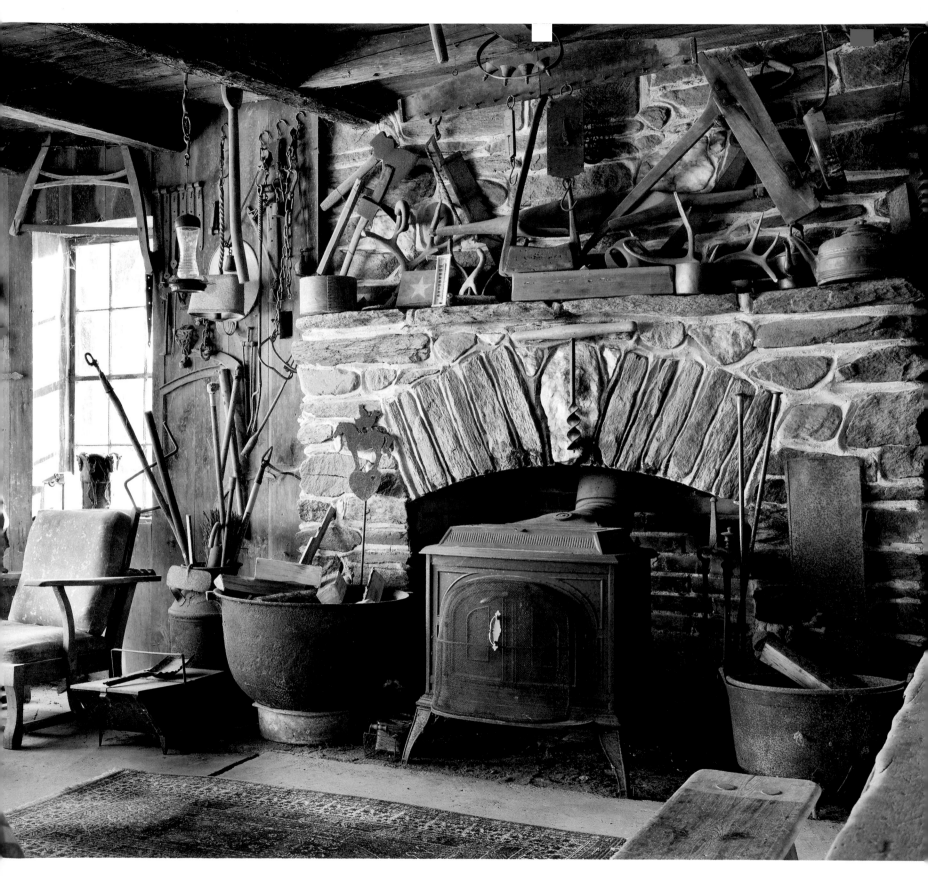

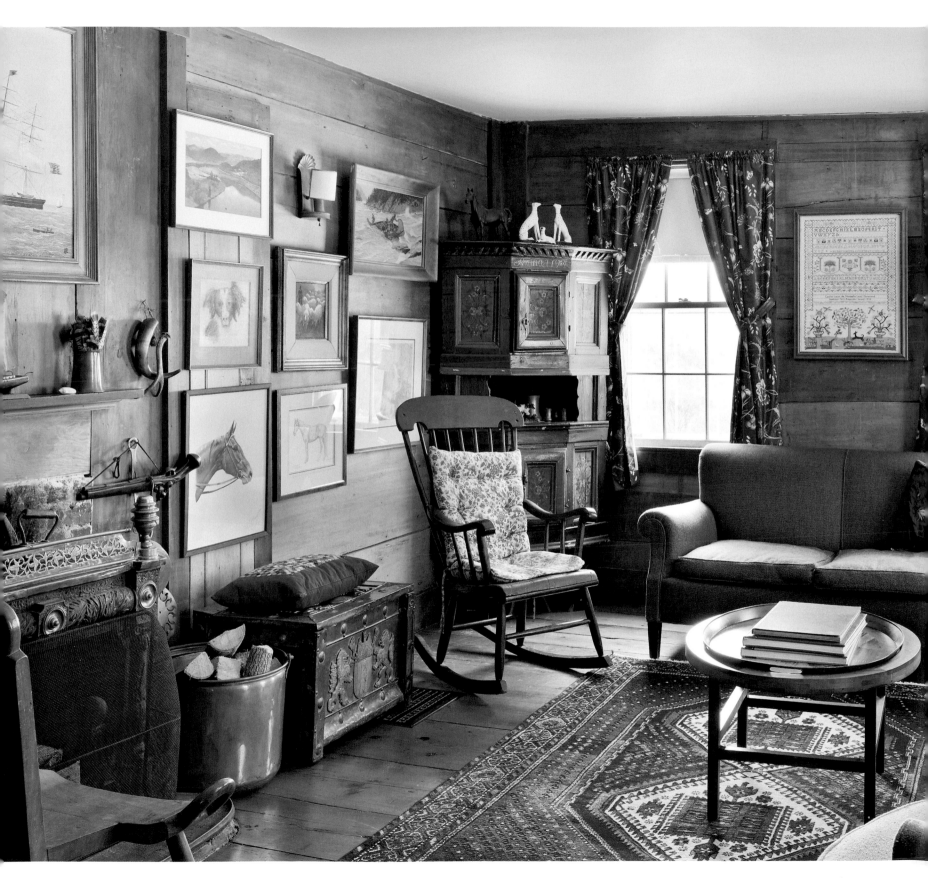

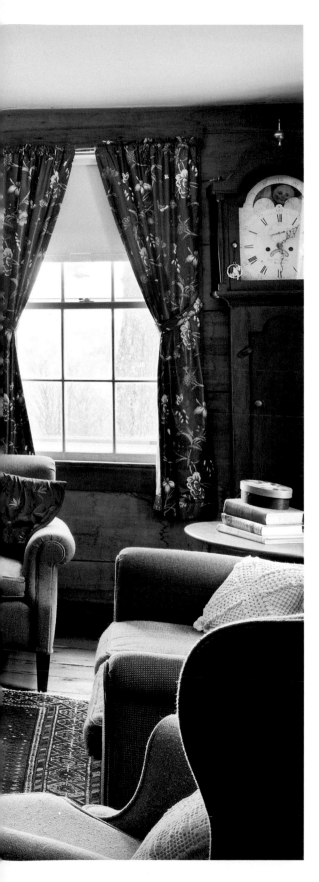

Saddlebow has been in the Hoyt family since 1937, and the walls are covered with prints, paintings, and samplers that depict the farm's history. Although originally painted, the stripped plank walls impart an intimacy to the best parlor, and the antiques are heirloom pieces that convey a sense of timelessness.

"when we decided to bring it back as an active small farm. We raised hay, beef cattle, sheep, and finally horses, and built a horse barn and sheep barn, a woodshed, and machinery shed, culminating in a large Morton indoor arena for training horses. The farm used to be an equestrian center with many horses. I also built a small house for a caretaker, a rustic cabin on the trout pond in the woods up the mountain behind the house."

The house commands a forty-mile view across two rivers and deep into the New Hampshire mountains, and the Hoyts made a variety of improvements to the house, all the while honoring as much of the historic fabric as possible. A kitchen wing was added, but most distinctively, a four-season room was created by converting the attached woodshed into habitable space. "This outdoor living room," Bill says, "with its glass doors removed in summer, opens to the warm weather, and its fieldstone fireplace allows for enjoyment on chilly evenings."

The 1937 kitchen still uses a Dockash iron wood burning range as backup heat and the basswood-paneled sitting room is heated with an antique Franklin stove that is ornamented with a brass rail and Dutch tiles. The living room is the site of the original kitchen and features built-in pine china cupboards, a wide pine-paneled fireplace, and wrought-iron hooks in the ceiling for drying corn and apples.

The Hoyts have done their utmost to continue the farming tradition, and they strive to ensure it for future generations. "These hundred forty acres are varied and capable of many uses, about forty acres of which are open and a hundred acres deeply wooded. We take good care of our pastures and hayfields, baling over a thousand square bales of timothy and red clover annually. The land is in current use and is regularly logged," says Bill. The farm was conserved by the Vermont Land Trust in 2000.

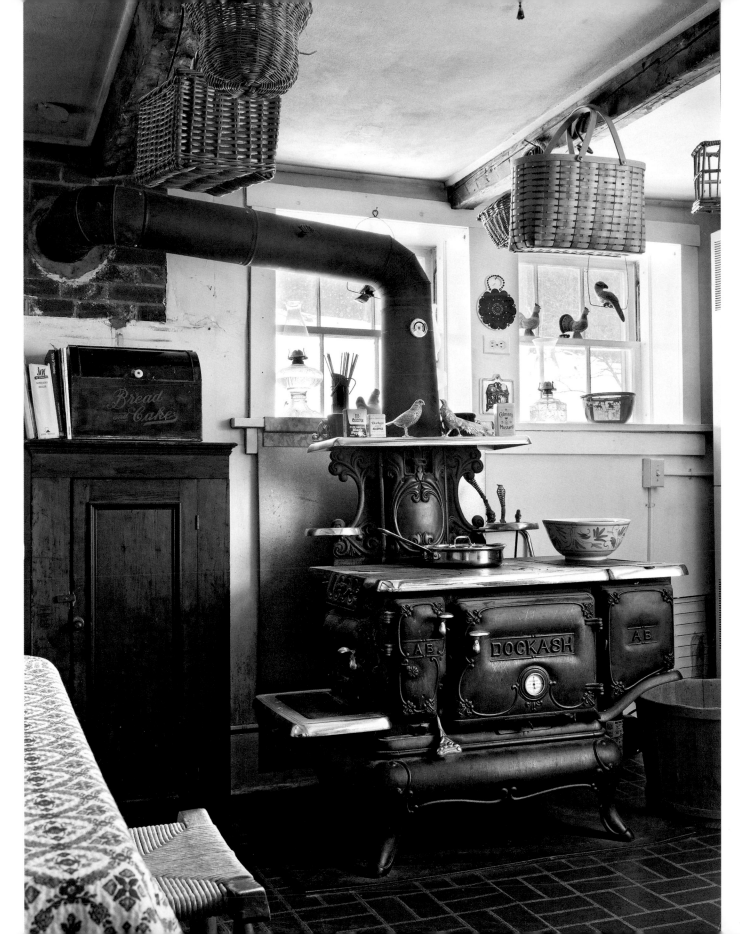

Wood- and coal-burning stoves heated many a farmhouse kitchen and were constantly tended; this turn-of-the-century Dockash still provides backup heat during winter cold spells. Residents often stored baskets by hanging them from the ceiling beams overhead, alongside drying herbs for cooking and medicinal purposes.

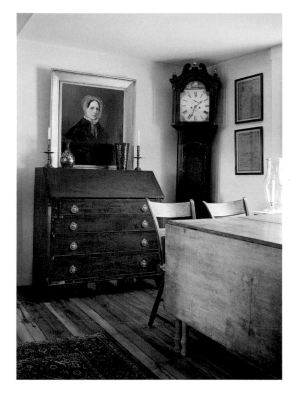

TOP LEFT
Whether inherited or acquired, antiques in the farmhouse proudly show their age and create a timeline of past owners from the Colonial, Federal, and Victorian eras. The eighteenth-century desk, tall-case clock, and drop-leaf dining table each display centuries of use. The woman in the gilt-framed portrait is Bill's ancestor.

TOP RIGHT
Franklin stoves were a vast improvement over fireplaces, as they radiated much more heat into a room. Nautical paintings and models were a favorite decoration well into the nineteenth century. The unusual three-legged chair with handled seat is from Lisbon, Portugal.

BOTTOM
Farmhouses with rooms built into their eaves must take advantage of space that, due to the pitch of the roof, is too low for foot traffic. Here, low closets frame a window seat in a dormer window.

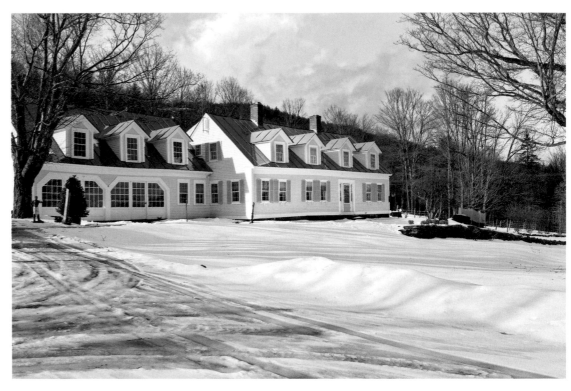

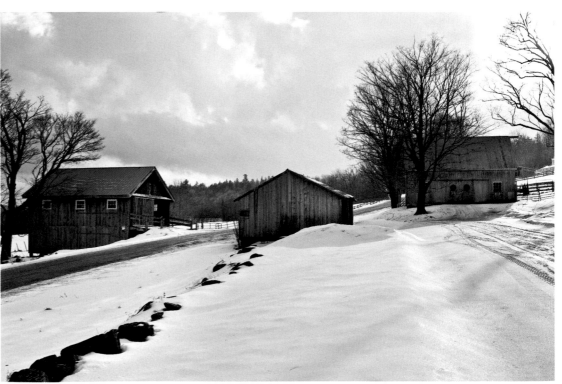

The Hoyts' Vermont farmhouse, which dates from the end of the eighteenth century, commands a 360-degree view that includes Mount Washington in New Hampshire and Killington Peak in Vermont. The wing to the left is not an enclosed garage but a vernacular structure the Hoyts call an "outdoor living room."

Originally a large and diverse farm, Saddlebow took in skiers in the 1930s and later became an equestrian farm. There are still many outbuildings on the property, including several barns, a cabin, and a caretaker's house. The Hoyts also tend three vegetable gardens and a sunken perennial garden, along with an acre of pumpkins and corn.

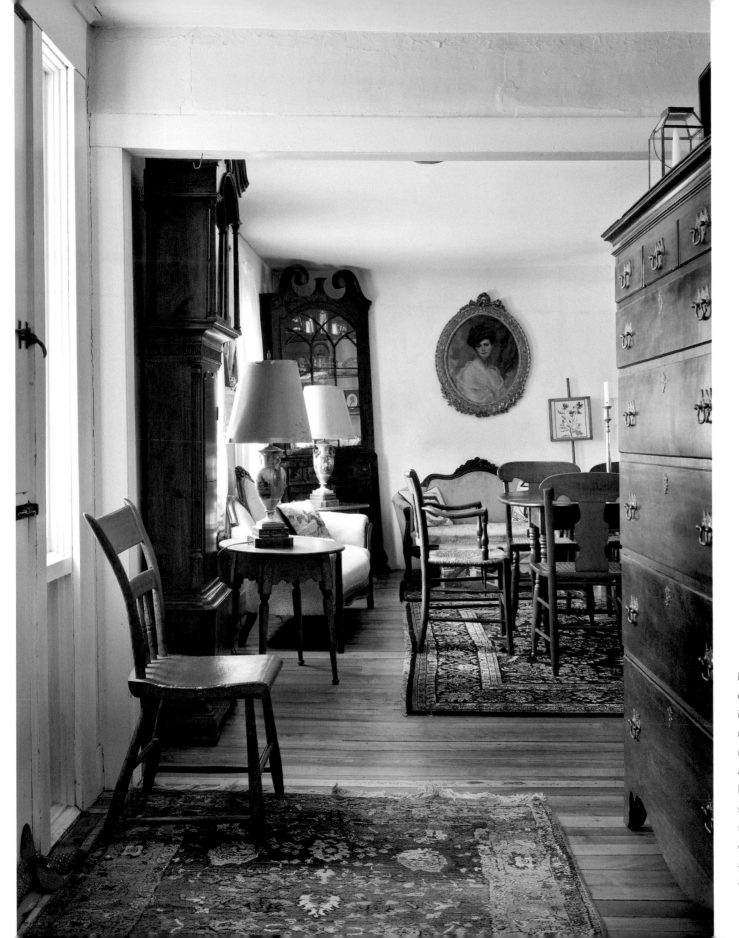

Many of the eighteenth-century interior finishings still remain, including the raised-panel doors and handwrought hardware. The dining set is composed of neoclassical side chairs and thumb-back armchairs at the heads of the table.

PLUMSTEAD HILL

Plumstead Hill, a small farm in Bucks County, Pennsylvania, is the home of Michael May, a historical preservationist, and Housley Carr, a writer. Theirs is a tale of not only preserving the property's beautifully simple stone farmhouse, but also of following a holistic approach for the care of the entire farmstead, which includes a former carriage barn, twin silos, and an orchard.

"We really think of ourselves as stewards," says Housley. "When you're lucky enough to find an historic house with many of its original features, it's your responsibility to respect what's there and, at most, make only small, evolutionary changes. A friend of ours has described it as having a light touch." They've added an allée of sycamore trees along the drive to the house, as well as split-rail fences. The couple also converted the Civil War–era carriage barn into a guesthouse, hiring skilled Amish workers from Lancaster County to restore the facade, build a new porch, and install a cedar shingle roof.

The three-stage stone house, which they purchased in 1997, was built by English Quakers in 1744 and later grew to be part of one of the largest dairy farms in the area. The oldest part features original details such as an "Indian door" that is only five feet ten inches high and heavily reinforced with protruding nail heads to strengthen it against raiders or marauders. An 1820 addition consists of a hall with a huge walk-in cooking fireplace and beehive oven, which is believed

The kitchen was added in 1949, and great care was taken to incorporate sympathetically designed paneling, doors, and cabinetry, as well as iron hardware, into the room. This concept of reinterpreting the Colonial Revival extended well into the twentieth century, adapting the spirit of the mid-eighteenth century to modern needs.

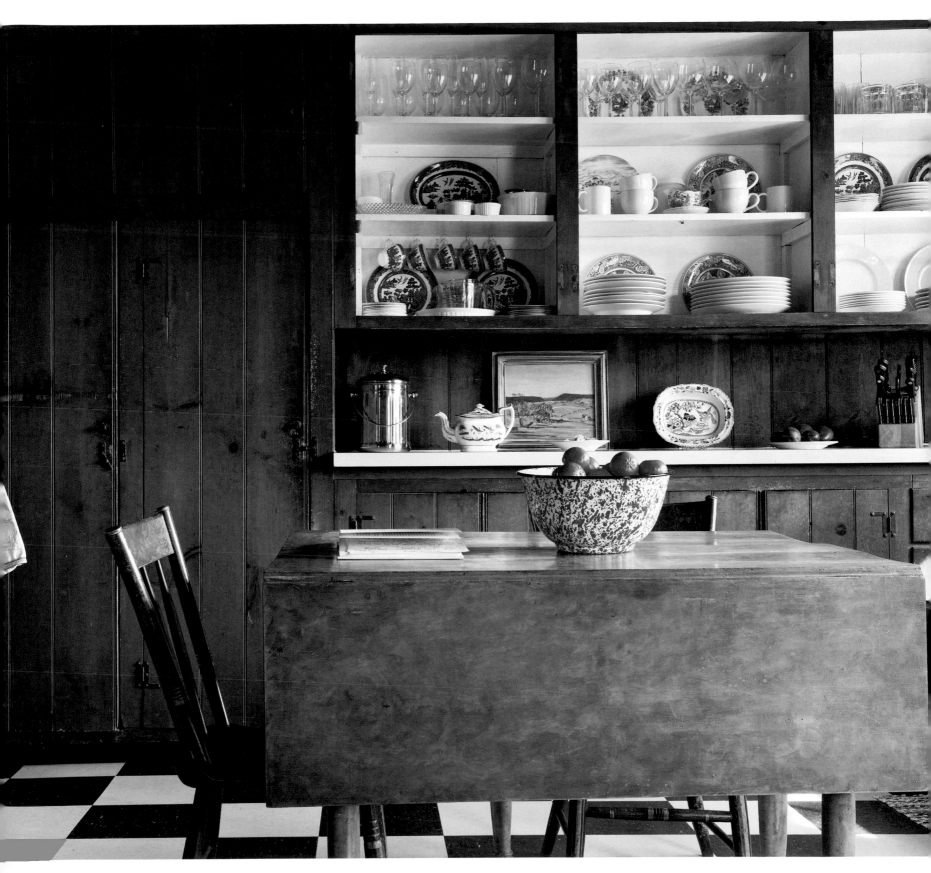

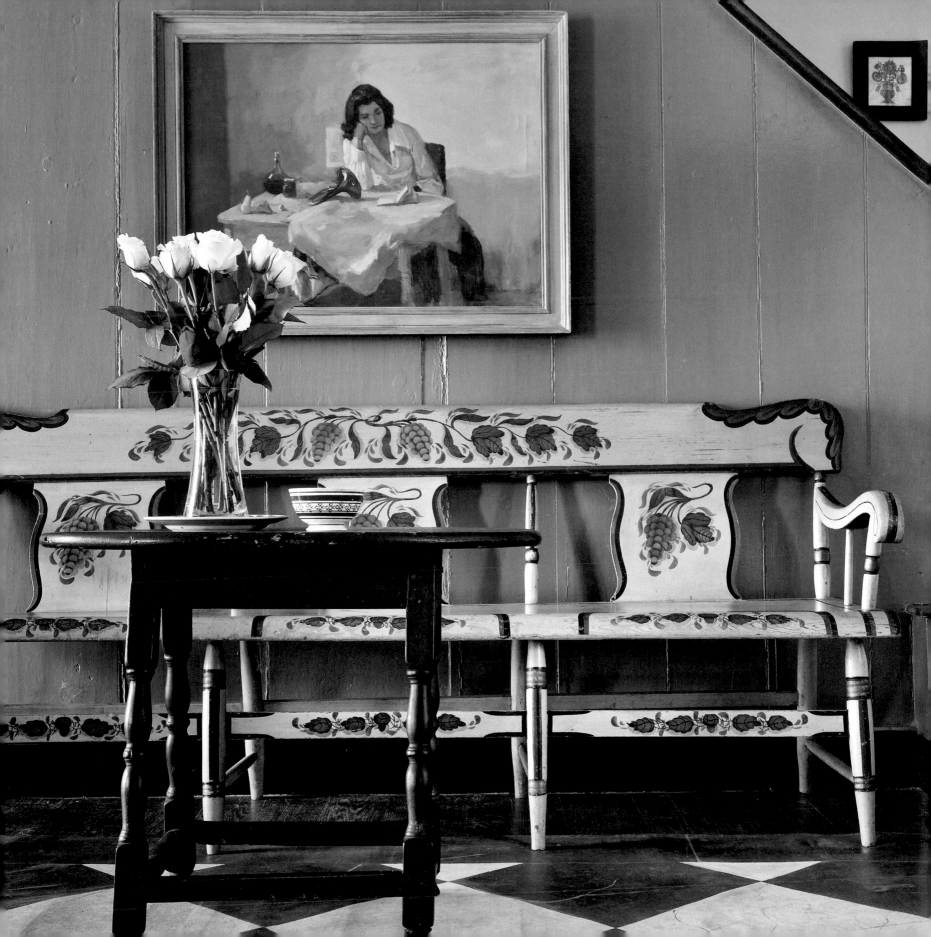

Michael and Housley are fascinated with painted surfaces, in both fine and decorative arts. The portrait was rendered by Michael's grandfather, while the bench, with its ornate grape and vine detailing, dates from the 1830s. In front is an eighteenth-century tavern table. The first treads of the winder staircase to the second floor are visible at right.

to have produced bread for the community. A third section, constructed in 1949, includes the current dining room and kitchen. The beamed ceilings in this newest part of the house were milled to resemble the beams in the original section of the house. On the exterior, the traditional door hood and roof of the porch are painted a crisp white, in keeping with local custom.

The interiors of Quaker houses were known to be exceptionally tidy, orderly, and very spare. The worldly asceticism of their religion required an austerity within the house; decoration was considered needless and vain, a philosophy that extended to their clothing as well as their furnishings. This plainness and restraint created the opportunity for lively contrast with the exuberant ornamentation of Housley and Michael's possessions. The couple have an affinity for painted surfaces, and many of their antiques are stenciled and gaily painted furniture from the eighteenth and early nineteenth centuries.

They have also augmented the interior with mid-twentieth-century paintings rendered by Michael's grandfather and other contemporary artists. The understated way they have placed these works throughout the house is in keeping with the simplicity of the Quaker aesthetic. The couple adds, "What we're drawn to most are things that are colorful and authentic, with the telltale signs of use and wear over the years, and we think old and new can go together well."

Michael and Housley, with their passionate desire to continue the farm's agricultural tradition and to preserve the farmscape of the area, hope to establish a small organic farm that produces fruits, vegetables, and herbs. Housley notes "We'd also like to raise chickens for egg production, and possibly goats." They've already planted a small orchard with a mix of organic heirloom fruit trees, including Calville Blanc apples, Moorpark apricots, and George IV peaches; the revival of this traditional farmstead is well under way.

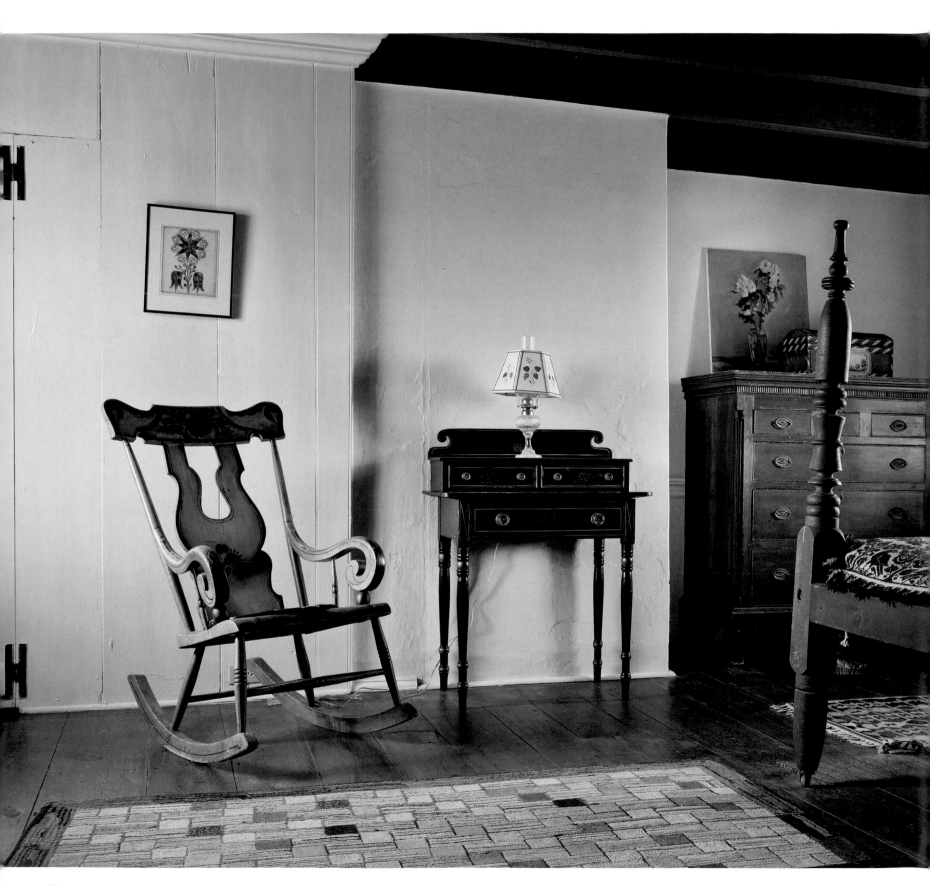

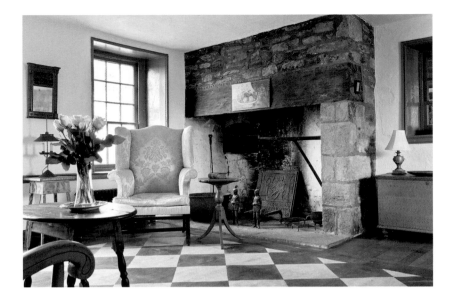

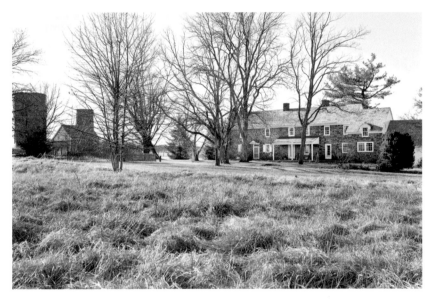

The west bedroom is filled with antiques, many of which are now two centuries old. The rocking chair, another example of finely decorated furniture, sits alongside a thickly turned rope bed and a Chippendale dresser.

The hall room, with its massive stone fireplace and thick, hand-hewn wooden lintel, displays several pieces of antique ironwork, such as the cooking crane, fireback, and firedogs. A black-and-white checkered floorcloth protects the floorboards.

The original section of Plumstead Hill's stone farmhouse, which dates from 1744, was built by English Quakers. The owners, Michael May and Housley Carr, have worked to preserve their farm, once part of one of the largest dairy farms in the region.

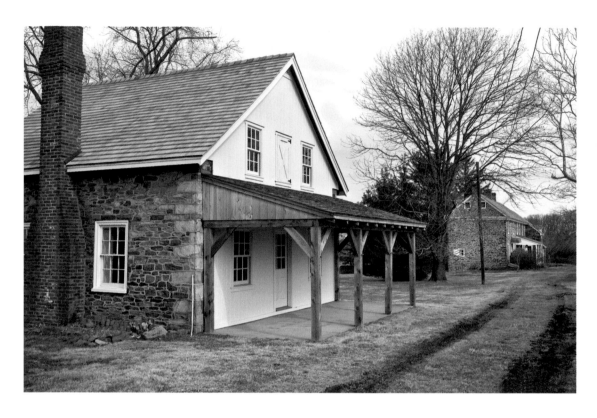

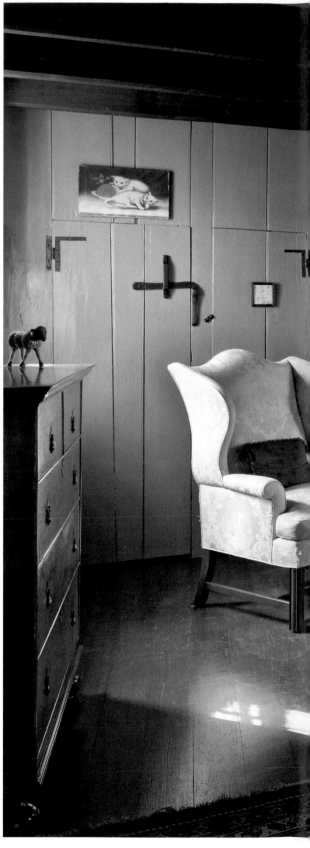

ABOVE

The current owners made the guesthouse from one of the property's barns, and its masonry is of particular note, as it is thought to have been done in the mid-nineteenth century by Amos Strouse, a German-American stonemason in Bucks County who later owned the property. The stonework on the older parts of the main house is typical of Bucks County Quakers in the eighteenth and early nineteenth centuries.

RIGHT

Built in the oldest part of the house, the parlor is centered on a fireplace and several pieces of Chippendale seating. The fireplace wall is composed of integral paneling and two doors, which have their original hardware. A late Federal folding card table has been placed behind the sofa, and to the far right, a hanging shelf displays nineteenth-century spatterware.

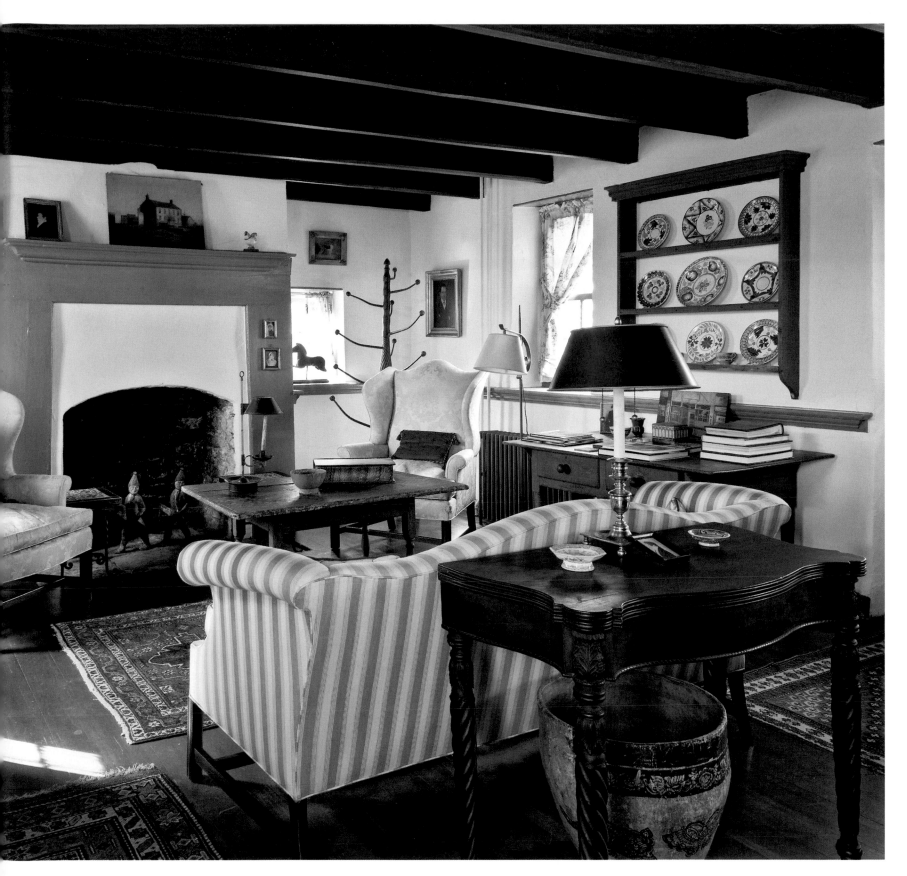

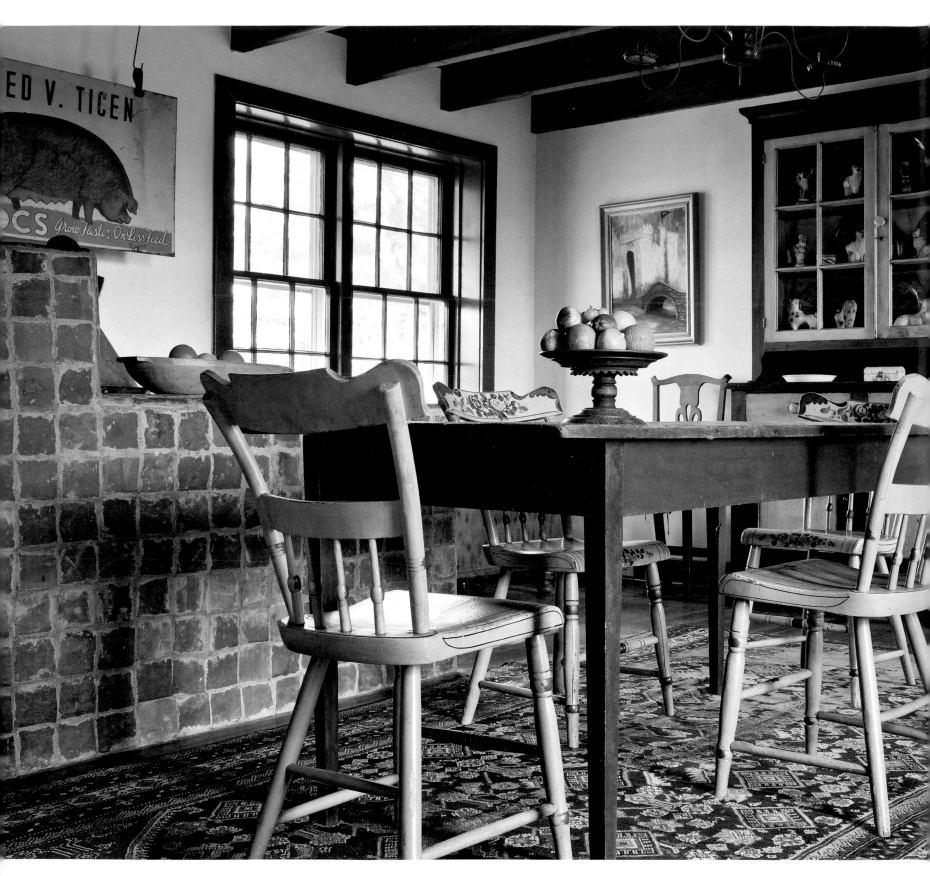

LEFT

In the dining room is a Mercer-tiled beehive oven; the house was the site of bread-baking for the community. A set of four bright yellow painted chairs decorated with stenciled rose bouquets is placed around a simple, tapered-leg table. The cupboard stores the owners' collection of chalkware dogs.

ABOVE

Figurines of dogs were immensely popular in the eighteenth and nineteenth centuries and were typically made from Staffordshire pottery or, as in this case, chalkware. They were often sold as mirror-image pairs and graced many a mantel. These two, though not a pair, are accompanied by two hand-decorated redware plates from roughly the same period.

ACKNOWLEDGMENTS

We wish to express our gratitude to all the farmhouse owners for their warm hospitality in letting us photograph their homes. And many thanks to Eric Himmel at Abrams, and our supportive editor Dervla Kelly and our gifted book designer Anna Christian. We also thank the people who helped us in our quest to find houses to include in this book: Stephanie Carter, Chris Darton, Glenn Gissler, Laura Gottwald, Jeffrey Lent, Tom Luciano, Mary Lou Nahas, and Dina Palin. And thanks to E. & E., as always.

THIS BOOK IS DEDICATED TO THE MEMORY OF IVAN C. KARP.

Editor: Dervla Kelly
Designer: Anna Christian
Production Manager: Tina Cameron

Text and photographs copyright © 2013 Steve Gross and Susan Daley

Cataloging-in-Publication Data has been applied for and may be obtained from the Library of Congress.
ISBN: 978-1-4197-0586-1

The text of this book was composed in Absara Sans.

Printed and bound in China
10 9 8 7 6 5 4 3 2

Abrams books are available at special discounts when purchased in quantity for premiums and promotions as well as fundraising or educational use. Special editions can also be created to specification. For details, contact specialsales@ abramsbooks.com or the address below.

THE ART OF BOOKS SINCE 1949
115 West 18th Street
New York, NY 10011
www.abramsbooks.com

6984

6984